THE ART & DESIGN SERIES

For beginners, students, and professionals in both fine and commercial arts, these books offer practical how-to introductions to a variety of areas in contemporary art and design.

Each illustrated volume is written by a working artist, a specialist in his or her field, and each concentrates on an individual area—from advertising layout or printmaking to interior design, painting, and cartooning, among others. Each contains information that artists will find useful in the studio, in the classroom, and in the marketplace.

Chinese Painting in Four Seasons: A Manual of Aesthetics & Techniques
Leslie Tseng-Tseng Yu/text with Gail Schiller Tuchman

Drawing: The Creative Process
Seymour Simmons III and Marc S. A. Winer

Drawing with Pastels
Ron Lister

Graphic Illustration: Tools & Techniques for Beginning Illustrators
Marta Thoma

How to Sell Your Artwork: A Complete Guide for Commercial and Fine Artists
Milton K. Berlye

The Language of Layout
Bud Donahue

Understanding Paintings: The Elements of Composition
Frederick Malins

An Introduction to Design: Basic Ideas and Applications for Paintings or the Printed Page
Robin Landa

Lithography: A Complete Guide
Mary Ann Wenniger

Painting and Drawing: Discovering Your Own Visual Language
Anthony Toney

A Practical Guide for Beginning Painters
Thomas Griffith

Teaching Children to Draw: A Guide for Teachers and Parents
Marjorie Wilson and Brent Wilson

Transparent Watercolor: Painting Methods and Materials
Inessa Derkatsch

Nature Drawing: A Tool for Learning
Clare Walker Leslie

The Art of Painting Animals: A Beginning Artist's Guide to the Portrayal of Domestic Animals, Wildlife, and Birds
Fredric Sweney

Charles Le Clair has taught at the University of Alabama, Chatham College, and Temple University, where he was dean of the Tyler School of Art for many years. His watercolors have been shown at the Whitney Museum, the Brooklyn Museum, Carnegie Institute, and in numerous other national exhibitions.

The ART of WATERCOLOR
Techniques and New Directions

CHARLES LE CLAIR

Technical Illustrations by the Author

A SPECTRUM BOOK

Prentice-Hall, Inc.
Englewood Cliffs, New Jersey 07632

Library of Congress Cataloging in Publication Data
Le Clair, Charles.
 The art of watercolor.

 (The Art & design series)
 "A Spectrum Book."
 Bibliography: p. 199
 Includes index.
 1. Watercolor painting—Technique. I. Title. II. Series.
ND 2420.L4 1985 751.42'2 84–24945
ISBN 0–13–047861–X
ISBN 0–13–047853–9 (pbk.)

THE ART & DESIGN SERIES

A SPECTRUM BOOK

10 9 8 7 6 5 4 3 2 1

Printed in the United States of America

ISBN 0-13-047861-X

ISBN 0-13-047853-9 (PBK.)

This book is available at a special discount when ordered
in bulk quantities. Contact Prentice-Hall, Inc., General
Publishing Division, Special Sales, Englewood Cliffs, N.J. 07632.

Cover illustration: Joseph Raffael, *Summer Memory in Winter*, 1982.
Watercolor, 44½ × 53 inches. Collection of Booz, Allen and Hamilton, Inc., New York;
courtesy Nancy Hoffman Gallery, New York.

Editorial/production supervision by Fred Dahl/Inkwell
Page layout and color insert design by Maria Carella
Cover design by Hal Siegel
Manufacturing buyer: Frank Grieco

Prentice-Hall International, Inc., *London*
Prentice-Hall of Australia Pty. Limited, *Sydney*
Prentice-Hall Canada Inc., *Toronto*
Prentice-Hall Hispanoamericana, S.A., *Mexico*
Prentice-Hall of India Private Limited, *New Delhi*
Prentice-Hall of Japan, Inc., *Tokyo*
Prentice-Hall of Southeast Asia Pte. Ltd., *Singapore*
Whitehall Books Limited, *Wellington, New Zealand*
Editora Prentice-Hall do Brasil Ltda., *Rio de Janeiro*

To my students

Contents

PREFACE, xi

Chapter 1

MATERIAL CONCERNS, 1

Watercolor Papers, 2
To Stretch or Not to Stretch—That Is the
Question, 3
Methods of Stretching Paper, 4
How to Flatten a Watercolor, 6
Tearing and Soaking Paper, 6
Watercolor Brushes, 7
Watercolor and Gouache Mediums, 9
Your Palette—A Word with Double
Meaning, 9
Recommended Colors, 10
Other Equipment, 12
Summary: Your Shopping List, 14

Chapter 2

BASIC WASH TECHNIQUES, 15

Dry vs. Wet Paper Techniques, 16
Laying a Flat Wash, 18
Graded Washes, 18
Edge Shading, 20
The Bottom Line: Shaping Geometric
Volumes, 25
Warming-Up Exercises, 25

Chapter 3

LAYERED TRANSPARENCIES, 27

Values, 28
Composing with Four Values, 28
Stepping Up and Down the
Value Scale, 30
Color is a Many-Layered Thing, 32
The Properties of Color, 33
Applying Color Principles, 33
Color Exercises, 36

Chapter 4

FROM CONCEPT TO FINISHED PAINTING, 39

Thinking White, 40
Arranging the Set-Up, 41
Composing with a Viewfinder, 43
Lighting the Subject, 46
The Preliminary Drawing, 49
Developing the Composition, 51
Still Life Projects, 56

Chapter 5

REALISM AND CLASSIC WATERCOLOR TECHNIQUE, 57

Watercolor in England, 58
Realism in France, 58
Homer and the Well-Made Watercolor, 60
Sargent and Eakins, 63
Academicism and Modernist Reaction, 65
The New Realism: Return to the
Figure, 66
The Contemporary Still Life, 72
The Great American Landscape, 77
Photographic Realism and Unrealism, 79
The Many Faces of Realism, 84

Chapter 6

THE "MARK" OF A LANDSCAPE PAINTER, 87

Using a Traditional Landscape Format, 88
Brushmark Techniques, 92
Modernist Landscape Idioms, 95
Editing Landscapes in the Studio, 99
Field Trip Strategies, 101

Chapter 7

WET-IN-WET TECHNIQUES, 103

Painting into Premoistened Areas, 104
Working on Saturated Paper, 108
Overpainting Wet-in-Wet Work, 112
The Puddle as "Process," 115
Exercises, 118

Chapter 8

PAINTING THE FIGURE, 119

Figure/Ground Relationships, 120
Nude vs. Clothed Poses, 125
Line and Wash Sketches, 126
Inventing Your Own Figures, 127
Composing with "Flats," 128
Rounding Things Out, 129
Underpainting and Indirect Technique, 130
Glazing Over a Sealed Ground, 133
Capturing an Impression, 134

Chapter 9

STILL LIFE STRATEGIES, 135

The Single Subject, 136

Still Life as Icon, 138
Modular Composition, 141
Patterning and Positioning, 144
The Mirror Image, 149

Chapter 10

FORMALISM AND EXPRESSIONISM, 153

Cézanne and Formalism, 154
Abstract Modes: Kandinsky and Delaunay, 156
American Modernists: Marin and Demuth, 158
Expressionism: Nolde, Grosz, and Burchfield, 162
Expressionism Today, 166
Experimental Modes: Klee and Some Contemporaries, 170
Conclusion, 178

Chapter 11

SPECIAL EFFECTS, 179

Dry-Brush Painting, 180
Salting, 181
Lifting, Scraping, and Scratching, 182
Masking Devices, 184
Spattering, 186
Taping, 189
Alternative Ways of Applying Paint, 190
Folding, Collage, and Other Options, 194

AFTERWORD, 197

BIBLIOGRAPHY, 199

INDEX, 201

Preface

There are a good many books on watercolor available, but they are by no means all alike, and—as the French say of the sexes—"vive la différence!" This book, for instance, differs markedly from other guides to the medium you may have encountered in at least four respects:

> First, it reflects the attitudes of a modern university or professional art college, offering the serious student—whether working independently at home or in a classroom situation—a thorough, sequential program of study rather than easy formulas for rendering flowers, nudes, or glamorous sunsets.

> Second, it features the work of artists who have won recognition as serious painters rather than that of watercolor "specialists" known for their eye-catching facility with the medium.

> Third, it offers how-to techniques, not as ends in themselves, but in the context of visual ideas. In art there are many ways to express oneself rather than a single "correct" approach. Thus, technical explanations are related here to esthetic concepts they might serve. And arguments for and against a procedure are noted so that you can make a thinking person's choice.

> Fourth, it combines studio information with art historical comment. For whatever reasons, this is an unusual structure for a handbook, yet it is a logical approach to the subject and one that reflects the way painting is taught in our better art schools, where studio teachers correlate practical assignments with slide presentations and museum visits.

Watercolor is a medium that offers a unique painting experience. In contrast to oils or acrylics, a watercolor can be dashed off in an afternoon. Thus, by completing the projects suggested in the chapters ahead, you should come up with fifteen or twenty paintings—a substantial and, as you will see, quite varied portfolio.

The speed and flexibility of watercolor make it appealing for people with various levels of experience and training. Those who haven't painted before find its brief, small-scale projects congenial. Accomplished artists, who often take up watercolor as a "new" medium after years of working on canvas, find its technical range exhilarating. Teachers can adapt watercolor to precollege, undergraduate, or graduate curriculums. And for anyone working at home in close quarters, the medium's minimal equipment requirements are an obvious attraction.

This book is written with many audiences in mind. It is a handbook addressing the practicing artist in the manner of a studio encounter. Yet much of the text will interest people who are not painters themselves but want to know more about art. The general reader will find chapters on the history of watercolor, developing a composition, and the nature of such genres as still life, landscape, and figure painting particularly informative.

I must emphasize that though this book has evolved from a college course, its content goes far beyond the material I would present in a normal class. Two years of research have gone into the project. I have visited the back rooms of SoHo galleries and the stacks where museums store old masters. The works of thirty-six contemporary artists are considered, and in most cases I have been able to talk with these painters in their studios, sometimes for an hour or two, and often for the better part of a day.

The result is a broad picture of the state of watercolor as it is practiced by leading American artists today. The book is also packed with lore—the type of paper Welliver uses, how Raffael creates his wet effects, the pigments Pearlstein prefers, and so on. This kind of personal information fascinates me, and I think it will interest you, too.

Finally, let me say that this book is designed as a guide, rather than a schedule to

be followed rigidly like a diet or exercise program. Each chapter presents alternative strategies, and one or another should appeal to you. If not, give the suggested exercise a quick try, and perhaps later you will come to see its value. Then, before moving on to the next chapter, do a painting entirely on your own.

Watercolor is distinctive in that it depends, more than any other medium, upon the extremes of utter spontaneity and complete control—the seemingly accidental splash done with just the right timing. By following a fairly straightforward path of study, yet digressing from time to time when creative impulses strike you, you will develop the qualities of a watercolorist.

ACKNOWLEDGMENTS

I am deeply indebted to each of the artists who graciously consented to be interviewed for this book. The invaluable information they provided is reflected in the pages that follow.

The courtesy of five museums, a score of galleries, and numerous private collectors in permitting their paintings to be reproduced must also be acknowledged. In some cases there was frequent assistance or unusual encouragement, and I would like to extend special thanks to the staffs of the Philadelphia Museum of Art and the Fischbach, Hirschl & Adler, Nancy Hoffman, and Salander-O'Reilly galleries.

I deeply appreciate the advice and guidance of Mary Kennan, my editor, and the expertise of Prentice-Hall's editorial, production, and design staffs who have given tangible shape to my book. Particular thanks go to cover designer Hal Siegel, to Maria A. Carella, who is responsible for the interior layout, and to Production Editor Fred Dahl, who has steered this project to completion with a skilled hand.

Above all, I am indebted to my wife, Margaret, who has clarified the text as the first editor of the manuscript and offered continuing help and support.

The Art of Watercolor

Material Concerns

You can't make a silk purse out of a sow's ear. Yet many art students (unless forcefully persuaded otherwise) try to paint with materials that cannot produce the desired result. *He* uses a palette so small that color mixtures run together in a mottled mess. *She* has a brush, bought at a saving of ten dollars, that bends left or right but will not spring back. *They* work on paper that will yellow within the year. My first purpose, therefore, is to assure you that the list of basic supplies presented at the end of this chapter is a minimum, rock-bottom, requirement. To cheat on it is to cheat yourself, since "making do" with inadequate materials will lead to a discouraging experience and prevent you from realizing your potential.

As painting mediums go, watercolor is relatively inexpensive. Space and equipment needs are minimal: you can work on the kitchen table or in the backyard with a board on your lap. Pigments go a long way, brushes are slow to wear down, and even the most elegant paper is cheaper than canvas. Still, be prepared for a substantial initial outlay. Afterward the fun begins, and you will want to protect your investment by learning how to use and take care of your materials. This chapter is devoted to such practical matters.

Material and equipment costs are particularly modest if, like most artists, you plan to work in a traditional small-scale format. A #6 sable brush costs 75 percent less than a #12, a lightweight paper sketch block eliminates the need for a heavy drawing board, and pigments go a long way in small areas. In recent years, however, many leading watercolorists have turned to the new oversize papers, and perhaps—after you gain confidence with the medium—you will want to follow suit. In any case, when you work in a larger scale, costs escalate and so do the technical problems relating to stretching and flattening the paper which are discussed in these pages.

WATERCOLOR PAPERS

A smart chef can substitute margarine for butter without ill effect, but as far as I am concerned the serious watercolorist *must* work with good paper. *Student grade paper* is composed of wood pulp or other material that self-destructs like an old newspaper. Furthermore, its absorbent surface responds to washes quite differently than the glazed finish of quality stock and, although easy to use, it encourages bad technical habits.

Artists' grade paper, on the other hand, is made of chemically neutral 100 percent rag fibers. It has a firm finish and permanent whiteness. Traditionally, it was laid by hand with a beautiful deckled edge now imitated by machine technology.[1] Linen is the best rag stock, although nowadays less costly cotton is usually substituted. Quality papers also have embossed logos, like the emblems of Gucci or St. Laurent, and—although both sides are useable—the "right" side, with a slightly more subtle finish, is determined by holding the trademark up to the light. Nine out of ten painters interviewed for this book prefer *Arches*, the French paper, but there are equally fine American products as well as English *Whatman* (available now after an absence of twenty years) and Italian *Fabriano*.

Manufacturers offer a choice of three standard finishes:

- *Hot Press*. A smooth surface polished by a hot "iron." Designed for detailed rendering and fine brushwork, this paper is inappropriate for the broad technique we will start with. It lacks the tooth needed to hold a wash, and the surface buckles and leaves rings when wet.

- *Rough*. A heavily textured paper that also has somewhat specialized uses. It acts like pebble board with dry-brush work, in commercial design it encourages a stylized rendering, and occasionally a major artist like John Marin finds a way to use it excitingly (see fig. 11.2). In general, however, a Rough finish tends to "take over," and you should have some experience before tackling it.

[1]Genuine handmade paper has all but disappeared from art stores. However, several firms make watercolor papers to an artist's special order. James McGarrell uses paper from Twinrocker, Inc., R. F. D. 2, Brookton, Indiana 47923. Inessa Derkatsch lists a number of other sources for handmade, as well as oriental and standard, papers in her book *Transparent Watercolor*, pp. 233–35. (See bibliography.)

• *Cold Press.* The all-purpose paper you will rely on at the outset. Its surface is pressed between cool rollers to a degree of smoothness, but with some texture remaining. The tooth is unaggressive, yet sufficient to hold wet passages attractively.

Watercolor paper comes in various weights (or thicknesses).[2] Professionals generally prefer 300-lb. stock almost as heavy as cardboard because of its handsome physical presence and resistance to buckling. Yet all finishes are available in thinner 140-lb. and 90-lb. weights at half or one-third the cost. A medium-weight 140-lb. Cold Press paper is recommended for the beginner. This is the thickness of most papers that come in a roll, incidentally, and thus the necessary choice of many professional artists whose work is very large. I often use this weight, and Sondra Freckelton says she prefers it to heavier 300-lb. Cold Press paper because the texture, though theoretically the same, is in fact less insistent.

Size is another consideration. If you are cost conscious, the 22-by-30-inch standard (or Imperial) sheet is advantageous, since it is well proportioned when used whole or torn into 15-by-22-inch halves or 11-by-15-inch quarters. Instead of cutting corners with inexpensive substitutes, learn to get the most out of a piece of really good paper. The half-sheet, favored by artists over the years from Winslow Homer to Sidney Goodman, is an excellent shape for your first endeavors, and the quarter-sheet will do nicely for small studies. This last was Demuth's preference, and both he and Cézanne were not averse to making a second start on the back. You can do this, too, when the sketch up front fails to jell. One mark of quality rag stock is that it can be used on both sides.

The watercolor block (or tablet) is a convenient alternative to separate sheets. This is a pack of paper secured in a gummed binding, so that you can paint on the top sheet and cut away afterwards to a fresh layer. Made by Arches, Whatman, and other leading manufacturers, blocks come in several sizes and usually contain twenty-five 140-lb. sheets. The paper develops hills and valleys when wet, since it is not really "stretched." However, it *is* held in place on a light cardboard backing which eliminates the need for tacks, tape, and drawing board. If convenience is important to you, by all means buy a tablet, but in an 18-by-24-inch or larger size, with the thought of painting within a penciled border when a smaller format is needed. Like convenience foods, however, sketch blocks are not to my personal taste. They lack the deckled trim of sheet paper, the raised edge of the block inhibits the sliding action of the painter's arm, and they tend to lock the artist into a conventional size and proportion.

Oversize paper is in the news today as manufacturers respond with new products to the current interest in larger watercolors. A 29½-by-41½-inch size, which Elizabeth Osborne uses, is better proportioned than the old, overly long Double Elephant paper (25½-by-40-inches). Philip Pearlstein and Carolyn Brady use 40-by-60-inch 300-lb. Arches as a standard format, and Joseph Raffael and other contemporaries paint watercolors six or eight feet long on paper that comes by the roll.

Working at this scale is not for everyone, but if you are interested in doing so, buying paper by the roll is probably the answer. In contrast to the difficulty of obtaining separate oversize sheets, which are available only in New York and a few metropolitan centers, a roll can easily be special-ordered by any art store. Arches 140-lb. Cold Press paper comes in 10-yard rolls 44 or 50 inches wide, and I always keep one on hand for the convenience of being able to cut a piece in any size or proportion when needed. And on a cost-per-square-inch basis, this is by far the best buy. It is particularly recommended for an art class where students and teacher can divide a roll and share costs.

TO STRETCH OR NOT TO STRETCH— THAT IS THE QUESTION

Before you start to paint, you face an immediate question: whether to stretch or not to stretch the paper. This is an important issue bearing on equipment, technique, and esthetics, and one on which artists have opposing views. After listening to the arguments, you may—like Hamlet—have difficulty making up your mind, because there are advantages either way.

Stretched paper is a nuisance to prepare, but it is a surface that—however much scrubbed, sponged, and pummelled—will spring back to

[2]The "weight" of watercolor paper stock is determined by the actual weight of a ream (500 sheets) in standard 22-by-30-inch size.

drumhead tautness when dry. For a perfectly smooth finished painting, for finely detailed lines, or for wet-in-wet techniques, where a great deal of water is poured on, stretching is necessary and well worth the trouble. The tape or tacks used in stretching, however, destroy the original paper edge, and when the painting is finished, it must be matted. Presenting a watercolor in this way, with the picture running under and behind a framing window (sometimes with an indeterminate outer boundary that could be changed by a different mat) is a Renaissance device favored by conservative painters. Modernists, on the other hand, often prefer to exhibit a watercolor as an "object," like a tapestry or embossed print, complete with deckled edge and naturally rippled surface.

Unstretched paper, in contrast, requires no preparation and has a handsome physical presence undamaged by stapling or trimming. This is my own preference, and I exhibit watercolors mounted *within* the mat or frame, rather than cut off by it. In any case, not having to stretch makes for a more natural, easy-going experience in which you can walk into the studio or art class and go to work without preliminaries. The one drawback is that unstretched paintings, even on heavy stock, sometimes become unduly warped. Now, with the discovery of techniques for smoothing out wrinkles *after* your watercolor is painted, even that handicap may be eliminated.

METHODS OF STRETCHING PAPER

There are three basic stretching techniques, each of which is designed for a particular situation. If you decide to stretch your paper, consider its size, weight, and what you will use it for, and then select the process described below which is most appropriate.

1. *Stretching with tape on a drawing board* (or plywood) is a neat, simply executed process for small papers in the 12-by-16-inch range. Although some artists, like Don Nice, have learned to use it for huge watercolors, this is tricky and I do not recommend taping for large work. More often than not, shrinkage will be so great that the paper will pull loose before the gummed tape has had time to set.

Proceed by penciling a one-inch margin around the paper as a guide for the tape. Next wet both sides of the sheet *briefly* with a sponge, faucet, or dip in the tub. Then lay it on the board to expand for ten minutes, and remove excess surface water with a towel. As an added precaution, the one-inch border may be further dried with a blotter. Now cut strips of two-inch brown paper wrapping tape—the kind with a water-soluble gum backing. Moisten each strip with one stroke of a sopping-wet sponge, so that the glue side is evenly wet and the back dry, and apply half on the paper and half on the board. Press down firmly and rub repeatedly for several minutes. The paper must dry in a horizontal, not a vertical, position.

2. *Stretching over wooden canvas supports* is a rough-and-ready method with advantages for students in an art class. Open to the air on both sides, the paper dries in minutes. Very little work is involved, and the apparatus is inexpensive, lightweight, and portable. Standard 22-by-30-inch paper fits over a 20-by-28-inch canvas stretcher with a one-inch border all around, and other dimensions with similar margins can be used.

Since the stretched paper will be a drum that a pencil point might puncture, complete the preliminary drawing first. Then soak the paper thoroughly in a tub for ten minutes, lay it down with the slightly smaller stretcher on top, and fold up the extended sides. Fasten one side at a time with thumbtacks at two- or three-inch intervals, and fold in the corners. Push the tacks in diagonally, with only one edge against the paper, for easy removal later. After drying, the paper becomes a taut drumhead that will soften as washes are applied and then tighten up again.

3. *Stretching with a staple gun* is the most professional and dependable method of stretching sizeable watercolor paper. Afterward, it will tighten up for fine details yet take any amount of soaking, drying out, and rewetting.

Charles Schmidt suggests covering a piece of ⅜-inch plywood with colorless polyethylene plastic sheeting folded around and stapled on the back. This keeps the paper's underside clean and prevents harmful substances from leaching out of the plywood. Then soak the paper thoroughly in cold water, staple it to the plastic-covered plywood with tack points about 1½ inches apart and ¼ inch from the edge. Dry

Fig. 1.1.
Tips on handling paper.

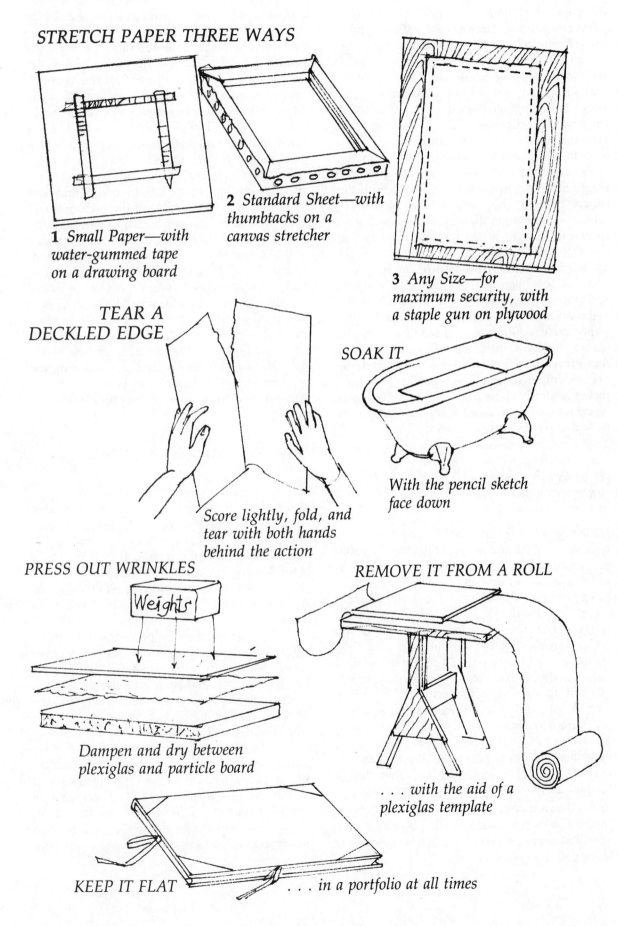

STRETCH PAPER THREE WAYS

1 *Small Paper—with water-gummed tape on a drawing board*

2 *Standard Sheet—with thumbtacks on a canvas stretcher*

3 *Any Size—for maximum security, with a staple gun on plywood*

TEAR A DECKLED EDGE

Score lightly, fold, and tear with both hands behind the action

SOAK IT

With the pencil sketch face down

PRESS OUT WRINKLES

Weights

Dampen and dry between plexiglas and particle board

REMOVE IT FROM A ROLL

. . . with the aid of a plexiglas template

KEEP IT FLAT *. . . in a portfolio at all times*

the paper horizontally, to prevent tearing or wrinkling, and if there is some slight ripping away from the staples, a few new ones can be driven in halfway between the others. When the picture is finished, do *not* cut it off with a mat knife, as you would if it were taped. Instead, remove all staples with a thin screwdriver and needle-nose pliers, so that the plastic sheeting will be intact for future use.

Joseph Raffael's technique is similar, but with variations that may be helpful. Instead of plastic sheeting, he coats the plywood with Veruthane varnish. Then, after soaking his paper—which is often larger than Schmidt's, and hence in greater danger of tearing—he blots it thoroughly with large white blotters. He also applies brown wrapping tape to carefully penciled borders *before* stapling. The gummed tape will not hold by itself, but it keeps edges flat, and staples driven through the double layer of paper and tape hold more firmly than in paper alone. Raffael's painting of a white rose, reproduced on the cover of this book, illustrates his technique. The giant sheet of paper, 53 inches wide, is shown cut from the stretching board with a brown tape border that will later be tucked under the frame or mat.

HOW TO FLATTEN A WATERCOLOR

Flattening a watercolor after it is finished, to remove wrinkles and prevent buckling, is a simple process few artists know about. This is unfortunate, because painters often exhibit lumpy work without realizing how much it might be improved by a few days under weights. Buckling develops as one area of the paper becomes wetter than another and thus expands at a greater rate. To regain its original flatness, the whole sheet must be dampened, allowed to expand, and permitted to shrink back slowly and evenly under pressure. There are various techniques. Elizabeth Osborne uses a system she learned from museum conservators involving masonite sheets, blotters, and felt pads. The method I have invented is simpler, however, and entirely dependable:

Obtain a sheet of ⅛-inch plexiglas and a piece of ¾-inch particle (or flake) board cut to a size that leaves a 3-inch margin around your paper. (I put student paintings that are 22-by-30 inches in a 28-by-36-inch flattener, for example, and have a larger one at home for my own work.) Lay the particle board on the floor, where it will serve as the bed of the "press," and place the plexiglas on a table with your finished watercolor face down on it. While holding the paper firmly, moisten the back for a good ten minutes with repeated motions of a square-cut sponge. When strokes are kept ¼ inch from the paper's edge, the sponge doesn't usually wet the plexiglas, but if a little moisture creeps around to the front of the picture it will evaporate later without damage. Next lay the paper, dry picture-side up, on the particle board and blot any visible moisture lightly with facial tissue. Then cover the painting with plexiglas, add evenly spaced piles of books or other weights, and let stand for several days. The porous particle board absorbs water slowly from the back without noticeable dampness penetrating to the floor. Weather and furnace heat determine drying time, and sometimes one removes a paper too soon, before it is bone dry. If rippling should recur, just repeat the process.

TEARING AND SOAKING PAPER

Tearing watercolor paper, instead of cutting it, produces a soft, natural edge that is compatible with the linenlike texture of the surface. This is important for the artist who paints out to the edge instead of using a mat. It is particularly helpful when a paper must be split into half-sheets, since the new torn edge will then simulate the beautifully deckled finish of the other three sides.

I recommend this procedure: Draw a lightly ruled pencil line on the reverse of your paper, score with a mat knife that barely cuts into the surface, and then fold along this line, sharpening the ridge with thumbnail or ruler. At this point, the heaviest paper can be torn with confidence, provided you know the trick of moving both hands back as you go, so they are always between you and the point of the tear. In taking paper from a roll, a large rectangle of plexiglas is most helpful: when laid on the stiffly curved paper, it flattens it onto the table, provides a template for ruling dimensions with an assured right angle, and serves as a firm sup-

port against which to tear off the piece that is to be removed.

Soaking the paper is required for stretching it or painting in the wet-in-wet technique we will consider in chapter 7. A home bathtub accommodates standard flat sheets or oversize paper rotated in a loop. In a school situation, a plastic photographic or printmaking tray large enough to hold 22-by-30-inch paper is needed.

The process sounds as simple as pouring coffee, yet there are a few refinements. Your pencil drawing of the subject, for instance, should be done in advance and placed in the water face down because the floating top side can develop dry spots. And though directions usually call for cold water, you can safely speed things up with a lukewarm temperature. When paper is wet "through," rather than on the surface only, it appears translucent. This takes time, however, and there is no sure way to determine when it is "done." I advise ten minutes in the tub for average paper and an hour for a 300-lb. sheet, but the exact time doesn't matter much if you plan to stretch it. On the other hand, for wet-in-wet painting, it is a good idea to play it safe with a two- or three-hour or overnight soaking, since the longer paper stands in water beforehand, the longer it will stay wet while you work on it.

WATERCOLOR BRUSHES

Nowadays the corner grocer displays caviar in a padlocked case, and my art supplier keeps Winsor & Newton's finest Series #7 red sable brushes—the type that sell for up to four hundred dollars in the larger sizes—in his safe. These are what professionals use, and a few years ago a book like this would have advised you, too, to buy a top quality brush—the kind traditionally made by hand, from Siberian Kolinsky sables, with the natural curve of each hair turned toward the point rather than pressed into position.

But times change, and inflation has put both Russian caviar and fine sable brushes "out of sight" for most of us. Fortunately, manufacturers have come up with serviceable alternatives. These include "inexpensive" *genuine sables* (made from less than top-grade fur);

Sabelines that mix in other kinds of animal hair; *brushes of synthetic fiber*, like Robert Simmons's White Sables; and Sable and *Synthetic blends*, as in the Winsor & Newton Sceptre line.

I recommend either Sabeline or Sceptre, but whatever your choice of brushes, they must be of decent quality. Although I say "brushes," it is better to buy one good brush than several that won't do the job. You will find that a bargain brush—the kind, for instance, that is included free in a set of colors—invariably loses its shape and turns to mush the moment you dip it in water.

You need three basic painting instruments: a large #12 or #14 round brush; a medium-size #6 or #8 round brush; and a broad, flat, wash brush. There is no harm in trying some of the specialized brushes shown in art store displays—Oriental bamboo-handled styles, round-ended "mops," squared-off brushes, and fan-shaped "ticklers." In practice, however, you will do 90 percent of your work with a good round brush that comes to a point, holds a generous amount of fluid, and springs back into shape after each stroke. This is an all-purpose tool that produces fine lines as well as juicy strokes. Open spaces—a sky or a wall behind a figure—are best laid in quickly and smoothly with a wide, square-ended wash brush. This is also used at the start of a picture to establish general tones that will be painted over later. Expensive artists' wash brushes are available, but a one-inch housepainter's brush from the hardware store will do just as well. (See Fig. 1-2, p. 8.)

Good brushes thrive on tender loving care. Some of mine are ten years old and still going strong. There are only a few principles to remember, but as in caring for teeth, they must be followed regularly:

1. Wash the brush in warm water and Ivory soap after each usage. Then shape the point with suds to hold the hairs in position when dry.
2. Avoid using it for acrylics, ink, or any other medium.
3. Don't let it stand in water, because the wooden handle will swell, and the point may become blunted. Instead, lay your brush on the table when not in use, or bristle-end up, in an empty jar.
4. When carrying several brushes in a case, attach them with a rubber band to a slightly longer stick to prevent the tips from hitting the box.

Fig. 1.2
The brushes I use shown ¾ actual size.

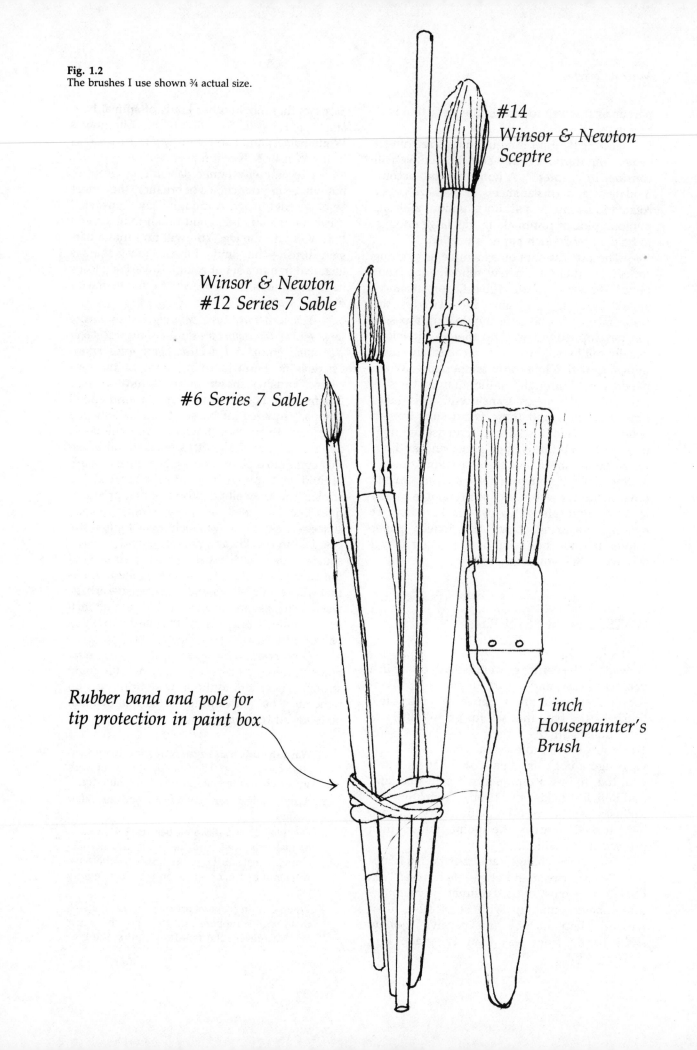

#14
Winsor & Newton
Sceptre

Winsor & Newton
#12 Series 7 Sable

#6 Series 7 Sable

Rubber band and pole for
tip protection in paint box

1 inch
Housepainter's
Brush

WATERCOLOR AND GOUACHE MEDIUMS

Transparent watercolors are made of finely ground pigment mixed with gum arabic, one of those natural products—like maple syrup, which also comes from a tree—that science has yet to improve on. A secretion of the acacia, gum arabic has the virtue of not only binding pigment to the paper when dry, but of encouraging color particles to float, evenly suspended in water. A distinctive feature is that, unlike most mediums, gum arabic remains forever soluble. Thus you can soften and reuse dried paint on your palette, or wash down a picture with a sponge and start over again.

Watercolors are available in two forms: moist tube colors and solid cakes (or pans). The latter are convenient (especially when packaged in a neat tin case you can stick in your vacation suitcase) but they dissolve more slowly, and tend to produce paler washes, than pigments squeezed from a tube. Most professional artists prefer tube colors, although there are exceptions. Philip Pearlstein, for instance, uses pans precisely because the washes are thinner and he wants to avoid heaviness. In any case, dry colors invariably inhibit the beginner, and I urge you to start with moist tube paints. Mastering watercolor is like surfing—a matter of developing ease and expansiveness. For this reason, I favor generous brushes and paint squeezed out "at the ready" in a creamy mix.

Gouache is a widely misunderstood medium because it has been traditionally defined as "opaque" watercolor in contradistinction to "true" or "transparent" watercolor. Actually, modern gouache (or designer's color) is an improved and versatile medium which, like acrylic, can be used either heavily or in thin washes. Obviously, "thin" painting requires avoidance of colors mixed with white, but when a selection of gouaches is matched color for color with your watercolor palette, washes in the two mediums are of equal transparency. About half of my students use gouache, and in a critique, no one can distinguish between the mediums.

If the effect is so similar, why use it instead of regular watercolor? One reason is that modern gouache has a binder that "sets" when dry. Afterward, spills and splatters can be wiped off with a damp sponge, and the picture can even be put to soak without dissolving the image. I find this a tremendous plus, since one can build up layers of washes without worrying whether what is underneath will come off. It is also an advantage for anyone in the design field, and students like gouache because the tubes are bigger and last longer. Gouache is not, however, a medium you can push around, dissolve with spray, or sponge off. Straight watercolor is far more compatible with happy accidents and runny passages.

Perhaps more painters would opt for gouache if its usefulness in transparent painting were better understood. Still, I suggest that you start with the classic medium of Homer and Cézanne, and consider experimenting with gouache at a later time.

YOUR PALETTE—A WORD WITH DOUBLE MEANING

The word *palette* has two basic meanings. Artists put out their colors on a slab called a palette, and a painter's selection of pigments is also spoken of as his or her palette. The term has a further connotation of esthetic attitude, as when we talk of Eakins's "sober" or Monet's "luminous palette."

In any sense of the word, choice of palette is significant. Some artists need a spacious work surface, while others work neatly within the dimensions of a shoebox. One painter achieves profundity with a few tones; another, excitement with every color in the rainbow. My advice for the beginner is to be generous on both counts—get yourself a big palette, and play with lots of colors. You can always cut back after you have explored the full range of possibilities.

For a palette to mix paints on a 12-by-16-inch cookie sheet from the hardware store is an excellent choice. This comes in white Teflon or plain metal with a little turned-up rim. As permanent studio equipment, I prefer a 24-by-30-inch sheet of plate glass, but portability is crucial in many situations, and you can tuck a cookie sheet under your arm or toss it in the car with the greatest of ease. An advantage in either case is that colors are squeezed onto a flat sur-

face, rather than in little pockets that collect water. There is also ample mixing space that can be sponged off or rinsed under the faucet when you clean up.

Art store palettes, in contrast, are elaborate, heavily molded with indentations like a TV-dinner tray, and usually too small. If you want to splurge, get a professional palette, but look for something generously proportioned like Martha Mayer Erlebacher's plastic tray (fig. 1.3). And note how the artist has simplified the central space, which originally had four compartments, by inserting a single piece of glass that can be removed for washing.

RECOMMENDED COLORS

In a perfect world, you would need only three tubes of paint—red, yellow, and blue—because theoretically everything else is a mixture of these primary hues. Unfortunately, however, combining pigments diminishes their brilliance, and the orange you mix with red and yellow is less intense than one squeezed from a tube marked "Orange." Fine art pigments have little to do with "perfection," in any case. They are oddly assorted substances—made from metals, synthetic compounds, and natural earths from historic places like Umbria and Sienna—that artists value for two qualities: permanence and distinctive character.

Thus an artist's palette of colors is not an evenly calibrated affair, like the rainbow hues in a set of poster paints. Rather, it is a highly personal collection of warm and cool or bright and dull pigments that reflects the artist's taste. As connoisseurs of color, painters, like other collectors, tend to fall into three groups: minimalists, those with a taste for abundance, and those who prefer a workable but not overly extensive palette.

"Less is more" is a famous art axiom, and those who follow it use what is known as a *limited palette*. In Rembrandt's time, this was normally a choice of pigments used throughout the artist's oeuvre. Today painters often choose specific pigments for particular paintings, in the way that musicians compose in the key of C major or B-flat minor. Neil Welliver and Frank Galuszka, for instance, limit their palettes to

seven or eight vivid colors while Charles Schmidt creates subtle effects with only three or four pigments. One typical Schmidt scheme consists of Cadmium Red Light, Indian Red, Ivory Black, and Payne's Gray; another is composed of Ultramarine, Burnt Umber, and Raw Umber.

John Dowell's collection of seventy-one colors is the opposite extreme, and Martha Mayer Erlebacher uses forty-seven pigments. These are laid out on the palette shown here (fig. 1.3) and a second auxiliary one. Not surprisingly, most watercolorists prefer something in between—a palette that is neither comprehensive nor minimal. Don Nice's, for example, includes eleven colors; Philip Pearlstein's, seventeen.

This is an appropriate range for the beginner, who should start with a dozen or so tube watercolors and consider impulse shopping later on. Certainly you will need this broad a selection if you are to include neutral earth colors, gray, and more than one version of some spectrum hues. Since there is no one "true" red, the painter must have both a purplish Alizarin and an orangey Cadmium, and the same principle applies to greens and blues. Here, then, are my recommendations for your initial palette:

1 **GRAY** (Optional): *Payne's Gray, Davy's Gray, or Neutral Tint*
The inclusion of gray is a matter of personal taste. My neutrals are a mix of blues and Burnt Sienna, but Payne's is a cool gray used by many artists. Davy's is a warm slate gray, and Neutral Tint a balanced tone.

1 **VIOLET**: *Thalo (Winsor) Violet* or *Cobalt Violet*
Phthalocyanine colors are labelled either "Thalo" or by a brand name like Winsor. They are very intense, and Cobalt Violet is a milder alternative.

2 **BLUES**: *Cerulean* plus *Permanent* or *Ultramarine Blue, Light*
Cerulean is sky blue; the others are inkier. The Ultramarines—Brilliant, French, Light, and Deep—are modern imitations of the original lapis lazuli that is still available for a "price" as Ultramarine Genuine.

2 **GREENS**: *Viridian* or *Thalo (Winsor) Green* plus *Sap Green, Hooker's Green,* or *Winsor Emerald*
The first group are dark bluish greens; the second are lighter and warmer. Chromium Oxide and Terre Verte are additional dull greens to consider.

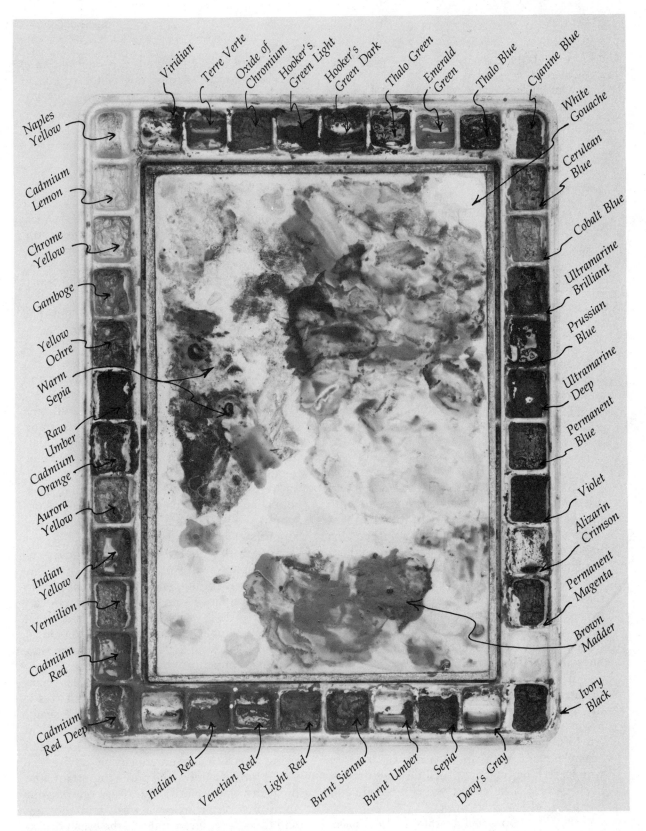

Fig. 1.3.
Martha Mayer Erlebacher's palette. In addition to
the forty-one pigments on her main palette, Erlebacher
uses six others: Cobalt Violet, Quinacridone, Rose Doré,
Carmine, Antwerp Blue, and Manganese Blue.

1 **YELLOW**: *Cadmium Yellow* (sometimes marked *Medium*)
One medium yellow will suffice, but if you can afford it, a pairing of Cadmium Pale and Cadmium Deep—one with a twist of lemon, the other with a hint of orange—is better.

1 **ORANGE**: *Cadmium Orange*

2 **REDS**: *Alizarin Crimson* or *Cadmium Red Deep* plus *Cadmium Red* or *Cadmium Red Light*
The first group are purplish reds, but the second red must be a bright geranium hue that is hard to find. Study the manufacturer's charts and see if a salesperson will remove the cap to show what you are buying.

2 **EARTH COLORS**: *Burnt Sienna* and *Raw Sienna*
Reddish Burnt Sienna and leather-tan Raw Sienna are the most transparent "earth" colors, although Venetian Red and Yellow Ochre are also useful.

NOT RECOMMENDED: *Chinese White* and *Ivory Black*
To master transparent watercolor, you must give up opaque white; and though some artists use black, it tends to be sooty. Learn to mix optical black with other colors instead.

TOTAL: *A palette of eleven or twelve colors*

When you have selected your colors and are ready to paint, squeeze your pigments onto the palette in a logical rather than random order. After the session, left over paint remains in place for future use. Because the arrangement of pigments becomes fairly permanent, it might as well be a sensible one so that you can reach for a particular color with an assured, automatic gesture. The above listing of pigments suggests the kind of order you might use—a sequence from gray and cool spectrum colors to warm hues and earth browns.

The mixing area on your palette has to be cleaned regularly with a sponge or tissues, but the piles of colors remain undisturbed and become dried-out cakes between sessions. Thus a helpful before-breakfast ritual is to spray yesterday's paint with an atomizer or laundry spritzer so it will soften up. A little later, dabs of fresh paint can be added where needed, and you are ready to go to work.

Finally, two small warnings: *Tube colors must be rolled up from the bottom like toothpaste* or paint will squirt out the back seam. *To avoid a sudden* spurt this must be done *after* each usage rather than just before removing the cap. Also remember that, to avoid tearing the tube, *a cap*

that is stuck should be expanded by heat instead of forcefully twisted. Apply hot water or match flame until it turns easily.

OTHER EQUIPMENT

Like a chef in a well-stocked kitchen, the watercolorist relies on various incidental studio supplies and equipment. Some standard items are included without description in the Shopping List that ends this chapter. Others need explanation:

Pencils are an obvious necessity, but they must be just right—neither so soft as to encourage a graphite film on the paper, nor so hard as to dig into it. A Venus 2B is suggested, but touches vary. Discover what is best for you and keep it at hand.

The water jar must be capacious, and some artists use two—one for rinsing the brush and one for clear washes. A wide-mouthed quart pickle jar is an excellent choice, and it should be frequently refilled.

A portfolio of some kind is essential, since both your finished paintings and your paper supply should be kept flat and held between supports at all times to prevent buckling. For carrying work around town, a professional portfolio complete with waterproof cover, handles, and zipper is recommended. But if you plan to use the portfolio at home and transport it by car, consider a do-it-yourself foamcore folder that can be assembled in minutes for a "song." Foamcore is a weightless, rigid, styrofoam stiffener that comes in 4-by-8-foot sheets. Simply trim off two pieces with a mat knife, lay them side by side, make a hinge of quick-stick Mystic cloth tape, applied above and below the seam, and—presto—a portfolio! I keep several on hand, for large and small papers, and use metal spring clips as a convenient closing device.

A turkish towel is one of the important little things in a watercolorist's life. Keep one on your lap so that, after laying a wash and allowing fluid to settle, you can squeeze the brush dry on terry cloth and then use it to suck up the excess liquid on your paper.

A supply kit will not improve your work, but it is a great convenience. Professional kits are equipped with snap-locks, handles, and

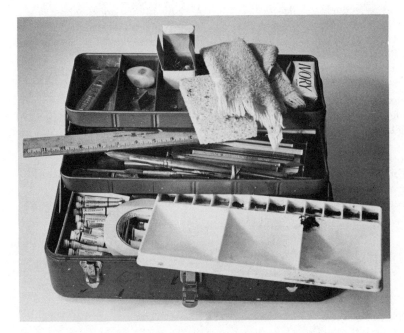

Fig. 1.4.
My "compleat" paint kit.
A fishing-tackle box that holds
everything except paper, board, and
water jar.

suspended trays for paints and brushes, but a standard fishing-tackle box offers the same features at less cost. Whatever you choose, be sure it will hold all your gear except paper and water jar. On a sketching trip, you should have no more than two or three things to carry.

Sponges are needed for both palette cleanup and paper dampening. Square-cut synthetic sponges are particularly useful, and you need two—one to be kept clean and one for dirty work. Many artists also use a natural sponge as a painting instrument, either for putting on a large, even tone, or for premoistening an area to be filled in later with a brush.

Transfer paper, in the graphite shade, is recommended for anyone who has to struggle with the pencil drawing. With a complicated subject, it is often best to do the drawing on a separate page and transfer it so that your watercolor will be undamaged by smudges and pencil-point indentations.

Finally, a *drawing board*, or suitable support for your painting, must be arranged. Art schools provide drafting tables, and if you work at home a rigid sketch block may be sufficient at the outset. Eventually, however, you will want to work larger and experiment with wet paper that requires a firm backing board. This must be big enough to accommodate a standard 22-by-30-inch paper with a margin all around, and unfortunately the drawing boards available in art stores are often small and unsubstantial.

Thus you may have to devise something for yourself. These are the main alternatives:

1. *Plywood*, ⅜-inch thickness, cut to order at a lumberyard. Coat it with synthetic varnish, and attach the paper with thumbtacks or masking tape.
2. *Homosote*, also cut to order at a lumberyard. Homosote takes tacks but is a bit soft for tape. It has two disadvantages: considerable weight and a rough outer edge. Nancy Hagin minimizes the first problem by making a rectangular jigsaw cut out about 1½ inches from the edge of the board. Centered on the long side, and large enough to put her fingers through, the cut out creates a convenient handle. Sondra Freckelton meets the second challenge in an elaborate but interesting way. She frames the homosote with 1-by-2-inch wood stripping, has several boards to fit various paintings, and hangs them on the wall from time to time in order to study work in progress.
3. *Plexiglas* (or transparent acrylic sheeting), ⅛-inch thickness, provided by a supplier listed under "Plastics" in the yellow pages. Attach paper with a spring clip or lay it down loose, as I do. I work at a drafting table tilted so that the paper does not quite slide off, and I sandwich the painting between two acrylic sheets after each work session. This inhibits buckling and permits the watercolor to be studied under "glass" as it will appear later when framed. Plexiglas is lightweight, portable, and rigid enough to provide support beyond the edges of

the drafting table. Thus it can effectively enlarge your work surface. On a 30-inch table, for instance, you can use a plexiglas sheet cut to fit 40-inch watercolor paper with ten inches simply extending over the top or sides as you paint.

4. *Foamcore*, purchased at an art store and cut to the desired shape by a mat knife. This would seem an unlikely, overly fragile possibility. However, Pearlstein uses it for 40-by-60-inch watercolors, and it is even more feasible for small-scale work. Cut the foamcore to the exact size of the paper, without margins, and attach with spring clips. Keep several boards on hand, and discard them when bent.

SUMMARY: YOUR SHOPPING LIST

Everyone has something old, borrowed, or blue to add to watercolor gear, whether it be left over colors, a baking pan that might do for a palette, or simply pencils and erasers. So check your holdings against the supplies listed below before going to the store. These are basic requirements. Some of the more exotic materials you may be interested in later are considered in chapter 11.

Essentials

Paper	Artists' grade cold-pressed 140-lb. 22-by-30-inch watercolor paper *or* an 18-by-24-inch block of similar quality
Brushes	One #12 or #14 *and* one #6 or #8 round Sabeline or Scepter watercolor brush *and* one 1-inch flat housepainter's brush
Palette	A 12-by-16-inch cookie sheet *or* a large professional palette
Pigments	Eleven or twelve tubes of moist watercolors (see p. 10)
Drawing Board	See p. 13, not required with paper in sketch-block form
Water Jar	Quart-size glass *or* plastic container
Pencils	Venus 2B *or* equivalent
Eraser	Nonstaining White Vinyl *or* Art Gum
Sharpener	A small hand unit is satisfactory
Masking Tape	½ inch width only
Sponges	Two square-cut cellulose sponges
Thumbtacks	
Ruler	
Ivory Soap	
Facial Tissues	
Turkish Towel	

Useful Extras

Atomizer	
Gummed Tape	2-inch brown paper wrapping tape
Mat Knife	
Paper Flattener	Matching sheets of plexiglas and particle board (see p. 6)
Portfolio	Professional *or* cloth-hinged foamcore folder (see p. 12)
Spotlights	Two clamp-on spots with 150-watt reflector floodlights (see p. 46)
Spring Clips	Two in 3-inch width
Staple Gun	
Supply Kit	Fishing-tackle box *or* artists' supply kit
Transfer Paper	Graphite color only

2

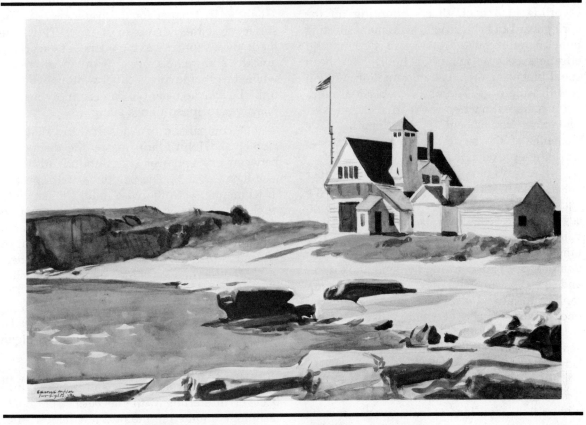

Basic Wash
Techniques

There is no more exhilarating sight than athletes cavorting in a pool, divers bouncing off the springboard in half gainers, swimmers snorting bubbles in the crawl. Motions are rhythmic and effortless because marathon hours have been spent practicing the most efficient "form." So it is with watercolor. Anyone can splash around, but it is more fun when you learn some strokes. Therefore, we will begin by exploring the basic elements of the medium through a series of warming-up exercises.

The ways of applying watercolor to paper are as clearly differentiated as the swimmer's backstroke and Australian crawl. And though several approaches may be combined in one painting, they are usually done as separately timed actions that require specific conditions: damp or dry paper, a rough or smooth surface, and so on. Fortunately, these techniques are not too complicated and can be mastered, one by one, in a few practice sessions. What *is* difficult is learning to use them with clear intent in an actual painting. When you confront a naked lady, a tree at sunset, or an arrangement of Chianti bottles, there is so much to consider that it is often difficult to decide what to do. That is why it is a good idea to have practiced basic washes separately, so that you will know what strategies might be effective.

DRY VS. WET PAPER TECHNIQUES

Watercolor may be applied either to dry or to dampened paper. The two techniques—*wet-on-dry* and *wet-in-wet* painting—are quite different in effect and call for opposite ways of working. The wet style is soft and atmospheric; the dry method, bright and crisp. Just as there is no such thing as "a little" pregnancy, there is no "slightly dry" paper for the watercolorist. The surface is either damp or it isn't. Thus one method calls for preserving wetness by working quickly and remoistening with an atomizer, while the other involves either waiting patiently until the area you want to paint is dry or using a hairdryer to speed things along.

A comparison of landscapes by Winslow Homer and John Marin makes the distinction between dry and wet styles abundantly clear (see figs. 2.2, 2.3). The paintings are opposites in technique, yet otherwise quite similar. Both depict sea and sky against a rocky foreground developed with light/dark contrasts and striated brushmarks. The Homer, however, captures Nassau sunshine with sharp-edged washes, while the Marin evokes Maine fog with strokes that blot and blur on dampened paper. The nineteenth century master's realistic outlook is served by a clean-cut style; the modernist Marin, on the other hand, uses a wet technique to achieve a more abstract "impression."

In studying watercolor, one of these approaches must come first, and I am a firm believer in starting with the basic wet-on-dry technique outlined in the next few pages. After developing confidence and a working rhythm, you will be ready to expand your range by exploring wet-in-wet painting and the experimental processes described in later chapters. Watercolor requires equal parts of spontaneity and control. Those with a casual or recreational interest in it may want to plunge immediately into the adventure of soaking paper and watching colors run. For anyone willing to engage in sustained study, however, disciplined practice should come first, because—as in dancing or stunt flying—it provides the assurance needed for genuine freedom.

As we begin, then, we will explore the basic grammar of watercolor by working with a wet brush on dry paper. The marks will be distinct and "measurable" in the sense that you will be able to control them to a desired darkness, shape, or coloration. You will learn to build volumes, preserve lights, deepen washes

Fig. 2.2.
WINSLOW HOMER (American, 1836–1901).
Natural Bridge, Nassau, ca. 1898.
Watercolor, 14 × 21 inches.

Fig. 2.3.
JOHN MARIN (American, 1870–1953).
Seascape, Maine, 1914.
Watercolor, 14⅛ × 16⅝ inches.
Philadelphia Museum of Art, Samuel S. White III
and Vera White Collection.

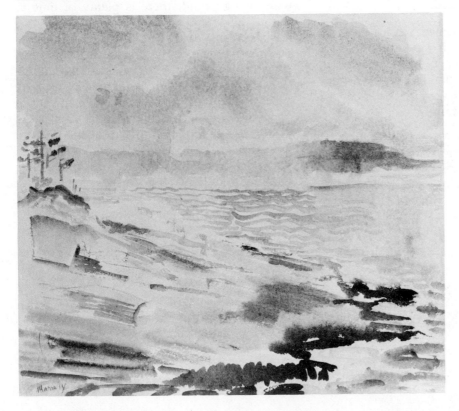

in even gradations like stair steps, and lay transparent colors over one another in effective combinations. These are the methods of artists as diverse as Sargent and Klee, and later you will find that many of these principles apply to wet-in-wet painting as well.

LAYING A FLAT WASH

Some handbooks distinguish between *washing* (on wet paper) and *glazing* (when the surface is dry). However, few artists make this technical distinction in discussing their work, and I find it useful to save the term *glaze* for the kind of glossy overlayer we find in resin-oil painting or ceramics. Therefore we will simplify matters by talking only of washes here.

Learning to put down a smooth, flat, evenly liquid tone is one of the first skills you must acquire. Fortunately, laying a flat wash is as easy as cracking an egg. For years the trick of breaking the shell without mishap eluded me until I saw Audrey Hepburn demonstrate it in the movie *Sabrina Fair*. Suddenly all was made clear! You simply use a smart wrist motion, with the hand snapping downward and sharply back, instead of moderating the force of the blow. So it is with laying a smooth watercolor wash. Follow a few simple principles (see fig. 2.4), and success is assured:

1. Work on an inclined surface. Tilt the drafting table slightly, or if you have a drawing board or sketch block, prop it on books. Remember that watercolor runs downward, and there must be drainage in one direction if "back-up" puddles are to be avoided.

2. Use the biggest brush you can handle. Fewer strokes mean fewer "seams" between strokes; and since a good round watercolor brush comes to a fine point, a surprisingly large one can be used in close quarters. For wide open spaces, use a flat wash brush or house-painter's brush.

3. Keep a juicy mixture of pigment and water ready. Some artists fill mixing cups in advance so they can flood the paper and thus prevent spottiness and irregular drying. The solution must be strongly pigmented, since it is

easier to dilute a strong wash than to beef up a weak one after you have started.

4. Start at the top, work within marked boundaries, and let each stroke settle before continuing. Outline the wash area in pencil so you will know where you are going. Make a broad, slowly brushed stroke at the top of the paper. After the fluid has settled, make a second and then a third horizontal mark, each time blending in the surplus from above. An irregular zigzag twist to the stroke makes transitions smoother and avoids a striped effect.

5. When the whole area has settled, remove excess fluid at the lower edge with the tip of a dry brush. You will discover that this acts like a miniature suction pump. I keep a turkish towel in my lap, and the process of painting juicily, squeezing the brush dry on the towel, and then using it to suck up excess fluid is a basic watercolor rhythm.

These are simple procedures, but they do run counter to one's instincts. The natural tendency is to work quickly, yet swiftly executed strokes leave bare spots or taper off to thin, fast-drying edges. The trick is to use *lots* of fluid and work *very slowly*, remembering that the edges of your brushmarks will not dry as long as they are brimming with water.

Capillary action gives a fully loaded wash a certain stand-up thickness, like syrup. Thus, with enough fluid, there is plenty of time to reload the brush, decide how to enlarge the wash, and shape it as you wish. If each stroke is slow and fully pressed down, the color will have time to flow into the paper's hills and valleys. Otherwise it will dry with bubbles of white and you will be tempted to go back and touch things up. Retouching almost inevitably makes matters worse. So learn to start at the top of a slanted board, pull the wash downward with successive horizontal strokes, and maintain a standing puddle that will be sucked up only at the last minute.

GRADED WASHES

In dancing, you learn a basic step and then being to relax and "swing" with it. For the

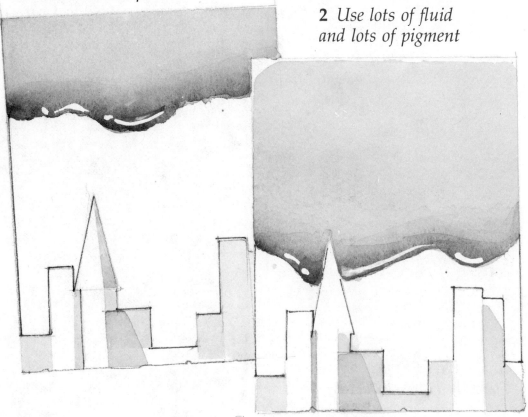

1 *Outline area in pencil*

2 *Use lots of fluid and lots of pigment*

3 *Make horizontal, slightly zig-zag strokes*

4 *Leave standing puddle at all times*

Fig. 2.4.
Laying a flat wash.

5 *Suck up excess with dry brush*

GRADING FROM DARK TO LIGHT

1 *Add more water to each successive stroke*

2 *Let surplus settle before continuing*

GRADING FROM ONE COLOR TO ANOTHER

1 *Put strongest color on top— even if paper is upside down*

2 *Add more new color to each successive stroke*

3 *Finish with second color*

Fig. 2.5.
Graded washes.

watercolorist, flat washes are like that—a basic vocabulary for visualizing a composition in terms of clear-cut planes. Yet in practice variations are usually called for. Skies lose their depth, and shadows in a still life turn to cardboard, if they are painted too mechanically. Thus the artist "swings" a little by using a *gradation* instead of a flat tone.

To illustrate, let's look at Winslow Homer's washes in *Palm Tree, Nassau* (pl. 1). A master of simplification and broad watercolor style, Homer designed the space behind the silhouetted trees as three geometric shapes—a rectangle of pale sky, a wedge of bright sea, and a triangle of waving grasses. You might say that the basic scheme is as "flat" as a poster. Yet the artist makes it convincing by variations within each area. A subtle mingling of two colors, cerulean and ochre, evokes the palpitating atmosphere of the sky; the sea's brilliance is achieved by shading from indigo to ultramarine and then to purple at the horizon; and the grassy bank is conjured up by rough brushmarks and a shift from light in the foreground to dark at the water's edge.

Thus, we see that washes may be graded either from one hue to another, or from a deeper to a lighter shade of the same color.

Grading from dark to light, you will find, is actually easier than trying to make a wash perfectly even. In a large area, start with full color at the top and add more and more water to the strokes as you move down the page. If you want the bottom edge to dissolve into nothingness, make a stroke of clear water at the end and blot with tissue or suck it up with a dry brush.

Carolyn Brady is a contemporary watercolorist who works this way, typically starting with the darkest tones and shading into light (see fig. 5.16). This technique requires a certain amount of space, however, since strong colors above must have room to drain into lighter areas below. Therefore, for abrupt transitions in small areas, you may want to reverse the process. Start with a light stroke, add intense color beneath it, and water from above will run down into a smooth middle-value blend.

Finally, as you decide upon the shading you want, remember that it is entirely kosher to turn the paper right-side up, upside down, or sideways in order to get the desired effect (see fig. 2.5).

Grading from one color to another is as easy as pie after you have learned to shade from dark to light. Simply add more and more of a new color instead of diluting the wash with water. Begin by mixing two distinct pigment solutions. Then make a stroke with one, follow with a blend of the two colors, and finish with a brush dipped only in the second hue.

In general, these shifts should be from a bright color to a muted tone (to suggest sunlight and shade), or from one intense hue to another (to achieve a radiant effect). *Analogous colors*—the hues next to each other on the color wheel—make particularly luminous gradations. A tangerine, for example, is more vivid when blended with yellow and red-orange than when painted from a single tube. In nature, the redness of an apple ranges from warm vermilion to cool russet, and what we think of as "sky blue" is actually a chameleon tone that shifts from blue-violet to greenish cerulean.

Monet discovered all this a century ago, and it is interesting that, among today's watercolorists, it is the more abstract painters who are interested in spectrum colors. Joseph Raffael paints exotic fish in irridescent drip-puddles (pl. 15), and Robert Keyser evokes a jukebox rainbow at the bottom of his *The Oracle Contemplates the Great Clapper* (pl. 20). Meanwhile, realists like Sondra Freckelton and Carolyn Brady stick to the essential, or *local*, color of an object, relying on gradations from dark to light rather than changeable hues (see plates 7 and 8).

Your questions about graded-color washes, then, will have less to do with the technique, which is simple, than with how many jazzy effects to get into. My advice is to try everything—experiment with all sorts of color combinations and pull back to a more sober palette later if you wish. Remember that watercolor has a special affinity for luminous color because it is a transparent medium, and most of the things we associate with transparency—flashing water, sunlight on snow, the glitter of glass—are perceived in terms of changeable hues.

EDGE SHADING

Dealing with edges is a key issue in watercolor. There is a constant dialogue, sometimes heating

up to an argument, between an initial pencil drawing and the more exuberant marks added later by the brush. Neil Welliver calls this the "name of the game"—playing with the line, using it here and destroying it there. For an inexperienced person, however, reconciling lines and washes may seem a precarious balancing act, because one soon learns that too much fussing with edges dampens spontaneity, while painting without "guide" lines may lead to incoherence.

Basically, there are two ways to resolve the dilemma: by painting flat washes up *to* your penciled contours or by using graded washes that fade *away* from these edges. Edward Hopper's *Coastguard Station* (fig. 2.1) illustrates the first strategy; Earl Horter's *Toledo* (fig. 2.6), the second. Both paintings depict architecture, sky, land, and water, yet they are approached in quite opposite ways. Hopper uses blocks of solid color—light blue sky, ultramarine water, tan beach—whereas Horter avoids local color altogether. Instead, he creates dramatically shaded planes that carve out shadows in a space that is like a block of fog cut through with klieg lights.

Edge shading of this kind is easily mastered technically. It involves no more than brushing a stroke of rich color against a pencil line, then dissolving the other side with a stroke of clear water that is sucked up by a brush or blotted into vagueness with tissue (see fig. 2.7). Essentially, this is the graded wash done in a more compressed space. But sudden transitions add drama, and the artist most closely associated with the technique, Demuth, uses it with marvelous refinement. In a typical work like *Peaches and Fig* (pl. 3), he shades from an edge and then blots the open side of the wash with crumpled tissues. He also employs textural devices, like spattering and salt sprinkles, that we will consider in chapter 11.

For success with this technique, remember that *edges can be shaded effectively in only one direction.* The wash's function is to create a shadow which pushes one side of the pencil line back and the other forward. Since you obviously can't get anywhere by pushing both sides of an edge back, sometimes an arbitrary choice is required. Study Horton's *Toledo* to see how this works and how, in the few areas where the artist shades in both directions, he leaves a separating strip of white paper.

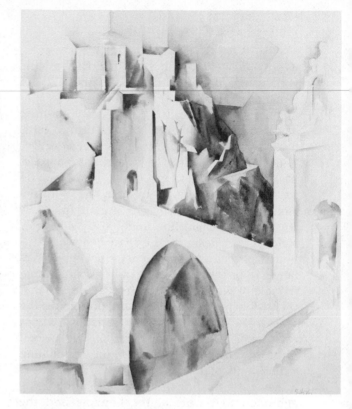

Fig. 2.6.
EARL HORTER (American, 1881–1940).
Toledo, 1924.
Watercolor, 13⅜ × 15¼ inches.
Philadelphia Museum of Art, Samuel S. White III and Vera White Collection.

The abstract artist John Dowell makes especially potent use of the Demuth tradition of elegant edge shading in watercolors like *Paradox on a Parallax* (fig. 2.8) and *Love Jamb* (pl. 22). This is a painter who likes to make selective decisions and carry each tactic to the nth power.

Dowell defines his strategy as "making a line and then carving out the space behind it." He starts with forty or fifty spontaneous pen-and-ink drawings on Arches Cold Press paper. Dowell then studies the drawings, sorting them out until the best, like cream, rise to the top of the pile. Next he visualizes them as watercolors, deciding in particular which side of a given line should emerge as the positive image and which as the negative painted space. The final painting is then done with brilliant colors mixed, not with water, but with stale beer which dries with a slight sheen.

Reverse edge shading is a variant of this technique which is especially useful in representational work. When you start shading on one side of a line, there is a point at which you must switch sides, or reverse the shading, if the shadows on your subject are to make realistic

22

Fig. 2.7.
Edge shading.

1 Brush firm color against pencil line

2 Add clear water on other side

3 For more control, blot with tissue

4 Develop edge patterns with dark-light reversals

5 Leave white strip between two darks

6 Broaden and deepen tones with added layers

sense. While an abstract painter like Dowell can make arbitrary decisions, Demuth must respond to both the abstract relationships on the page *and* the logic of what he sees. The result, in a painting like *Peaches and Fig* (pl. 3), is a wonderful interweaving of edges that "come and go" as fluctuating contours emerge from and then dissolve into space.

THE BOTTOM LINE: SHAPING GEOMETRIC VOLUMES

Mastering the washes outlined in this chapter will give you a simple, direct technique for representing most things you might want to paint—or at least for establishing their basic shapes in line with Cézanne's dictum that all of nature can be reduced to the cube, cone, and cylinder. In summary, these are the three kinds of washes we have discussed and what they can do:

1. *Flat washes* provide a vocabulary for bread boxes, books, tables, church steeples, factories, and all things architectural.

2. *Graded washes* can evoke the arch of a Western sky, the sunlit wall behind a figure, or almost any large area that needs dramatic shading.

3. *Edge shading*, as we have seen, can create angular, cubistic architectural planes. It also has general usefulness in rounding out spherical or cylindrical volumes like fruits, vegetables, pitchers, and bottles.

In watercolor, the bottom line is being able to use washes of this kind to capture the essential volumes of the objects you are painting. And note that this must be done *before* fussing with details. In other words, you paint a wall before putting the cracks in it, or a green sphere before making the form look like an avocado. The reason is that watercolors are built in layers, like a pyramid, with the biggest layers underneath. Since specifics are usually described by small, rather dark strokes, they inevitably come last and on top.

To understand these principles more clearly, consider for a moment how a watercolor like my *Breakfast Coffee* (fig. 2.9) might be developed. Here I started by laying in the large

spatial planes with subtly tinted *graded washes*. These tones established the cubical forms of the wall, table, and plastic basket. Next the cylindrical shapes of the cup and its mirror image were defined, again with *graded washes*. Cast shadows were then indicated by clusters of overlapping *flat washes* (as in the circular tones around the coffee cup). Finally, each of more than two dozen cherry tomatoes was carefully rounded out with *edge shading*. Only then—after the essential volumes were clarified—was it time to add such realistic details as the sheen on a china cup or the variegated colors and twisted stems of the tomatoes.

WARMING-UP EXERCISES

At this point you may be inclined to read ahead, perhaps with the thought of trying out wash techniques later, when they are called for in an actual painting. However, a golfer who practices his swing drives a longer ball on the fairway, and the same is true in painting. You will get further, and avoid discouragement, by giving serious attention to the exercises outlined here. Use materials listed in chapter 1, and the paper should be a quarter-sheet (about 11-by-15 inches) of Cold Press Arches or the equivalent. To make directions clear, the problems are stated rather literally, but they are meant to stimulate your imagination. After grasping the strategy of an exercise, feel free to transform it in ways that will make it your own.

Exercise 1
HOUSES IN FLAT WASHES

With ruler and 2B pencil make a fanciful drawing of cubelike houses—simple boxes without windows and doors or precise perspective. After drawing a horizon line, paint sky and land with flat washes in firm, but not too deep, tones. Then fill in the remaining rectangular shapes, letting one section dry while you work elsewhere, until the compositional mosaic is complete. As you proceed, assume light from one side and shadow on the other, toning each house accordingly so that it emerges as a dimensional block.

Exercise 2
GRADED BANDS

Divide the page with a horizontal, ruled pencil line. In the upper section, press down five or six vertical

strips of 1/2-inch masking tape in a pipe-organ effect. Fill in the columns with playful combinations of intense graded colors. When dry, pull up the tape slowly and carefully. Then paint similar bands in the lower area, but this time use a single rich color in each stripe, shading it from dark to light by adding water rather than other colors.

Exercise 3
EDGE-SHADED STILL LIFE

Draw the following imaginary objects: four or five pieces of fruit of contrasting shapes and colors, a plate, a cigar box, and a wine bottle. Be sure objects overlap and that a table top is indicated. Then paint the background areas of table and wall with edge-graded washes in neutral colors, and go on to create the cylindrical bottle and spherical fruit forms in spectrum hues. Technique: *To create a cylinder*, use edge gradation from either side fading to a central white strip (outlined beforehand in pencil so that you will remember to "save" it). *For spherical fruit*, paint a ring of color around the outer contour while saving a central highlight (also outlined in advance). Add water toward the center of the form and then blot with tissue so that the middle of the fruit is lightened and the edges are left firm. Repeat this process several times for greater definition.

3

Layered
Transparencies

VALUES

In watercolor, as in life, it is important to have sound "values." The function of tonal values in art is much like that of ethical values in daily life, in the sense of providing an orderly principle, or scale, against which to measure ongoing actions.

For an artist, *value* is the lightness or darkness of a color, and we speak of tones as "high-keyed," "deep," or of "middle value." This is an element to be consciously studied in your work, and the way to visualize values is to imagine your watercolor as a black-and-white photograph. In looking through a pile of sketches, you will see that some are pallid, while others are gloomy. Doubtless the best of the lot will have clear lights and snappy darks. These are the pictures that not only photograph well but also "carry" when you look at them from a distance in an art gallery.

Now that you have practiced basic washes, you must figure out how to combine them into a coherent image. Here the systematic use of values can be a great help. Start by reducing each wash to one of the tones on an evenly stair-stepped value scale—making it not just any color, but a distinct light, medium, or dark tone. Once you have learned to simplify tones in this way, you will be able to group washes of various sizes and weights so that they suggest objects in space.

As an illustration of this principle, note how much Fairfield Porter accomplishes with minimal means in his watercolor *Easthampton Parking Lot* (fig. 3.2). Sky and land are brushed in with light washes, trees and middle-ground forms are evoked by small dark touches, and the automobile is given dimension by crisp cast shadows. The brushwork seems free, yet the tones have been carefully thought out. Porter

has responded to lights and shadows observed in nature, but with a brief notation of main elements that leaves details and transitions to the observer's imagination. At first glance one might think the work unfinished, yet the artist's signature affirms that enough has been said.

COMPOSING WITH FOUR VALUES

Watercolor can be many things, and as we shall see in later chapters, some painters use elaborate processes and dozens of glazes. Yet just as there is a classic cuisine, there is a classic approach to watercolor that views it as a shorthand medium. This is where you should begin, both because the technique is comparatively easy to grasp and because it will provide a solid foundation for future experiments.

Homer, Sargent, Cézanne, Marin, and many other modern masters work in a classic watercolor style. By this I mean that—despite otherwise divergent attitudes—they base their techniques on evenly stepped light-to-dark tones that establish a composition with utmost economy. As in Porter's work, key washes are laid in quickly to suggest the image, and then each area is developed by an orderly progression of smaller and darker accents.

There is a question, of course, as to how many layers to use. Or to put it another way: How minimal should an abbreviated style be? In *Parking Lot*, as we have seen, Porter stops short after the intial thrust. Cézanne usually works with two or three layers of pale tones supported by a pencil drawing. And Klee's watercolors often feature gradations of six or seven values calibrated in a perfectly even scale. The most common "classic" technique, however, calls for four values: light, medium-light, medium-dark, and dark. This is far and away the most practical approach, since three values are limiting, while more than four cannot be easily kept in mind and have to be rather mechanically figured out.

The contemporary realist Neil Welliver holds quite strictly to four values in composing

Preceding page: Fig. 3.1.
CHARLES DEMUTH (American, 1883–1935).
Three Red Apples, ca. 1929.
Watercolor and Pencil 7½ × 9½ inches.
Courtesy Salander-O'Reilly Galleries, Inc., New York.

28

Fig. 3.2.
Fairfield Porter (American, 1907–1975).
Easthampton Parking Lot, 1973.
Watercolor, 12¼ × 16 inches.
Courtesy Hirschl & Adler Galleries, New York.

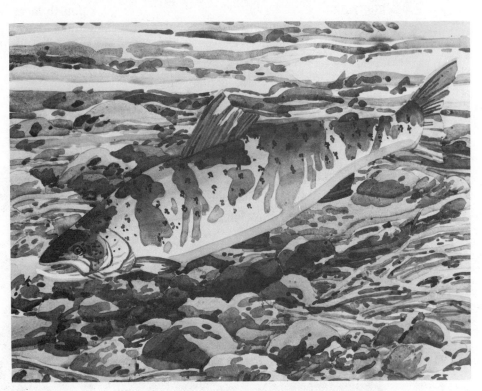

Fig. 3.3.
Neil Welliver.
Study for Print of Salmon, 1977.
Watercolor, 22¼ × 30 inches.
Courtesy Brooke Alexander, Inc., New York.

his watercolors, and *Study for Print of Salmon* (fig. 3.3) demonstrates how the principle works. After penciling in the subject—a fish swimming in shallow water—an initial layer of *light* washes is brushed throughout the composition; this is followed by *medium-light* tones overlaid in each area, then *medium-dark* strokes and, finally, some small *very-dark* accents. The identifying colors of salmon, water, and sandy rocks are established, but within each color zone there are four clear values.

As you can see, classic technique has an assured rhythm, and Welliver is able to work fluidly, with improvisatory brushmarks, precisely because the overall plan for his painting is so logical.

29

STEPPING UP AND DOWN THE VALUE SCALE

Welliver and Porter show us how to create an image with a few well-placed tones. There is another lesson in Paul Klee's work: the use of washes, not as individual shapes, but in an overlapping cluster that we perceive as a visual chord, like an arpeggio plucked on a harp.

Klee's *Goldfish Wife* (fig. 3.4), for instance, is a wide-eyed creature with a valentine heart and a pearl necklace, who swims, like Welliver's salmon, in an undulating pool. Here, however, watery ripples are created with a different technique. Instead of the loose brushmarks Welliver uses, Klee's style is based on flat washes that overlap in sequential clusters like layers of colored tissue paper. I count five layers of progressively darker tones around the lady's hairdo and six between her fan-tail legs (see diagram, fig. 3.5).

If you have attended art school, you will recognize this device as the *value scale*—a

sequence of tones progressing evenly from white to black—that every freshman must learn to paint. And if you are a gallery goer, you will find stair-stepped tones turning up everywhere. The calibrated stripes of Pop Art continue to appear in contemporary abstract painting, while overlapping shadows cast by track lighting are a feature of the new realism. Turn to Pearlstein's *Model in Kimono on Wicker Rocker* (pl. 5) to see what I mean. Shadows cast on the model's creased abdomen create a pattern of pointed shapes that is almost identical to Klee's rippling water motif.

Evenly stepped tones are difficult to paint in oils because each color must be separately mixed, tested, and fussed over until a crisp edge is achieved. In watercolor, on the other hand, this is a natural idiom, since colors show through one another, and you can make use of overlapping marks. Two applications of a light wash produce a middle value, and a third or fourth layer over that adds up to a fairly deep tone.

To appreciate how this works, consider

Fig. 3.4.
Paul Klee (Swiss, 1879–1940).
Goldfish Wife, 1921.
Watercolor, 14 × 20¼ inches.
Philadelphia Museum of Art, Louise and Walter Arensberg Collection.

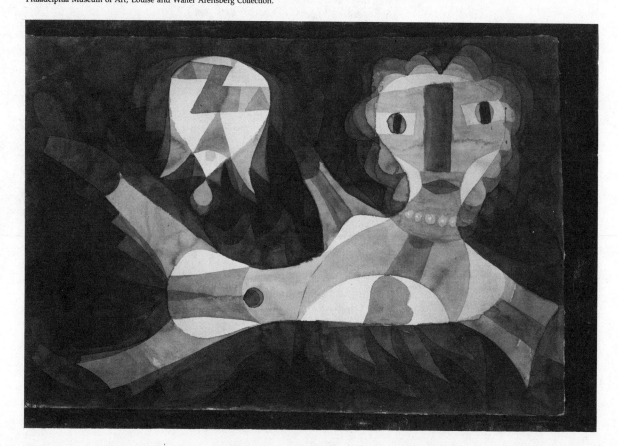

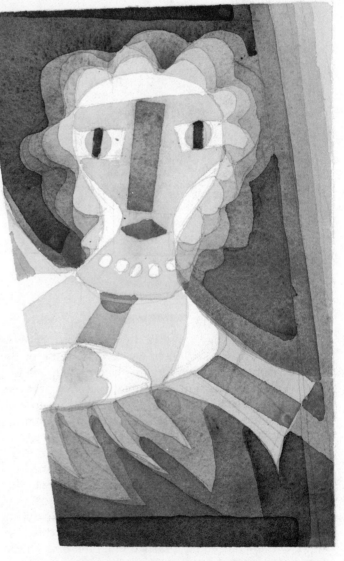

DARK—4 LAYERS

MEDIUM-DARK—3

MEDIUM-LIGHT—2

LIGHT—1 LAYER

A VALUE SCALE IN 4 EVEN STEPS

KLEE USES 5 or 6 OVERLAPPING TRANSPARENCIES

Fig. 3.5.
Using a value scale
in layering technique.

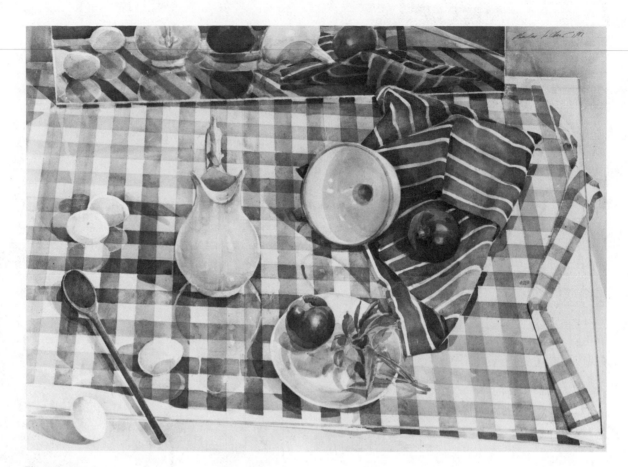

Fig. 3.6.
CHARLES LE CLAIR.
Checks and Balances, 1981.
Watercolor, 29 × 41 inches.
Courtesy More Gallery, Philadelphia.

the plaid tablecloth in my painting *Checks and Balances* (fig. 3.6). The horizontal stripes were laid in first, followed by vertical bands of the same light pink. Where they cross there is a double pigment layer that forms squares of deeper red, just as the intersection of up-and-down threads do in a woven cloth. Thus the basic checked pattern was established by simple overlays, rather than by mixing and applying paint for each separate square. Later, shadows were brushed in with a single bluish wash that transformed the colors of individual squares in various subtle ways. The principle is like dyeing different fabrics in a single solution. In this case, the white squares turned blue, the pink checks became violet, and the red ones deepened into crimson.

Playing with such transparent overlays is fun and a bit like solving a puzzle. The title

Checks and Balances, incidentally, suggests the picture's "game" strategy and—like Whistler's portrait of his mother, which the artist exhibited as *Arrangement in Black and Gray*—my kitchen still life should be seen as an essentially abstract composition of stripes, circles, and squares.

COLOR IS A MANY-LAYERED THING

The "layered look" is a familiar fashion idiom, and theatrical designers often use layers of colorful materials you can see through. An emerald gown overlaid with lavender tulle appears iridescent, whereas a forest's changing seasons are evoked by scrims that materialize and then dissolve under stage lights. Layers of transparent watercolor act in much the same way.

As we have seen, successive washes deepen the value of a painting, and some artists build forms with repeated applications of the same color. This is Elizabeth Osborne's strategy, for example, in *Still Life with Black Vase* (pl. 12). The artist shows us how to give weight to a color area by going over it again and again—sometimes with a color variant, but more often with the essential hue—until it becomes lustrous.

On the other hand, variegated layering of blue shadows over red (as in my checkered tablecloth) or of more brilliant combinations like oranges over yellows and purples over greens is another possibility. Joseph Raffael brings off such effects with panache in enormous watercolors of flowers or splashing fish (see cover illustration and pl. 15). This approach deserves your full attention because the process of working with multicolored washes, laid over one another like sheets of stained glass, is a distinctive feature of the watercolor medium. It also provides a unique opportunity for understanding the interaction of various pigments and applying color theory in a creative situation.

THE PROPERTIES OF COLOR

Color has three basic properties: hue, value, and intensity. *Hue* is simply the color's identity on a spectrum or color wheel. The six main hues are red, orange, yellow, green, blue, and violet. Hues in between are described as yellow-green, red-orange, and so on.

Value, as we saw earlier, refers to the lightness or darkness of a color. In technical language, then, pale colors with everyday names like "pink" or "aqua" are identified as reds and blues of very light value. Similarly, "maroon" is a red of dark value; and "navy," a blue that has been lowered in value.

Finally, *intensity* describes a color's brightness or dullness. Of the three terms, this is the most difficult to grasp, since words like "light" and "bright," or "dark" and "dull," sound so much alike. The trick is to remember that, whereas the extremes of the *value* scale are black and white, an *intensity* scale shows vivid hues at one end and neutral tans, browns, or grays at

the other. Thus an orange that loses intensity becomes terra cotta, yellow dims down to mustard, and blue fades into slate.

These are simplified definitions, but it is important to understand color principles in such a way that they can be used and enjoyed in your work. All too often art students study color theory and, after laboring over terminology and charts, discover that in the studio painters don't think like that. "Nice color," someone will say in a critique, or "the color seems raw," on the assumption that these things are understood intuitively. Thus color theory and color practice can become unconnected studies. One reason is that creative studio work resists rules. Another is that having to mix oils or acrylics to a predetermined shade can be unutterably tedious.

It is just here that the watercolor process of layering becomes invaluable. One wash can establish an object's *hue* (or local color), a subsequent shadow tone can deepen the *value* (or make it darker), and a third layer can modify the *intensity* (or kill some of the brightness). Thought of in this way, transparent wash technique is an admirable vehicle for exploring the components of color and putting them together in exciting combinations.

APPLYING COLOR PRINCIPLES

The interaction of color layers is most easily observed in an abstract painting like Kandinsky's *Landscape* (fig. 3.7), where each wash is independent rather than merged with a figurative image. Like Welliver, Kandinsky has a four-value technique which you can easily make out at the top of the picture where large kitelike shapes are crossed by small squares.

Kandinsky's manipulation of these floating color planes is a model of clarity and ingenuity. He starts with broad light washes which are systematically followed by smaller and darker ones. What is most significant, however, is that each new layer is positioned over both white paper *and* a previously established tone or group of tones. In this way, colors are made visible in their original state as well as in intriguing layered combinations. At the upper left, for instance, a small dark square with an X-shaped center is placed so that it neatly overlaps three

Fig. 3.7.
Wassily Kandinsky (Russian, 1866–1944).
Landscape, 1924.
Watercolor and Ink, 18⅞ × 13¼ inches.
Philadelphia Museum of Art, Louise and Walter Arensberg Collection.

other colors and thus creates four new ones. The beauty of the system is that it not only makes color-mixes easy but also produces them with an inevitable physical logic. Thus the artist is assured of a harmonious "chord," rather than separate, ill-matched colors.

As you explore color in your own work, it is a good idea to experiment freely with every combination you can think of. At the same time, keep a few guidelines in mind:

1. *Learn to move sideways on the color wheel.* In layering, each wash should be not only a step darker than the previous one but also a slightly different hue. So when you paint an apple, don't keep dipping into the same basic red. Instead, use the analogous colors that are next to red on the color wheel. Thus the first layer of your apple might be red-orange, the second true red, and the third a purplish wine-red. Richness and depth of color are achieved in this way. The technique also establishes convincing sunlight and shadow patterns when you use cool and warm hues in relation to an explicit light source. Put your red apple on a window

sill, for example, and you will see that the sun turns one side golden, while the other reflects the silvery coolness of indoors.

2. *Keep the "sun" colors—yellow, orange, and lime—underneath.* A glance at your palette will show that yellows and oranges are light in value, whereas other pigments are comparatively dark. This means that "sunlight" hues can be used as initial layers in a watercolor, but if they are painted over other colors, they will be as opaque as Chinese White. In any case, the illusion of warmth in transparent painting must come from below—yellow shining through green, orange from under red, red from beneath purple or brown. To test the principle, try putting a yellow-green wash over a blue-green one, and then reverse the process. Although the same pigments are used in each case, the second passage, with the warmer color underneath, will be much more luminous.

In accordance with this principle, watercolorists often use an underpainting of yellow, sienna, or ochre for objects that are to be brightly colored. A warm underpainting is especially helpful in recording the subtle greens in a landscape. Any subject that is to be highlighted, however, is an exception. Small gleams may be left white, but highlights often are sky reflections that require a touch of blue underneath. Grapes and plums, for instance, are best painted over a bluish initial wash, and Don Nice portrays glistening chocolate ice-cream cones that feature lavender highlights. He says this is a time-honored device of British "racehorse" painters who caught the gleam of a thoroughbred's chestnut coat by washing rusty tones over a violet underpainting.

3. *Use warm and cool "space colors" to create depth.* If you look at a white wall you will observe subtle shifts from *warm* (or sunny) to *cool* (or silvery) tones. Thus when you represent that wall, as a background area in a painting, your white paper must be covered with washes that are distinctly *not* white but which, instead, create the *illusion* of an illuminated white space. This is done with the vaguely warm, vaguely cool washes of indeterminate hue which I call "space colors."

Learning to use neutral tones is crucial for the watercolorist. The process calls for putting two colors on your palette that are warm/cool

Fig. 3.8.
Creating a color chord with layering.

FOR LOCAL COLORS
USE NEIGHBORING HUES

FOR SHADOWS
AND SPACE TONES
USE NEUTRALS

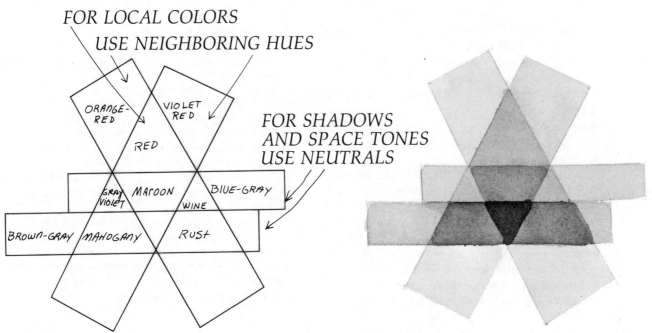

AN ABSTRACT COLOR CHORD

COLOR LAYERING IN REPRESENTATIONAL WORK

1 *ORANGE-RED—1st apple layer*

2 *VIOLET-RED—2nd layer (over 1)*

3 *BLUE-GRAY—3rd apple layer (over 1 and 2)*

4 *BLUE-GRAY—1st shadow layer (on white paper)*

5 *BROWN-GRAY—2nd shadow layer (over 4)*

opposites and then painting with changeable mixtures dominated first by one color and then the other. Your washes must be indefinite "blends" because distinct hues project an object forward, whereas vague coloration is recessive. And since the color of your subject is a known quantity, while the surrounding atmosphere might be almost anything, shadow patterns provide a particularly good opportunity for creative interpretation.

Any number of warm and cool pigment combinations can be used. Some painters work with grays and ochres; I prefer Cerulean opposite Burnt Sienna; and other possibilities include Violet with Raw Umber, Ultramarine with Venetian Red, or even Viridian with Alizarin. You can also stir up two mixtures of your own and dip alternately into these rather than into pigments straight from the tube.

COLOR EXERCISES

It is a rare artist, like Carolyn Brady (see chapter 5), who paints washes in a single layer and never goes back to retouch. The classic approach is to build forms gradually with repeated thrusts. For most watercolorists each section of a painting requires two or three rounds of washes—to establish local color, deepen it in places, and put in shadows. Getting these tones in the right order is terribly important, and the following exercises show you precisely how the technique of layered transparencies works:

Exercise 1
TRANSPARENT COLOR SAMPLER

Draw an abstract grid with pencil and ruler on a half-sheet of paper (15-by-22-inches). Any rectangular or diagonal formation—a brick pattern, spiderweb, or honeycomb—will do, but it must be a network of small areas. Within this labyrinth, you will work like a quiltmaker developing abstract shapes, some spread across many units of the grid and others contained within a single area. To illustrate, imagine using a checkerboard grid: your first wash might cover the page except for a few white squares; subsequent washes might establish horizontal bands; and, finally, you could add more specific motifs—nine

squares in the shape of an H, for instance, or five squares forming an X.

After completing the drawing, paint an initial layer of washes using each of the hues on the color wheel—red, orange, yellow, green, blue, and violet—in a different area of the composition. Be sure to leave small white shapes in each color zone, however. Next, paint a second layer of washes, smaller this time and a shade darker. These washes must also move the color "sideways"—lime over a yellow area, for example, or blue-green over green. Finally, paint a third layer of small, dark, neutral washes that will function as "shadows" or areas of low intensity.

At this point hues, values, and intensities have been established, and you are on your own. Many new washes can be added if they will make the picture work. What you are doing now is painting an abstraction à la Klee or Kandinsky and, in the process, developing a color vocabulary.

Exercise 2
STILL LIFE WITH MIXED FRUIT

Painting basic volumes on a flat plane is a time-honored pictorial format. Morandi's bottles and Cézanne's kitchen still lifes are legendary, and Demuth reduces the scheme to pure geometry in *Three Red Apples* (fig. 3.1), as three plain objects cast their shadows on otherwise blank paper. This is the model for your project, although you will use three *different* kinds of fruit, since our purpose is to experiment with under- and overpainting in varied color schemes. Some fruits you might use, with suggestions for color layering, are as follows:

Apple	Alizarin over Vermilion or Cadmium Red
Avocado	Viridian over Winsor Emerald
Banana	Yellow Ochre over Cadmium Yellow Pale
Green Apple	Cadmium Red over Winsor Emerald
Orange	Cadmium Orange over Cadmium Yellow
Peach	Alizarin over Cadmium Yellow Deep
Pear	Winsor Green over Cadmium Yellow Pale
Plum	Alizarin over Cyanine Blue or Cobalt Violet
Pomegranate	Alizarin over Venetian Red

Compose the fruit on a white surface, establishing interesting shadows with a lamp or spotlights. Draw contours in pencil, and set the stage by paint-

ing the shadows with neutral "space" tones. Then put in the underpainting for the three pieces of fruit, saving small areas as highlights. (These spots should be outlined in pencil and erased later.)

When the initial washes are dry, repaint each fruit in a contrasting color. The overlayer should be shaded to create roundness, so that its hue will dominate in dark areas and be thin enough to let the underpainting show through in the lights. Finally, finish the painting with touches that will accentuate edges, suggest texture, and define details like stems and ridges.

4

From Concept
to Finished Painting

Now that you have had some practice in laying washes and using color transparencies, you will want to put these techniques to work in an actual painting. This chapter, therefore, is designed as a guide to the various steps involved in creating a watercolor—arranging a set-up, lighting it, visualizing the composition, making the preliminary drawing and, finally, developing the painting in color. Along the way, we shall also consider watercolor's unique character as a medium and the distinctive attitudes a painter must bring to it.

Indeed, watercolor is so often taught as an elective subject that one forgets how very *fundamental* it is—fundamental in the sense of representing one of the three painting systems an artist needs to know. These are: opaque painting, glazing over an opaque underpainting, and working transparently on a white ground. Each of these idioms is distinctive, yet art schools generally give required courses in oil and acrylic while providing little opportunity for the student to explore the special qualities of transparent painting.

To appreciate the difference, compare a canvas by someone like Rembrandt with a typical watercolor. Rembrandt worked on a brownish ground, pulling gleaming lights out of the gloom with touches of thick oil paint. This system is called *chiaroscuro* (kyaro-*scoo*-ro), a term which means "light out of darkness." For a watercolorist, on the other hand, the ground is untouched, snowy paper. Lights are not brushed in but left white or faintly tinted. There is the same concern for brightness and shadow, but instead of bringing out light areas *directly* with brushmarks, the watercolorist must do so *indirectly* by surrounding each light zone with shading. In short, watercolor and oil painting involve quite opposite working methods.

THINKING WHITE

People who take up watercolor after having worked with oil or acrylic find that they must acquire a new way of looking at things—a mind-set I call "thinking white." This comes from a gradual appreciation of the fact that blank paper is a precious commodity to be savored until the last minute, rather than lost forever as the result of a too hasty brushmark.

The only trouble with "thinking white" is that like so many things in art—dancing on points, for instance, or singing high C—it ain't doin' what comes naturally. Everyone knows the natural way to paint: simply find a subject of interest, get the colors right, and afterward fill in the background. In more sophisticated language, this is called working with *positive* rather than *negative* space. Positive volumes, of course, are the solid objects that project forward in a composition, whereas negative volumes are the recessive empty spaces.

Painting positive images with the brush is by no means an unimportant watercolor idiom, as we shall see in chapter 6. This approach is most effective, however, in the hands of a modernist who wants to avoid three-dimensional illusionism in favor of a Matisse-like flattened image. Harry Soviak's *Tulips* (fig. 4.1)—a ghost bouquet done in grays against a brilliantly colored vase—illustrates the point. The watercolor has the directness of a child's drawing coupled with the elegance of a Japanese print. Instead of using washes to suggest shadowy space, the artist affirms the paper's flatness with a few calligraphic strokes and leaves the background quite untouched.

The impact of a painting like *Tulips* comes from its pared down simplicity and the directness of each positive color spot. Soviak makes no reference to the surrounding environment, however; and for a fully dimensional image, the watercolorist must develop a more arbitrary technique. This calls for painting the space *behind* before tackling the more intriguing things *up front*. It is a bit like eating smorgasbord

and saving the best until last. In watercolor the thing saved, of course, isn't a herring or deviled egg, but the all-important light areas of the composition.

Eileen Goodman's *Nine Eggs* (fig. 4.2) shows us how to do this, and a comparison of her watercolor with Soviak's clarifies the distinction between a positive brushmark and one that is used negatively to create space. Although the subjects and symmetrical formats are similar, Goodman takes as much pleasure in technical involvement and indirection as Soviak does in forthright statement. Her rich brushwork establishes shadowy hollows behind the eggs that pop them forward as a *light* image. This is what "thinking white" is all about—painting negative shadows so that a positive image will emerge where the whiteness of the paper shines through.

Nowhere are the artists' techniques more clearly differentiated than in their handling of ornament. Although Soviak's vase is vividly patterned, each orange, red, or emerald mark emerges as a comparatively dark tone against the white paper. Goodman, on the other hand, is careful *not* to paint the vine pattern on her ceramic plate. Instead, she laboriously fills in the blue background behind it, so that the white filigree that is "saved" will be perceived as the positive image.

Painters are often drawn to the theme of white objects on a white cloth because this situation, perhaps more clearly than any other,

epitomizes the special transparency of watercolor. And since the tones must be delicate, it is a strategy that capitalizes on nuance, as Goodman admirably demonstrates. Her painting is essentially a study in theme and variations, the contours of the eggs being achieved nine times in nine different ways much as a composer like Schubert might ring changes on a simple folk tune. Sometimes the egg is light against a dark ground, sometimes dark against light, and the cast shadows are orchestrated from evanescent washes on the upper left to climactic dark puddles on the opposite side.

ARRANGING THE SET-UP

Before tackling your first painting, you must come up with a subject that is at once interesting and one you can handle. Here you can take a lesson from Dolly Levi, Thornton Wilder's famous matchmaker who was so good at "arranging things." Proceed thoughtfully, even though you are in a hurry to get going, because in watercolor choosing what to paint is half the battle. An "arrangement" of fruit or flowers encourages a colorful painting, bottles in a row suggest structural shapes, and house plants on patterned fabric translate into a decorative composition. Thus, before you lift a brush, you must make crucial decisions that will determine the character of your watercolor.

Fig. 4.2.
Eileen Goodman.
Nine Eggs, 1980.
Watercolor, 15 × 22 inches.
Courtesy Gross McCleaf Gallery, Philadelphia.

Fig. 4.3.
ELIZABETH OSBORNE.
Pennsylvania Still Life, 1982.
Watercolor, 29½ × 41 inches.
Courtesy Fischbach Gallery, New York.

Fig. 4.4.
SONDRA FRECKELTON.
Spring Still Life, 1980.
Watercolor, 44½ × 54¾ inches.
Courtesy Brooke Alexander, Inc., New York.

There are good reasons for starting with still life. The figure presents anatomical problems best postponed for a while, and in landscape you must *find* a proper subject rather than being able to arrange it yourself. Still life, on the other hand, involves you with composition—deciding whether to change the background, move a bottle, or use a different tablecloth. Such choices are a vital first step in shaping your picture. Still life has the further advantage of offering a limited, tabletop space instead of complex perspectives. For a watercolorist with a dripping brush, there is comfort in dealing with a few simple objects that fill the page.

It is best to begin with an uncluttered arrangement in which the clear-cut values we have discussed are evident and where light objects are featured in the foreground in accordance with "think white" principles. Elizabeth Osborne's *Pennsylvania Still Life* (fig. 4.3) suggests how this might be done.

Although this is a subtly developed watercolor, its basic plan is simple. A few objects are lined up in what I call the "mantelpiece strategy" (here you might also look at John Moore's *Thursday Still Life*, fig. 5.13). Each jug and vase is drawn as an innocently straight-topped profile rather than with complicated elipses in a downward perspective. Objects create interesting shapes by overlapping, and they are shown against a variably toned ground that dissolves some edges and brings out others as light against dark or, in reverse shading, as dark against light. The flowering branches, for instance, are dark above and glowingly bright below. Incidentally, the up-ended table runner is a particularly interesting background device, since its striped panels are a classic statement of the light-medium-dark value scale we considered in chapter 3.

Painting a few objects on a table or windowsill is a good idea if you work at home. In a classroom, however, with a circle of students around the subject, such a neat arrangement will appear too far away, badly lighted, or seen from the wrong angle. In days of yore, the instructor simply tacked up a drape, put a plate and bottle in front, and said "paint!" Modern art schools, however, often feature elaborate "set-ups" with a wealth of material to suggest various compositional possibilities. The teacher collects white things, colored things, found objects, junk jewelry, wax fruit, and assorted rugs and drapes so that each still life can be

given a "new look." The student is then invited to find one small section of the arrangement that will make an exciting picture. So, in the end, there are as many compositions as there are painters; yet all share the concepts of color and pattern established by the initial set-up.

Sondra Freckelton's *Spring Still Life* (fig. 4.4) gives an idea of what such a massive set-up might look like. Her painting, of course, is a tour de force by a master watercolorist who has made an arrangement as complicated as a Bach fugue and then painted the whole blessed thing on a monumental scale. At first glance it would seem remote from a student's concerns. Yet any of the smaller sections—three apples on a quilt, lemons and grapes in a bowl, or a budding plant—are subjects a beginner might want to tackle.

There is also a contemporary sensibility about the whole set-up that is worth studying. Freckelton obviously respects the traditional unities of theme and design; yet her arrangement is crowded with unconventional incident that gives it vitality. Fruit, flowers, and quilts clearly "go together" in a country kitchen; and the rounded contours of chairs and tables harmonize with the plant forms. Still, the picture's fascination lies in unexpected and even awkward relationships—the way in which plates are tipped forward, grapes are spilled from their containers, and tablecloth corners are pulled down in points as if tacked to the frame.

Modernists like extremes, and today's still life painters tend to prefer either an "unarranged" arrangement—underwear on a closet floor, for instance—or one that is arbitrarily designed with objects placed symmetrically or in rows. Freckelton's preference for real-life clutter and Osborne's and Goodman's for a more formal scheme illustrate these contrasting attitudes. Even in your first paintings, it is important to opt for one or the other strategy. There is nothing complicated about it. Simply decide whether to arrange things as if on a chessboard or to scatter them about. Either way, you will establish a sense of direction for your watercolor.

COMPOSING WITH A VIEWFINDER

Arranging the set-up is like designing a movie set—important, yet only a preliminary. The picture actually starts only when the director likes

what he sees in the camera viewfinder and says "Shoot!" He may choose a long shot, a close-up, a view from above, or an expressionistic tilted angle. As you set out to paint, you will face similar decisions: whether to crop a figure or show the whole pose, put the horizon high or low, or place the flowers on one side or at dead center.

The best way to anticipate these problems—rather than starting to draw and then having to erase—is to use a simple framing device, or viewfinder. Just cut a rectangular hole about 1½-inches long in a small piece of paper or file card by folding it over, snipping a squarish tab out of the seam, and then unfolding it again. Through this opening you can survey the subject from different angles, finding your "view" as a cameraman does. Since the cutout should match the watercolor paper in proportion, keep several viewfinders on hand— some elongated, others more nearly square—so you can reach for the right one.

Start with only a few objects. If you are in a classroom situation with a wealth of material, the viewfinder will help you select an intimate close-up. To illustrate, let's imagine that you are faced with a set-up like Freckelton's. Too much

to handle as a whole, of course, but three small compositions that might be feasible are suggested in fig. 4.5. Each includes a few rounded objects that fill the frame with enough indication of a chair or table to make the space dimensional. Two are horizontal arrangements of fruit, while the third depicts a budding plant in an upward arching gesture that calls for a vertical format. Don't forget that deciding whether to turn the paper upright or sideways is your first crucial compositional decision. This would seem so obvious as to be hardly worth mentioning; yet even experienced painters are sometimes so eager to start painting that they do not take time to make a considered choice between a vertical and a horizontal arrangement.

A viewfinder has many advantages. It eliminates the need for preliminary studies, since alternative possibilities can be visualized in minutes. It is a marvelous help on sketching trips. It is as useful at home as in an art school. And if you put center lines on the viewfinder, it will enable you to visualize the composition in four quarters divided by imaginary horizontal and vertical axes (see fig. 4.6). As we will see later, this is the key to drawing a group of objects in correct proportion.

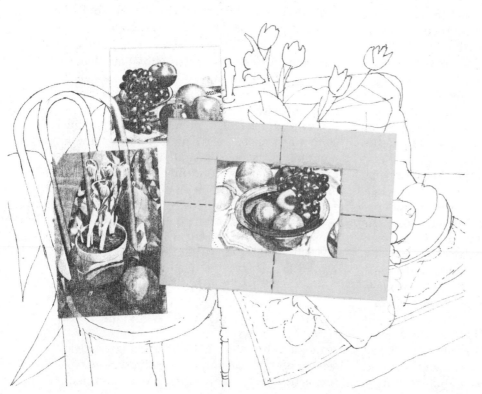

Fig. 4.5.
Composing with a viewfinder. A paper frame isolates three small compositions, appropriate for the beginner, within a complex set-up of the kind used in today's art schools.

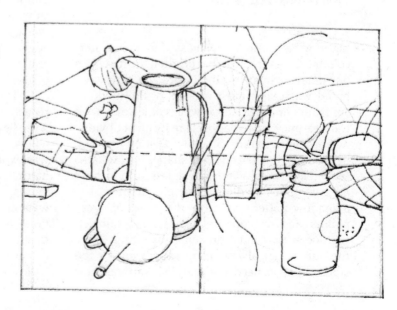

Fig. 4.6.
Using the viewfinder
as a guide to placement
and proportion.

1 *With the viewfinder,
visualize the composition in
four quarters divided by
horizontal and vertical
center lines*

2 *Draw one object in
relation to the vertical
center line (here the pitcher)*

3 *Draw one element in
relation to the horizontal
center line (here the drapery)*

4 *Locate remaining objects
in each of the four zones,
thus maintaining
proportional relationships*

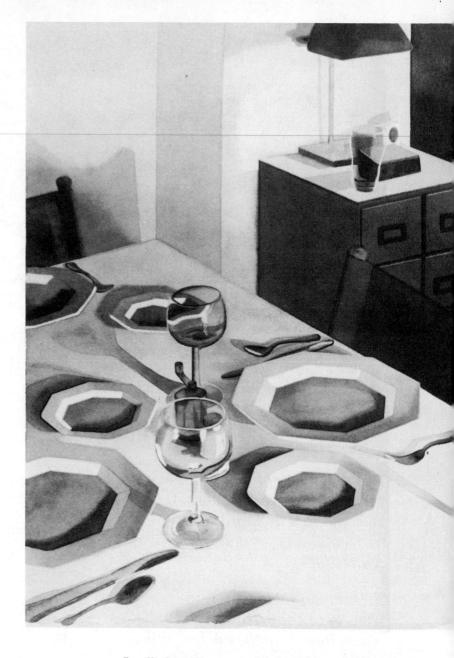

LIGHTING THE SUBJECT

Lighting is serious business for the water-colorist. One reason is that bright lighting wipes out details, thus contributing to the simplified broad wash style most masters of the medium cultivate. Another is that watercolor deals with transparency, and shadows are its most obvious expression in nature. Shadows cast by a strong light source are perceived as shapes, but we also **see** *through* them. Water, plexiglass, and mirrors **are** sometimes used for a transparent effect, but **a** shadow pattern is within the grasp of every **painter** and appropriate to most any subject. Outdoors, you must do some inventing, since **the** sun is not always cooperative, but in the studio all you need are two 150-watt reflector

floodlights. These can be found in a hardware store along with domed metal bulb holders that will clamp onto a chair, door frame, or table edge. Plug in your lights, move them about, and adjust the shadow angles until the effect is properly smashing.

The work of Leigh Behnke, the New York realist, is an object lesson in what can be done with lighting. Behnke turned to watercolor a few years ago because the glazing technique she was exploring seemed difficult in oils and more natural with washes on paper. Nowadays she works in both mediums, sometimes doing a watercolor as the study for a canvas and some-times as an independent painting. The artist's theme is light itself. Thus she prefers a white ground, and for some years did a White Series—paintings of colorless or transparent

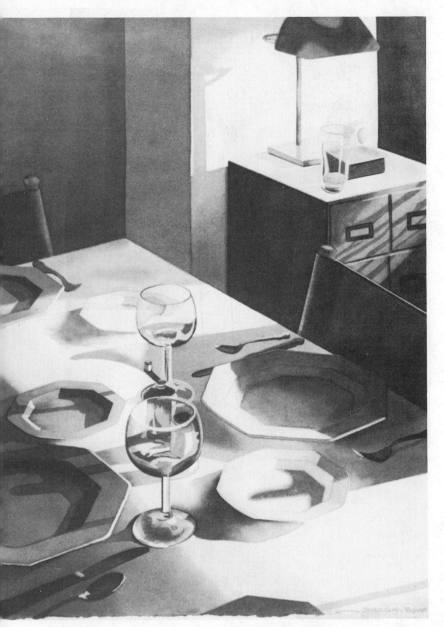

Fig. 4.7.
LEIGH BEHNKE.
*Study for "Time Sequence:
Value, Temperature,
and Light Variations,"* 1982.
Right and left panels of
watercolor diptych,
21 × 30 inches.
Courtesy Fischbach Gallery, New York.

objects like eggs, egg cartons, milk containers, and ice cubes. Behnke is also intrigued by combined images—paintings framed as a pair or trio (*diptych* or *triptych*), often with a row of small paintings (or *predella*) underneath. Typically, these reveal the same subject transformed by shifting light as in the diptych *Time Sequence: Value, Temperature, and Light Variations* (fig. 4.7). The mood of Behnke's pictures is poetic, but as a realist her method is precise. Here, she depicts the left image at 2:00 in the afternoon and the one on the right at 6:00 in the evening.

The technique of simplifying a composition with cast shadows can be most helpful for the beginning watercolorist. In Behnke's diptych, for instance, note how the back wall is reduced to flat bands of light, medium, or dark tonality, and how similar stair-stepped values shape the dinner plates and their cast shadows. Even the reflections on the crystal goblets are treated as flat tones; and the fork prongs, which might have been a fussy detail, are lost in shadow.

Somewhere along the line, you should try a white still life like this, although it might be wise to avoid so many hard-to-draw geometric shapes. One machine-made plate or bottle would be sufficient, perhaps combined with lumpier things like cauliflower, onions, or turnips. The point is that, early on, you must learn to paint things, not by themselves, but in the space they occupy. This can be done with any subject, even a brightly colored one, but the principle is most easily grasped with an arrangement of neutrally toned objects which permits patterns of light and shadow to dominate.

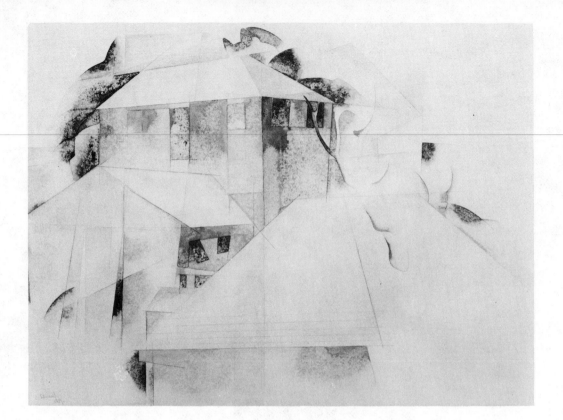

Fig. 4.8.
CHARLES DEMUTH (American, 1883–1935).
Bermuda Houses, 1917.
Watercolor, 10 × 14 inches.
Philadelphia Museum of Art, Samuel S. White III and Vera White Collection.

Fig. 4.9.
CHARLES DEMUTH (American, 1883–1935).
Zinnias, 1921.
Watercolor, 11⅞ × 18 inches.
Philadelphia Museum of Art, Samuel S. White III and Vera White Collection.

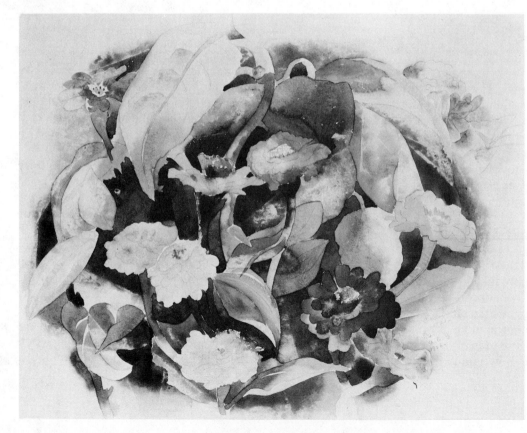

THE PRELIMINARY DRAWING

Although we speak of "painting" a watercolor, the experience is closer to making a drawing than working with oil or acrylic. Instead of covering the surface, the paper shines through. And as with a drawing, you may stop at any time—immediately if the effect of a few marks is right, or after fully developing the composition. This is because informal jottings have been the province of small-scale works on paper since the time of Leonardo, and because untouched paper does not have the aura of incompleteness conveyed by naked canvas. Then, too, a watercolor starts with an outline, usually in pencil, that is a far cry from the sketch one "roughs in" on a canvas with the thought of painting over it later. In watercolor, the initial drawing is for keeps—a decisive contour that provides a road map for what is to follow. As washes are added, a contrapuntal dialogue ensues between these structural lines and the fluid washes that run under and around them like water lapping at the piles of a wharf.

Pearlstein draws with a brush dipped in Raw Sienna watercolor; John Dowell uses pen and ink; Sidney Goodman and Xavier Gonzalez have been known to float watercolor over a charcoal drawing; Todd McKie puts in white lines with a china marker; and Demuth's illustrations for stories like *Nana* (see fig. 10.6) feature scribbles and hatching with a bold black pencil.

Clearly there are as many ways to draw as to skin a cat, but remember that nine out of ten watercolors in galleries and museums are painted over a clean-cut pencil line, and this is undoubtedly how you should start. Demuth's work—in the more familiar style of the landscapes and still lifes—is an especially good guide because, unlike many painters today, he didn't have a compulsion to "finish" everything and cover all of the lines with paint. His pencil marks *show*. In a typical watercolor like *Bermuda Houses* (fig. 4.8) or *Zinnias* (fig. 4.9) some areas are vague and unpainted while others are more fully defined. This conveys a sense of the gradualism of the painting's development and encourages us to observe lines and washes both as separate elements and as interacting forces.

In the drawing for a watercolor, cleanliness is next to godliness because graphite soils the paper, a pencil point leaves grooves, and heavy erasure removes the glaze finish. Contours must also be continuous rather than broken or sketchy. As Carolyn Brady says, "There has to be a line there, so I can think about the paint and not where I am going to put it." Such neatness is foreign to most people who take up watercolor, since even experienced artists like to arrive at an image by making a flurry of exploratory marks which are only gradually firmed up. Unfortunately, this won't do. So I offer what the homemaking columns call "helpful hints":

1. *Use the right pencil*—neither so soft that it smudges, nor so hard that it digs in. A 2B is suggested, but touches vary, so discover what works for you. Keep it handy, and don't reach for the pencil used for grocery lists.

2. *Establish the overall composition before drawing specific objects.* If you start with a single object, it may turn out to be in the wrong place, or too large or too small, and have to be erased. Instead, use the halfway marks on your paper viewfinder as a guide, and draw one horizontal element, like a tabletop, that you can locate in relation to an imaginary center line. Next, draw a vertical object, such as a box or bottle, checking the viewfinder again to see whether it is right or left of the midpoint. These two steps divide the paper into four quarters in which subordinate elements can be easily located and sketched in lightly. Only then should you turn to particular objects and finish them off one by one (see fig. 4.6).

3. *Don't be afraid to use a ruler.* Despite the old saw about amateurs not being able to draw a straight line, this is difficult even for experts to do without a straightedge. Some artists avoid using one for esthetic reasons, but watercolor softens edges anyway, and you should welcome mechanical aids that can be helpful. Look at Demuth's *Bermuda Houses* (fig. 4.8) to see how a drawing made with a schoolboy's ruler can yield a most sensitive and unmechanical watercolor.

4. *Construct symmetrical objects around a center line.* Make the line pale and erase before you start to paint. Regularly shaped forms like vases and coffee cups cannot be constructed by starting on the outside. The center axis must be established first, and elipses for the top, bottom, and middle located. Outer edges can then be drawn with assurance (see fig. 4.10).

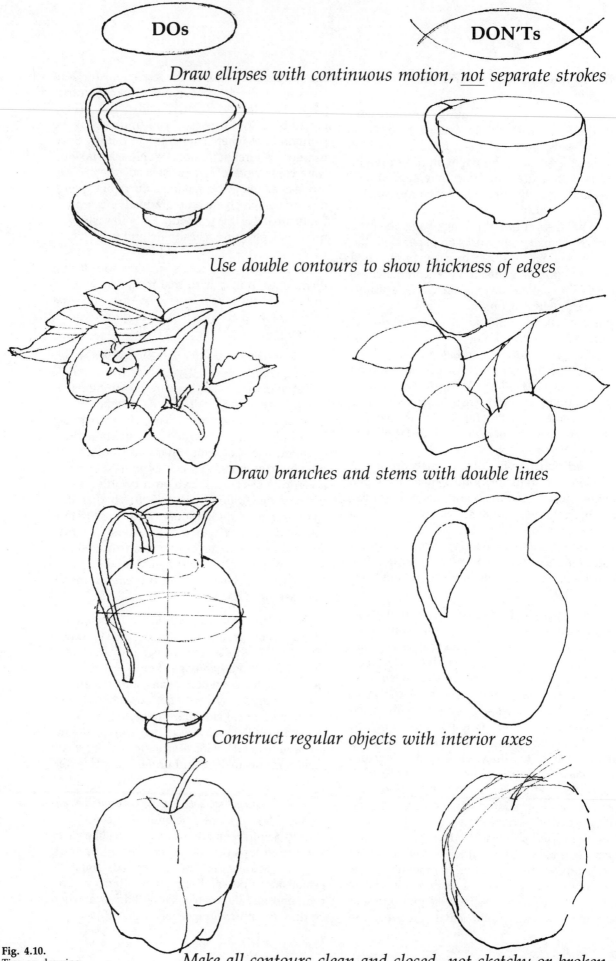

DOs

DON'Ts

Draw ellipses with continuous motion, not separate strokes

Use double contours to show thickness of edges

Draw branches and stems with double lines

Construct regular objects with interior axes

Fig. 4.10.
Tips on drawing.

Make all contours clean and closed, not sketchy or broken

5. *Shape elipses with a continuous motion* like a racing car driver speeding along and then slowing down for curves. The round opening of a cup or jar, when seen in perspective, is an oval "ellipse." If you draw the top and bottom lines separately, the corners of the ellipse will be pointy and cigar shaped. Instead, try for an easy swinging motion (see fig. 4.10).

6. *Indicate all thicknesses with two lines.* I have a lot of "how to get to our house" maps. Some friends show roads as a single line while others use two, with the space in between representing the highway. The latter format is the watercolor way. In oils, the rim of a wineglass is drawn with a single line, since it will be highlighted later. In watercolor, such a rim must be "saved" as white paper, and this requires both an inner and an outer contour to indicate thickness. The same applies to plant forms, as we see in Demuth's *Zinnias* (fig. 4.9) where all the stems are drawn with two marks.

7. *Draw drapery three-dimensionally with overlapping contours.* In representing drapery, the trick is to draw it, not as a general mass or impressionistically, but one fold at a time and with great firmness. Follow a long fold that moves dimensionally into the interior. Then draw other contours that overlap or tuck into the first, and continue in this way until a solid structure is achieved.

8. *Transfer the drawing from a preliminary worksheet* if you are a person who must make a lot of corrections. It is easy and more satisfactory than trying to clean a messy page with an eraser. In working from the model, I always draw on tracing paper, making changes on several overlays until the composition is "set." The final drawing is then traced cleanly onto Arches paper with a few pencil touch-ups. I have used black carbon paper without ill effect, but transfer paper is preferable. Saral makes transfer paper that comes in sheets or rolls in various colors, and the one called *Graphite* has a beautiful silver-point quality.

DEVELOPING THE COMPOSITION

They say a picture is worth a thousand words. So at the start of a watercolor course—just where we are now in this chapter—I like to pin up examples of work by contemporary painters. Invariably, students find the watercolors of Jane Sperry Eisenstadt of particular interest, because her approach is so closely related to their immediate concerns.

For one thing, her subjects are what most anyone has on hand. She paints flowers from her garden, fruit and vegetables from the kitchen, the view from her dining room window, and portraits of her father asleep or her granddaughter cutting out paper dolls. More importantly, she has a gift for leaving white throughout her compositions and works in the Demuth tradition of lightly brushed watercolor, with many areas defined by drawing alone. This is how a "beginner" should begin—with brevity in mind. Watercolor is an additive process. As you gain confidence, you may want to put in more information, but at the start it is best to set down a swift impression. Then, as the Italians say when they have dined well but prudently, "Basta!"

We have seen how a set-up of light-colored objects, like Goodman's arrangement of nine eggs, opens up white spaces in the finished painting. Eisenstadt takes the concept of "thinking white" even further by introducing whites into areas that represent objects of solid color. In *Strawberries and Asparagus* (fig. 4.11) she uses sunlight—as one would employ a kneaded eraser in a charcoal drawing—to pick out touches of blank paper throughout the composition. Thus each green stalk and red berry is white on top and colored only in the shadow. This technique of painting each form partially and leaving the rest untouched is especially effective in an outdoor situation where vivid colors are bleached by the sun.

The artist's *Flowers in a Doorway* (fig. 4.12) employs the same principle in a broader and more fluid compositional plan. Instead of treating objects separately, Eisenstadt divides the whole page into light (unpainted) and dark (heavily pigmented) zones. The positive image of the sunflowers is only vaguely suggested in a strategy that shows everything in the room as a bright silhouette against a view through the doorway of a dark landscape. Meanwhile, her original pencil drawing—done as I have suggested with double contours for stems and tendrils and ruled lines for the architecture—is strong enough to carry the composition in the unpainted areas.

Not all watercolorists stop short with an

Fig. 4.11.
JANE SPERRY EISENSTADT.
Strawberries and Asparagus, 1981.
Watercolor, 16½ × 21½ inches.
Collection of the artist.

Fig. 4.12.
JANE SPERRY EISENSTADT.
Flowers in a Doorway, 1981.
Watercolor, 36 × 26 inches.
Collection of the artist.

Fig. 4.13.
P. S. GORDON.
Quasi-Moiré, 1981.
Watercolor, 49 × 36½ inches.
Courtesy Fischbach Gallery, New York.

Fig. 4.14.
SONDRA FRECKELTON.
Yellow Apples, 1978.
Watercolor, 21¼ × 25½
inches.
Courtesy Brooke Alexander, Inc.,
New York.

immediate impression, as Eisenstadt likes to do. Tulsa artist P. S. Gordon represents the opposite extreme—someone who goes all the way toward trompe l'oeil realism. His paintings are of still lifes, arranged elaborately and with highly personal symbolism. And instead of homely subjects like strawberries and sunflowers, he works with precious things like Royal Doulton china, bizarre figurines, and ornate quilts and fabrics. The result is at once elegant and wittily "high camp." Gordon acknowledges this with a tongue-in-cheek title like *Quasi-Moiré* (fig. 4.13), which I suppose is akin to "fake fur" or "ultra suede" and might translate literally as "pseudo silken."

Gordon's *Quasi-Moiré* comes to mind in connection with Eisenstadt's *Flowers in a Doorway* because the two pictures represent opposite technical approaches while sharing essentially the same compositional scheme. Both feature a table, a container, and architectural elements supporting an exuberant spray of flowers that pushes beyond the frame. And in both paintings light, ornamental shapes are silhouetted against a dark ground. The similarity is particularly striking at the right sides where the jigsaw interlocking of light and dark motifs is almost identical. One quickly sees from a comparison of this kind that the basic composition

of a painting is like the standard plot for a story—it can be developed briefly or with elaborate detail, and it is subject to any number of twists and personal interpretations.

Still, there is a world of difference between these two watercolors. The difference is partly one of "finish," but more importantly, I think, of method. Although few of us could emulate Gordon's intricate detail—he spends up to three weeks on the drawing alone—his basic approach is feasible even for a beginner. Essentially, it is a process of composing by units or sections, like the pieces of a patchwork quilt, each of which the artist finishes before going on to the next. He starts with a key drawing, a tiny color study, and then the sections are laid in one at a time, often with complicated shading and glazes. This is the opposite of Eisenstadt's sketching in the space as a whole, but it is the method of many artists, particularly those who do very large works like Carolyn Brady and Sondra Freckelton. Perhaps it will appeal to you.

You might begin, for instance, with something on the order of Freckelton's *Yellow Apples* (fig. 4.14), a small-scale early work that suggests a number of guidelines for the watercolor student. The artist uses only a few objects that can be drawn with simple outlines. Subject and

technique are in harmony here, since the appliqué quilt theme lends itself to composing in "pieces." The device of distortions seen through glass adds to the picture's realism even as it emphasizes abstract patterning. Freckelton also makes dramatic use of controlled lighting, as I suggest you should do. It comes from the right, casts interesting oval shadows, and molds each apple with a dark side, a light side, and a spot of white paper as a highlight.

Finally, take note of Freckelton's format. The painting proper has been marked off by masking tape. This gives it a sharp edge, like the imprint of an etching plate on clean paper; and as in printmaking the artist's signature is penciled *below* rather than *on* the image. I prefer painting out to the deckled edge, but this is one of your options in watercolor. It does give the sense of a sharply bounded rectangle, which Freckelton wants, and the separate shapes of the quilt strips are made more incisive by the taping.

It is easier to give directions for starting a picture than for finishing it because the variables increase as you go along and, in the end, your own spontaneous reactions must take over. When Hollywood prepares a movie, several writers may be assigned to the script, but each "treatment" will be distinctive. The same principle of free-wheeling variations on your initial idea applies in watercolor. It is essential to start with a clear concept, since there is no way of correcting things later. Nevertheless, you can choose your strategy and make it altogether your own.

STILL LIFE PROJECTS

At this point, you should paint several modest still lifes in order to gain confidence with watercolor before tackling more difficult landscape and figural themes. As you proceed, you will need to have a plan in mind, and this chapter describes various approaches to still life you might find interesting and useful. Nine specific exercises are outlined here, and you will do well to explore three or four of these compositional strategies:

Exercise 1

The white-on-white still life gives you practice in developing shadows behind things. There can be a little color, but use a light background and primarily white objects such as eggs, turnips, onions, or a milk pitcher.

Exercise 2

An arrangement of white objects against a colored ground shows you how to paint large background washes while pushing the main forms forward as lightly tinted "whites."

Exercise 3

Painting white objects and then coloring them arbitrarily, like Easter eggs, is an enlightening exercise. By forming objects with neutral shadows and then "dyeing" them imaginary colors, you learn that the various layers in watercolor can have separate functions.

Exercise 4

The study that is primarily drawing, with very little color, may be as effective as the picture finished with every detail in place. With the same subject, try both approaches to get a sense of the additive character of the medium.

Exercise 5

The close-up arrangement, selected with a viewfinder from an assortment of random objects, provides experience in composing with unusual visual angles.

Exercise 6

The mantelpiece strategy or lining up objects at eye level, allows you to simplify the drawing and concentrate on light and dark values.

Exercise 7

Painting the same set-up with different lighting shows How shadows create abstract shapes and minimize unimportant details.

Exercise 8

Using color in shadows and blank paper in the lights teaches you how to simplify with an effect of intense sunlight. Since the white areas should not be too large, the technique works best with a subject like a bouquet or basket of fruit that is composed of many small forms.

Exercise 9

The patterned still life offers an alternative principle for organizing shapes. Place simple objects on boldly ornamented rugs, drapes, or quilts, and develop the painting as "piecework."

5

Realism and Classic Watercolor Technique

Now that your studio experience is underway, it is time to pause for a moment to look at the work of historic and contemporary watercolorists to see how they solve problems you yourself are encountering and to keep an eye out for new ideas. As in a thoughtful college painting course, the chapters of this book are divided between "studio sessions" centering in technique and "slide presentations" that focus on ideas. Later we will consider more abstract and experimental modes, but for starters you should be familiar with traditional or classic technique as it is used in still life, figure, and landscape painting.

WATERCOLOR IN ENGLAND

Watercolor is an ancient medium, but its modern use really began in the 1780s with a very practical development—the introduction of English dry cake colors and Whatman's innovative "wove" paper. It had been used since the Renaissance for studies and preparatory sketches, but having to grind one's colors fine enough and with the right amount of gum arabic was discouraging; and in any case washes sank into even the best paper as if it were a blotter. The new wove paper, on the other hand, revolutionized technique with a smoother surface and a hard, glazed finish that permitted washes to float on it and be manipulated for some time before drying in.

English landscapists were now encouraged to specialize in watercolor, and the battle to recognize it as an independent exhibition medium began. Blake, Constable, and Turner did impressive work which, by 1812, was finally permitted in Royal Academy exhibitions, al-

though initially in a segregated room. It was not until twenty years later that Turner could show his misty Venetian watercolors alongside his oils.

The English were acknowledged leaders in watercolor during the first half of the nineteenth century. A new phenomenon, the "colour man" (or commercial art supplier), promoted the medium. There were innumerable handbooks and further technical advances such as Winsor & Newton's 1846 introduction of moist colors in metal tubes. These innovations, and the works of British painters, were shown in the Paris *Exposition Universelle* of 1855 just as the Realist movement got under way. We will consider how the new watercolor idiom lent itself to the aims of French open-air painting, and, in turn, to the clean-cut technique and "realistic" reporting of the Americans Homer and Sargent, who have in a sense defined watercolor as it is widely perceived today.

REALISM IN FRANCE

There is probably no more misunderstood art term than *realism*, since it is so readily associated with smooth "photographic" rendering. Although this is sometimes a factor, fool-the-eye technique is as much the tool of a fantasist like Dali as of a factual Van Eyck, and more often than not the painters most closely associated with realism—Velázquez, Hals, Manet, and Homer—have preferred a broad, painterly style. To avoid confusion, then, it is important to understand that realism has more to do with an attitude of impersonal candor than with this or that technique. The realist paints from direct experience, recording what he sees without undue editorializing. His portraits are unretouched, his city views show factory smoke, and his landscapes are of familiar scenes rather than exotic places.

This was the attitude of the French novelist Flaubert whose clinical study of small-town

Preceding page: Fig. 5.1.
WINSLOW HOMER (American, 1836–1910).
A Wall, Nassau, 1898.
Watercolor, 14¾ × 21½ inches.
Metropolitan Museum of Art, Lazarus Fund, 1910.

adultery, *Madame Bovary*, heralded the Realist movement of the 1850s and 1860s, along with Courbet's "socialist" canvases and Manet's paintings of models and prostitutes. The Realists matched frank subject matter with a new bluntness of treatment. Flaubert set down cold facts, while Manet used harsh front lighting, like a modern flashbulb shot, and plaster-thick paint. For centuries artists had achieved subtle effects with an "indirect" technique based on underpainting followed by layers of transparent glazes. Now the Realists painted "directly," seeking immediate impact with pigments straight from the tube. This became a widely accepted practice which has encouraged interest in watercolor and other mediums suitable for quick sketching.

Open-air landscape painting, or *plein-air-ism*, was another phase of Realism that helped to popularize watercolor. While Manet and Courbet were making news in Paris, Eugène Boudin (1824-1898) worked quietly at Trouville and Honfleur on the Atlantic coast painting small beach scenes with notes about time of day, light, and the weather jotted on the back. Earlier landscapists like the Barbizon group had merely sketched outdoors and done their finished paintings in the studio. Now in 1858 Boudin and his eighteen-year-old protégé, Claude Monet, worked in an innovative way, directly from nature, intent on recording sunshine, fog, and rain. Later Monet went on to lead the Impressionists, and the idea of painting directly from nature became linked with more elaborate theories of instantaneity, accidental composition, and broken spectrum colors.

Clearly watercolor is an ideal medium for the *plein-airist* who wants to capture an immediate, not-too-detailed impression. It is practical to use at the beach on a windy day as Boudin liked to do. You can spread your gear on the sand while painting on your lap, and the medium's bright washes admirably capture sunlight, sea, and clouds. Boudin's *Beach Scene No. 2* (fig. 5.2) is a perfect starting point for our look at work by past masters because it is the kind of painting any beginning watercolorist might want to attempt. One is struck by the verve of this little picture, about the size of a sheet of typing paper. Watercolor can be fun, and here we see that freshness is encouraged by simple procedure. There is only a quick pencil sketch (loose and animated) followed by one wash for the sky, another for the sand (with a

Fig. 5.2.
Eugène Boudin (French, 1824–1898).
Beach Scene No. 2, ca. 1860.
Watercolor, 8⅛ × 12⅜ inches.
Philadelphia Museum of Art, Samuel S. White III and Vera White Collection.

few added texture marks) and, finally, some dark accents to suggest tents and people in bathing costume. That is all. In contrast to canvas, which requires a fairly solid application of paint, a watercolor "paper" may be lightly brushed, with empty areas and only a few touches of color to create an effect.

This is essentially the image of watercolor we have grown up with. Although contemporaries like Pearlstein and Brady are currently showing five-foot papers, monumentality is a very recent development. Before 1800 British landscapists established watercolor as a small-scale medium, and the later nineteenth century French open-air painters saw it as a vehicle for portraying both the natural world and everyday events—the little things in life, rather than the bold themes of Manet and Courbet. The Americans Homer and Sargent, as we shall see, descend from this tradition.

HOMER AND THE WELL-MADE WATERCOLOR

Henrik Ibsen (1828-1906), the Norwegian author of *Ghosts* and *Hedda Gabler*, has been called the father of the "well-made play"—the kind of small cast, one set drama devoted to a single issue that we see so often, even today, on Broadway. The American painter Winslow Homer (1836-1910) was a contemporary, and his treatment of man's struggle with the sea often parallels Ibsen's dark themes. More importantly, these men share a concern for tight compositional structure. It is in this sense that I see Homer as creator of the "well-made watercolor."

Homer's style is exemplified by *Ship Unfurling Sails* (fig. 5.3), a paper that reduces complex visual information to the shorthand

Fig. 5.3.
Winslow Homer (American, 1836–1910).
Ship Unfurling Sails, ca. 1888.
Watercolor, 10¾ × 14½ inches.
Philadelphia Museum of Art, Given by Dr. and Mrs. George Woodward.

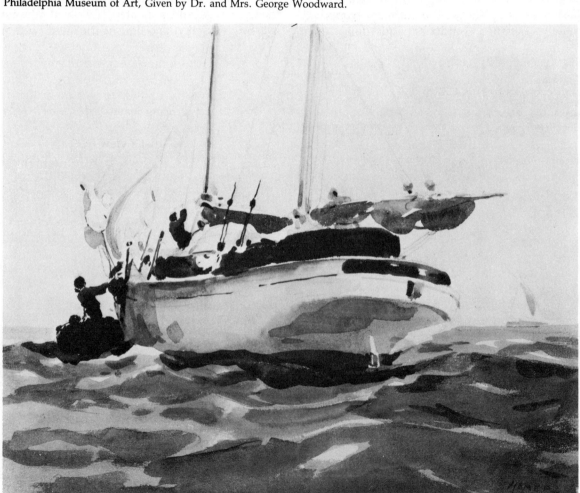

rendering that works so well in watercolor. The scheme is simplicity itself: a flat wash of violet-gray sky and bright ultramarine water marked with broad strokes indicating waves. This is the setting, or "space," I advise students to put in first and which, in this case, would take all of ten minutes to execute. Meanwhile, warm rust-orange accents are reserved for the middle zone of human activity. And the tyro who yearns to put in eyes, noses, and facial expressions should take note that in a Homer watercolor figures and sailing gear—although carefully located in pencil—are in the end rendered as blobs and splashes of a dripping brush.

Such a sketchy rendering of sails dissolving in atmosphere, if not as daring as Monet's famous *Sunrise: An Impression*, must have seemed bold and innovative in the 1880s. Certainly the style was widely imitated and still is, as anyone visiting Provincetown or Gloucester nowadays realizes. The remarkable thing about Homer is that he has been a model both for the watercolor "academy" and for our most progressive painters. This is because his work is direct, avoids rendering tricks, and has tremendous range, moving from an early conventional stance toward increasing adventurousness.

A self-taught Boston illustrator, Homer worked for *Harper's Weekly* during the Civil War doing sketches of soldiers at the front. His wash drawings of everyday camp life were a far cry from the heroic battle scenes the public was used to, and he attracted national attention when several were published as cover illustrations. Shortly afterward, Homer spent a year in France where he was exposed to the modern art of his day. He admired Manet and Bazille and was influenced to lighten his palette after the trip abroad.

Homer did not take up watercolor until he was thirty-seven, however, and the works of this period often tell a story. A series done in the remote English fishing village of Tynemouth, for instance, deals with the literary theme of man's heroic battle with the sea. In one painting a *Fisher Girl* looks up from her nets toward a schooner foundering on the rocks, while in another the survivors of such a wreck cling to a capsized lifeboat as a vision of land and safety lies ahead.

It is the late watercolors, however, that modern artists most admire. These, in contrast, are swift impressions of places and incidents done with sure strokes and vivid color. Homer painted into his seventies, living at Prout's Neck on the Maine coast where his studio was an open deck thrust out over the ocean. For over thirty years oil painting was the work of the winter, while summers were for outdoor life—hunting and fishing in the Adirondacks, Bermuda, or Florida—and literally hundreds of watercolors. Despite an isolated personal life, Homer was not, like Eakins, neglected in his time. This was America's most celebrated painter, and one whose self-estimate was shrewd. When asked by a biographer to evaluate his own work, Homer replied: "You will see, in the future I will live by my watercolors."[1]

Whether painting blackbirds in a thicket, leaping trout, sponge fishing in the Bahamas, or Florida mangrove jungles, Homer had a remarkable gift for finding a design motif that would express the subject in visual terms. In this regard his method, albeit in a realist idiom, closely resembles Paul Klee's system of announcing each "theme" with an abstract configuration. *A Wall, Nassau*, (fig. 5.1), for instance, is about narrow slits and things growing out of them. The idea is conveyed by pure geometry—blank areas of sky and wall pierced by two thin openings: the vertical rectangular gate at the left and the horizontal slit of wine-dark sea, drawn at the exact center of the paper. Gesturing shards of broken glass lined up atop the wall form a jaunty secondary motif that is echoed in the dancing leaves and distant sails.

Hurricane, Bahamas (fig. 5.4), represents a darker side of the artist's view of nature. A late work, it is designed with somber, distilled shapes that anticipate the vehemence of Abstract Expressionism. Threatening curves of darkness descend from the left, while shadowy triangles are stepped upward to form a funnel-like area of brightness against which squat palm trees whirl like dervishes.

In the last analysis, Winslow Homer—whose career took him past the turn of the century—is to be counted as a modernist. He broke new ground, particularly in the field of watercolor. And while much is to be learned from his orderly procedures, this artist's greatness lies not in the bare bones of such compositional schemes but in the richness and invention he brought to them.

[1]Donelson F. Hoopes, *American Watercolor Painting* (New York: Watson-Guptill, 1977), 60-61.

Fig. 5.4.
WINSLOW HOMER (American, 1836–1910).
Hurricane, Bahamas, 1898.
Watercolor, 14½ × 21 inches.
Metropolitan Museum of Art, Lazarus Fund, 1910.

SARGENT AND EAKINS

John Singer Sargent (1856-1925) succeeded Homer as the premier American watercolorist in an almost exact time sequence: Homer died in 1910, while Sargent took up watercolor around 1905, giving it his primary attention thereafter.

At fifty, he was a painter of world renown who was bored with painting prominent people in repetitive situations. As vacations in Italy, Spain, and the Swiss Alps became more and more lengthy, he found a second career in the watercolors he took along for these journeys. The travel sketches were done solely for his own pleasure, and at first they were given away to friends. But a 1909 exhibit at Knoedler's was an instant success. Afterward the Brooklyn Museum bought eighty of his watercolors, the Boston Museum of Fine Arts purchased forty-five, and the Metropolitan Museum, eleven.

Sargent was a dyed-in-the-wool Realist. He often said he painted only what his eye could see, and while this is not always evident in the portraits, which lapse into mannerism, it is a principle applied with distinction in the watercolors. He worked quickly, in one "go," and believed in painting almost anything he came upon rather than searching for the right subject. The result is a well of inventiveness in the face of unexpected situations. Where

Homer's watercolors are orderly, Sargent's erupt and flow in unpredictable ways. The paint may be applied to dry or wet paper; marks may be distinct, blurred, or dry-brushed; and when the subject requires it, the artist is not averse to scratching into the paper or adding opaque colors.

In the Generalife (fig. 5.5) gives us an idea of the total impression of people, incident, and environment Sargent was after. A portrait of his sister sketching in a Granada park with friends looking on, the watercolor owes something to Degas in its unrehearsed look and Japanesque perspective from above. Realistic elements move in and out of focus as they do in life when we glance casually at a scene. The head of the white-haired Spanish lady is marvelously detailed, for instance, while her hands are a mere smear.

In its overall plan, the picture has the well-made look of a Homer, with a diagonal line from the upper left to the lower right corner dividing the space into dark and light halves. Yet Sargent's paint handling breaks loose from this simple geometry with utter abandon. In contrast to Homer's clean wash style, Sargent's basic device is a lunging brushmark which is augmented here by an underdrawing in water-resistant wax crayon that highlights the greenery above and the circular pavement stones at the lower left.

Fig. 5.5.
JOHN SINGER SARGENT
(American, 1856–1925).
In the Generalife, Granada, 1912.
Watercolor, 14¾ × 17⅛ inches.
Metropolitan Museum of Art, Pulitzer Bequest, 1915.

Fig. 5.6.
THOMAS EAKINS (American, 1840–1916).
In the Studio, ca. 1875.
Watercolor, 19 × 13¾ inches.
Philadelphia Museum of Art, Given by Louis E. Stern.

American Realism claims three great ancestors: Homer, Sargent, and Thomas Eakins (1844-1916), who must also be considered here, despite a limited watercolor output, because of the influence of his ideas. Except for two student years abroad, Eakins (pronounced *ay*kinz) lived out his life in Philadelphia. A teacher and director for a time at the Pennsylvania Academy of the Fine Arts, he was forced to resign in 1886 because of his commitment to clinical studies, the teaching of anatomy and—what was most shocking—the notion that students should draw from naked models. A friend of Walt Whitman and an admirer of Homer, Eakins did not share their fame. There were few commissions, and the first major Eakins exhibition was held only after the artist's death. Yet today he is recognized as perhaps our most profound American painter.

Like Homer and Sargent, Eakins believed in working from life. His was a different brand of realism, however, based on scientific method rather than visual impression, on "knowing" rather than "seeing." And despite the fact that watercolor attracted him as a vehicle for depicting sunlight, his major efforts in the medium—like *John Biglin in a Single Scull* (Metropolitan Museum) or *Whistling for Rail* (Brooklyn Museum)—are done with such small dry strokes and attention to musculature and the foreshortening of a gun, oar, or scull that the result is closer to a tinted drawing than to a full-bodied painting.

For our purposes a modest figure study like *In the Studio* (fig. 5.6) is more enlightening. A diminutive, not-too-pretty woman poses eagerly for her portrait, and we sense Eakins's concern for the sitter as an individual rather than a mere participant in the scene. And where Homer or Sargent might suggest a figure with a spot of color, Eakins painstakingly renders the gesture and expression, thus establishing a "center of interest" to which all else is subordinate.

This is an unfinished work, signed after his death by Eakins's wife, and as is often the case, the incomplete page gives a better idea of the artist's working method than if all details had been filled in. Broad zones of light and dark have been established early on, and had Eakins continued, doubtless this structure would have been maintained—darkness above, as a frame for the portrait head, and a blaze of light below

to unify the cluttered details of ball gown and sofa.

The figure is blocked in with equal assurance: the crucial positions of head, hand, and toe already determine the lady's gesture, and all that remains is to connect these points. There is an important drawing lesson here for students who, all too often, start in the middle of a figure and find themselves, at the end of a pose, without time for the head or room on the page for hands and feet.

Eakins painted only about twenty watercolors during a brief period of the 1870s, so his influence is less extensive than that of Homer and Sargent. It is also an influence in the opposite direction, since his earnest approach had little in common with their fluency. But the faces of realism are various. In the recent watercolor revival some artists have used classic technique while others have tried to "start from scratch," rediscovering the medium much as Eakins himself did, with the earnestness of an explorer. Looking at the work of Erlebacher, Goodman, and Pearlstein one sees that—whether the connection is acknowledged or underground—Eakins's realist spirit lives on in certain quarters. Technically, this means an avoidance of simplification and a willingness to build forms with painstaking strokes. In spirit, it means a mood of pervasive sobriety rather than easy charm.

ACADEMICISM AND MODERNIST REACTION

I recently picked up a book about twenty-five watercolorists in which all but one were listed as *John Doe, A. W. S.* or, even more elaborately, as *Jane Doe, N. A., A. W. S.* The string of letters indicates membership in the National Academy of Design or the American Watercolor Society, and it implies the stamp of approval of an agency devoted, like the old French and British royal academies, to maintaining standards in the field. In the 1980s this is a curious situation, because although certain printmakers, sculptors, or oil painters might be considered "academic" by the critics, few would want to wear the badge with conscious pride as watercolor specialists often do.

As the saying goes, there is good news and bad news here. The good news is that for over a century the A. W. S. has fought, with some success, for recognition of watercolor as an independent medium comparable in importance to oils. It also has fostered a standard of "proper" technique, based on the Homer-Sargent tradition, that is now firmly established in the public mind. Everyone knows that the watercolorist should work freely and transparently, avoiding "muddy" passages and the evils of opaque white. While this view may seem conventional, it is still fundamental and to my mind the best starting point for the beginner.

The bad news is that serious artists all too often have been discouraged from using watercolor because of its seemingly academic character and its popular image as a vehicle for technical virtuosity and glamorously rendered sunsets and palm trees. When I started to exhibit in the forties, painting with transparent washes seemed hopelessly old-fashioned, and for years my so-called "watercolors" incorporated gouache, casein, India ink, and even collage. It was not until 1975 that I turned to classic watercolor technique and found, to my surprise, fresh challenge in a medium that had seemed old hat. Sidney Goodman tells of a similar experience, and most of the artists interviewed for this book have been working in watercolor for only about ten years. Unquestionably, the last decade has seen, if not a watercolor renascence, at least a new perception of the medium as one of solidity and substance.

One concludes this from the fact that, suddenly, *major* painters are doing *major* work in the medium, and prestigious galleries are promoting a new breed of watercolorist. Although the traditional intimate watercolor is alive and well, artists like Goodman and Welliver nowadays use it for weighty rather than casual themes, and when McGarrell arranges a one-person show, he is happy to display a group of minutely detailed watercolors alongside his huge canvases.

Meanwhile, for many younger artists—Brady, Freckelton, Ragin, and Shatter, to name a few—major achievement in watercolor means working at the scale of an oil painter. Thus the notebook size of a typical Sargent or Demuth—so small that it needs a mat to be sufficiently impressive for hanging—has been superseded by today's 30-by-40- and 40-by-60-inch papers, and many artists show even larger works under sheets of plexiglass up to eight feet long. Clearly the genteel "minor art" of watercolor is on the way to becoming a medium of major importance.

THE NEW REALISM: RETURN TO THE FIGURE

The New Realist movement has had a lot to do with changing attitudes. From the 1913 Armory Show to the heyday of Abstract Expressionism in the fifties, modern art was widely associated with an avoidance of traditional modes of representation. Then in the late sixties artists like William Bailey, Jack Beal, and Gabriel Laderman began to show us the possibilities of figurative painting as a vehicle for progressive ideas. The movement gathered force, and today museums are scrambling to arrange exhibitions and catalogs defining its divisions and subdivisions. Young artists no longer see working from life as retrograde, but as a viable alternative to abstraction. Quite naturally, the return to representation has sparked interest in mediums of proven appropriateness like charcoal, pastel, and of course watercolor.

Philip Pearlstein is widely viewed as the dean of the New Realists. A thoughtful painter, art historian, and teacher at Brooklyn College, he has written a score of articles defining the movement and his place in it. He has also been **extensively** written *about*. And his distinctive idiom—the foreshortened studies of models in a compressed studio space—is as instantly recognizable as a Braque or Picasso. For purposes of this discussion, one notes further that of all the pioneer figurative painters of the sixties and seventies, Pearlstein is the most closely identified with watercolor. He not only gives equal attention to watercolors and oils, but the works on paper deal with the same themes and are of comparable scale and complexity.

Pearlstein is a man in love with the past, yet fully in tune with the present. A major achievement has been his reconciliation of such traditional concerns as perspective, anatomy, portraiture, and landscape with post-Cubist concepts of abstract form. This is nowhere clearer than in the watercolor of *The Great*

Fig. 5.7.
Philip Pearlstein.
The Great Sphinx, Giza, 1979.
Watercolor, 29 × 41 inches.
Courtesy Allan Frumkin Gallery, New York.

Sphinx, Giza (fig. 5.7), which is at once a testament to historical grandeur and a model of spare, modernist composing.

As Winslow Homer liked to do, Pearlstein paints the scenes of his vacation trips to the canyons of the American West, the hills of Italy, and such monuments as Tintern Abbey and Stonehenge. During a 1977 Nile cruise with his family he did several watercolors, and it is interesting to compare this view of an Egyptian Sphinx with Homer's painting of a Bahama hurricane (fig. 5.4). Both compositions are based on triangles stepping up from the lower left. The Pearlstein is more compressed, however. There are just three elements: the unbroken sky; the richly textured image of the Sphinx, pressed forward so that it looms like a wide-screen close-up; and the pyramid which Pearlstein designs

as a flat geometrical triangle in the exact lower left corner.

To visit Pearlstein's studio is to experience an environment that is both a metaphor for his art (in the welter of visual incident that echoes his themes) and the physical reality that gives it form (through controlled dimensions and lighting).

One ascends a steep flight of steps to a Brownstone on New York's Upper West Side, entering a home packed with art objects—rugs, bric-a-brac, paintings, prints, primitive and classical sculptures—that cover walls, shelves, tables, mantel, and hearth. Dark decor gives the impression of an unretouched Victorian mansion, but the dull green floral wallpaper is actually modern—a William Morris design reproduced from the original blocks. Ascending more stairs, hung with Japanese prints, one

Fig. 5.8.
Philip Pearlstein.
Female Model in Kimono, 1979.
Watercolor, 29½ × 41½ inches.
Courtesy Allan Frumkin Gallery, New York.

arrives at the studio floor, the bulk of which turns out to be a prop warehouse stacked with the bamboo, wrought-iron, and bentwood furniture on which the artist poses his models. The actual work area is a bedroom-size space in front, about 15-by-17 feet, curtained off with plastic sheeting to keep out drafts. The windows have been blocked out, and the only illumination comes from three 150-watt color-corrected spotlights on opposite sides of the room.

Somehow one imagines Pearlstein painting his outsize canvases in an heroic space with a complex lighting system to produce the famous triple shadows. Instead, this is a classicist who gains strength from strict limitations. The artificial light is constant day and night, the spotlights immovable, and the claustrophobic space a wrestling ring that forces artist and models into close visual encounter. After equipment and furniture for the pose have been set up, there is barely room for the artist to peer around his huge, vertically positioned paper at a model no more than three or four feet away.

We see in a work like *Female Model in Kimono* (fig. 5.8) the effect of such a vantage point. A projecting elbow or knee looms large, while a foot seems to shrink as it recedes; there are unlikely juxtapositions (such as breast to elbow to flap of a plywood chair); and—in what has become a Pearlstein signature—the head may be cropped or cut off entirely from the field of view.

What distinguishes the New Realism from

Fig. 5.9.
PHILIP PEARLSTEIN.
Two Seated Female Models in Kimonos with Mirror, 1980.
Watercolor 40 × 59¾ inches.
Courtesy Allan Frumkin Gallery, New York.

academic figurative painting is the use of direct observation for formal rather than merely descriptive purposes. Thus, although Pearlstein's earnest rendering of anatomy is reminiscent of Eakins, the abstract expressionist goals of his youth remain strong, and a painting like *Female Model in Kimono* has all the swinging, rhythmic power of a de Kooning. Oher recent watercolors, like *Two Seated Models in Kimonos with Mirror* (fig. 5.9), have a fractured imagery that is almost Cubistic. Where Braque used literal paste-ons, Pearlstein creates the illusion of a "collage" of body parts, kimono patterns, and furniture legs as seen in disjointed close-ups and mirrored reflections.

Pearlstein explains that the tiny studio he had in the early days forced him into the stylis-tic manner for which he is known. Yet later, when he could have afforded a spacious SoHo loft, he preferred to buy the house next door, cutting a hole through so that now there are two identical small studios side by side. With this set-up, Pearlstein's work schedule is like that of no other artist one can imagine, unless it is Rubens back in the seventeenth century. He schedules models throughout the week and keeps seven or eight paintings going at once, placing appropriate furniture each day in Studio One and Studio Two for morning and afternoon projects. A watercolor takes several weeks to complete, an oil perhaps three months, but the pictures conclude at different times and are in various stages of development so that there is no chance, he says, of going stale.

Technically, Pearlstein compares his approach to that of a fresco painter.[2] The watercolor paper is fastened to a light foamcore backing with spring clips and positioned on an adjustable table turned up almost vertically like the wall a fresco artist faces. He then draws from life directly onto the paper with a small round brush dipped in Raw Sienna or Raw Umber tube watercolors, sponging off and redrawing any marks that do not suit. The effect is like a fresco "cartoon" in its outline of life-size figures, the typical earth color, and the fact that Pearlstein often draws muscles with a dotted line resembling fresco "pounce" marks.[3]

Again, as in fresco, the composition is developed in sections—an arm, a leg, the floor boards, the kimono pattern—rather than with the usual attempt at general effect. When an area becomes overly wet, the artist must move on and return after it has dried, so each section ultimately is developed in several stages. First local colors are indicated, then shadow patterns. Finally tones and edges are sharpened.

This process gives the color a "soaked in" quality not unlike fresco tints worked into wet plaster. Pearlstein explains that he could not reach the top of his five-foot paper if it were laid on a table in the normal way. On the other hand, avoiding spills in the vertical position requires cautious use of a thin mixture of dry cake pigment and water which is carefully worked *into* the paper rather than floated glassily *over* it in the manner of a Homer or Sargent.

We see, then, that Pearlstein has evolved a highly personal way of using watercolor that is, in some respects, at odds with traditional approaches. One need only compare the earnestly mottled background in his *Sphinx* with a crisply washed Homer sky to understand that Pearlstein wants to avoid passages that might seem glib. On the other hand, his method of composing in both oils and watercolors is very much in line with Homer's brand of realism. The style is always broad, and forms are reduced to clearly defined planes of light, medium, and dark tonality. Indeed, the sharpness of these planes, often painted in stair-stepped gradations (as in the lower corners of *Female Model in Kimono*), is crucial for Pearlstein. He says he particularly likes watercolor because "it is immediately precise, whereas oils are by nature impressionistic—smudgy—and you have to work much harder to make them precise."

Although the oversize watercolor is an important recent development, five-foot nudes like Pearlstein's are still a rarity, and for most of us the figure studies of Sidney Goodman are in a more familiar scale. Oil is Goodman's major medium, but he does a great many prints, drawings, and watercolors. Although his graphic work is generally somber, the watercolors often are quite small and done with a lightened tonality and subtle brushwork. They include some of Goodman's most impressive painting, and since the oils are more frequently reproduced, the extent of his commitment to watercolor is not always appreciated. In a recent retrospective exhibition, nearly a fourth of the works were, in fact, watercolors.[4]

A Philadelphian, Goodman has a position of influence—as a native son, leading realist painter, and teacher in the historic Pennsylvania Academy of the Fine Arts—that recalls Eakins's role a century ago. But whereas Eakins met with hostility and defeat, Goodman achieved early recognition, and his work has had continuing critical and public acceptance.

When I started this book a friend said: "Be sure to include Goodman—he will give *weight* to it." I suspect there is no more apt word to describe a peculiarly American realist sensibility that Goodman, Pearlstein, Eakins and, going back even further, John Singleton Copley share. Despite differences, there is a common ground of solidity and serious purpose. In Goodman's case this stems from both imagery and technique, although it is the theme that usually comes first. A subject seizes his imagination as an *idée fixe*, and he may return to it again and again over the years.

[2]Jerome Viola, *The Painting and Teaching of Philip Pearlstein* (New York: Watson-Guptill, 1982), 137.

[3]Fresco is watercolor painted on wet plaster and chemically bonded to it after drying. Neutral earth colors are widely used, since not all brilliant pigments are compatible with lime. The preliminary drawing is done on paper, outlines are punctured with dots made by a spiked wheel, and the design is then transferred by powder-puffing (or *pouncing*) dry pigment through the holes. Typically, a section of the painting is completed in a day. Excess plaster is then cut away, and when the artist wants to continue, fresh plaster is trowelled against yesterday's edges.

[4]Pennsylvania State University Museum of Art (University Park, Pa.), *Sidney Goodman: Paintings, Drawings, and Graphics 1959-1979*, Exhibition Catalog edited by Richard Porter, 1980.

My most striking recollection of Goodman's studio is of a drawing in progress showing a naked couple in a darkened room with a view through the window of tangled freeway ramps that echo their sexually entwined bodies. This is the theme of the figure in an urban setting, familiar in current films and literature, that is so different from Pearlstein's studio poses.

Typically, Goodman confronts us with enigmas—a matter-of-fact scene appears mysterious, a person seems mechanical, or a mechanical object becomes somehow humanoid. *Study for "Summer Afternoon"* (fig. 5.10), for example, is a vaguely disquieting watercolor of children in front of a playground slide whose angular poses and skinny arms and legs take on the character of the tubular metal gymnastic equipment. And his *Woman Disrobing* (fig. 5.11) might be a goddess, except that she wears a "cross-your-heart" bra.

This last image conveys particularly well those elements of classicism vs. modernity, and of the mundane with overtones of symbolism, that characterize Goodman's work. We are reminded of Balthus, Fellini, and Pinter in the way the woman shrouds her head while revealing her body. And the armless, legless torso could be a Greek caryatid if it were not so "twentieth century" in postulating a faceless woman whose body is constrained by a commercial contrivance. Suggested by a Polaroid snapshot, the pose was used for this 1974 charcoal drawing, a 1979-80 watercolor called *Woman Taking off Shirt* (pl. 6), and the artist says it may eventually be reinterpreted once again in oils.

Goodman is a master draftsman who makes vivid use of chiaroscuro. As we saw earlier, this is the technique of pulling lights out of heavy darkness, favored by old masters like Rembrandt and Caravaggio, which controls the mood of a scene the way spots and dimmers do

Fig. 5.10.
SIDNEY GOODMAN.
Study for "Summer Afternoon", 1976.
Watercolor, 14½ × 21¼ inches.
Courtesy Terry Dintenfass, Inc., New York.

Fig. 5.11.
SIDNEY GOODMAN.
Woman Disrobing, 1974.
Charcoal, 30 × 32 inches.
Courtesy Terry Dintenfass, Inc., New York.

on stage. How much so you can judge by comparing the two versions of *Woman Disrobing*. In the watercolor, chiaroscuro is softly suggested, and the mood is buoyant. In the charcoal drawing, on the other hand, heavy blacks create a mood that is somber, ominous, perhaps even macabre.

Unlike Pearlstein, who records the exact shadows cast by studio lights, Goodman uses the preliminary drawing as a factual underpinning over which the shadows of his imagination can play like clouds to be blocked in or erased out. The background can be made dark or light, the figure flattened or dramatically rounded, contours sharpened or dissolved. The possibilities are endless, and we see that Goodman the "realist" actually works very much as an abstract painter does, fitting invented shapes and tones into an overall scheme.

THE CONTEMPORARY STILL LIFE

Still life painting has an importance today that would have been unthinkable in an earlier age. One reason is that it is an ideal vehicle for the New Realist concept of *direct painting*—the art of portraying precisely what one sees. Models move, skies cloud over, but studio light is constant and the tabletop set-up doesn't change.

Another reason is that still life is an analogue in representational painting for the non-objective artist's experiments with shapes and colors. If art is to be judged, as many believe, for esthetic rather than literary content, then pictures of apples and oranges are closer to pure form and less suggestive of "story" than paintings of people and places. Still life objects are like chess pieces that can be arranged more

arbitrarily than other subjects. And for the watercolorist there is still another advantage—a comfortable scale. Just as Manet's figures are at home on a full-length canvas, so Demuth's arrangements of fruit or flowers sit well on a small piece of paper.

John Moore's work illustrates contemporary attitudes toward still life particularly well. Like many of the New Realists, he belongs to a generation of artists trained in the intellectual atmosphere of the universities, for whom painting figuratively represents a radical, progressive stance. Brought up on modernism, their quandary was how to proceed after the Abstract Expressionism of the fifties seemed fully explored. One answer was to return to representation, but with a difference. As Pearlstein explains, earlier artists made the subject conform to an abstract scheme, whereas today's realists "reverse the procedure, finding abstraction in nature." He says: "We all use realism as a vehicle, but we could have been abstractionists just as well."[5]

In this sense Moore is essentially a formalist. Nowhere is this more evident than in his watercolor still lifes which strike a note of wittily selective design. These are "well-made" compositions, but where Homer relied on simplification, Moore works like a musician, intricately, with motifs to be developed, transposed, and recapitulated. In *Watts* (fig. 5.12), for example, he rings every change on the theme of a rectangle and circle. The rectangle—strongly stated in the dark box at the left—is modified to an oblong with curved corners as our eye moves to a set of nesting trays. This shape becomes further rounded in tubular objects below; and the metamorphosis from rectangle to full circle is completed by the rim of a neighboring cup

[5]Sanford S. Shaman, "An Interview with Philip Pearlstein," *Art in America* 69, no. 7 (September 1981), 120-26.

Fig. 5.12.
JOHN MOORE.
Watts, 1977.
Watercolor, 22½ × 30 inches.
Courtesy Marian Locks Gallery, Philadelphia.

which, in turn, is set on a pile of saucers that are an odd mix of round and squarish forms.

There is similar strategy in the floral tablecloth motif which is first cancelled out by an overlaid sheet of blank paper and then reintroduced in the design on a ceramic pitcher. And everywhere one finds the device of layering—in gloves, trays, saucers, and table covers—that recalls the transparent overlapping planes of cubism.

If, as Pearlstein suggests, reality should not be distorted into an abstract design, still life objects can at least be advantageously arranged. You must of course decide whether or not to let the spectator in on your strategy—whether to compose a seemingly unstudied breakfast scene, with napkin and morning paper beside a plate, or to arrange odd objects in a frankly arbitrary scheme. Moore's watercolors fall somewhere in between. The situations—a tabletop or windowsill—are reasonable, and the clutter of objects might be found in any home. Yet we observe in *Watts* that the bowls and jars have not been assembled by a cook, nor is this in any way a table setting.

Comparison with other Moore watercolors reveals a man working serially with themes that are visual rather than anecdotal. *Goldfish* (pl. 4), for instance, has the same flowered cloth (this time layered with three sheets of paper instead of one) and the same circular objects plus some new ones; but here the mood is changed as the rectangle motif is replaced by images of palm trees, a figurine, and darting fish. Like Sargent, Moore paints quickly, counting on about two days for a watercolor, and he often works sequentially with ten or twenty variations on a given theme.

Deciding what to paint is a perennial beginner's problem which the professional solves by gradually acquiring studio furnishings, interesting fabrics, and small objects. These props influence the look of an artist's work and establish a personal *iconography*, or recurring imagery, that affects the viewer. Navaho rugs, African stools, and Oriental kimonos set the bold tone of Pearlstein's paintings. Moore's, on the other hand, have an elegance that derives from distinguished yet witty shapes. Moore has a collection of Victorian, Art Nouveau, and Pop Art objects, and in his watercolors he likes to combine such sophisticated elements with ironic images like cheap glasses

decorated with flowers, glove-stretching forms in the shape of hands, and vegetables that look real but are made of wax.

His themes sometimes take on symbolic overtones as they are repeated again and again. In *Thursday Still Life* (fig. 5.13), for instance, as well as in several other watercolors, the artist uses female-shaped vases opposite upright phallic objects such as asparagus stalks or corn spears, an arrangement that has distinct sexual connotation. Despite his formalist orientation, Moore says he has come to believe that "subject matter in representational painting is rarely neutral" and has, in fact, "important meaning, however subtle or overt."[6] In line with this, I would interpret the broad theme running through Moore's work as a dialogue between the reality of art and the reality of nature. Abstract references are made through a vocabulary of everyday cups and saucers, while conversely, humanistic references employ artificial devices like stenciled flowers and molded wax or bronze figurines.

Sondra Freckelton is another painter whose watercolor still lifes, like Moore's, are an intriguing blend of traditional technique and modernist esthetic. Studying their work side by side—Moore's *Watts*, for instance, and Freckelton's *Peonies and Bagel* (pl. 7)—one is struck by the fresh, scrubbed-clean color which is a mark of classic watercolor style.

Yet there is a big difference between this cool precision and the banal cheerfulness we often associate with watercolors done in the name of "freshness." For one thing, glamorous passages and happy accidents are carefully avoided in favor of smoothly impersonal washes. For another, the colors of objects are more intense and localized. To accomplish this, Freckelton lays out eight or ten different reds, yellows, and other key hues on a series of china plates. She also hangs charts of each pigment in diluted tints on the wall so she can select and match colors precisely. Finally, one notes that Moore and Freckelton, like most of the newer still life painters, like to "finish out" their compositions, avoiding any hint of the sketchiness favored by an earlier generation.

Freckelton and her husband Jack Beal

[6]San Antonio Museum Association (San Antonio, Tx.), *Real, Really Real, Super Real*, Exhibition Catalog, March 1981, with statement by John Moore, 84.

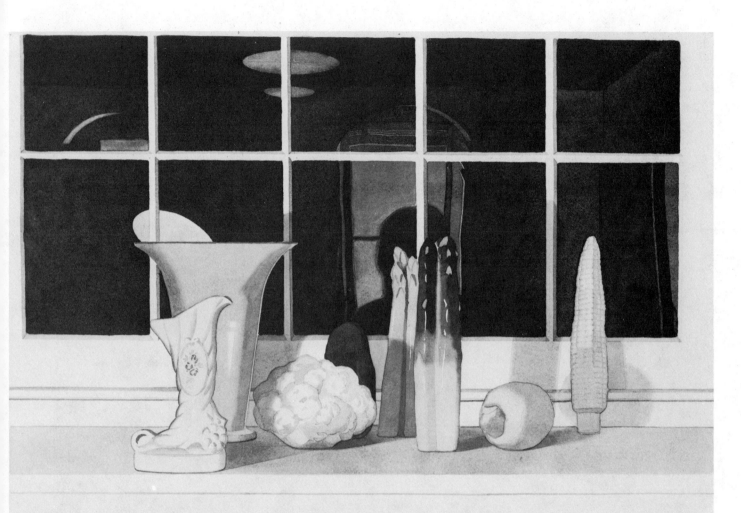

Fig. 5.13.
JOHN MOORE.
Thursday Still Life, 1980.
Watercolor, 22½ × 30 inches.
Courtesy Marian Locks Gallery, Philadelphia.

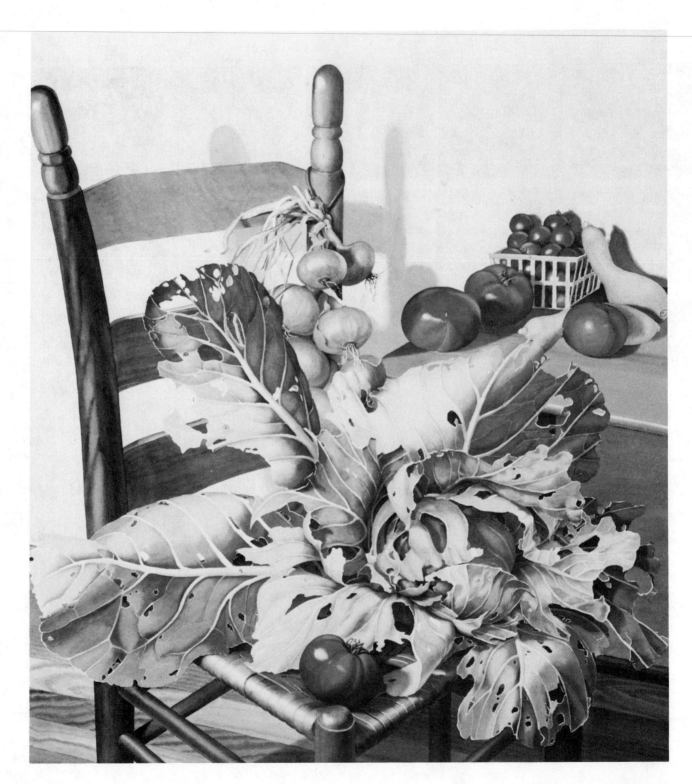

Fig. 5.14.
SONDRA FRECKELTON.
Cabbage and Tomatoes, 1981.
Watercolor, 36 × 33 inches.
Courtesy Brooke Alexander, Inc., New York.

share a commitment to realist art, but their areas of interest are different. Whereas Beal is known for figure studies in oil and charcoal, Freckelton is a former sculptor who has devoted herself almost exclusively to watercolor still life painting in recent years.

Looking again at *Peonies and Bagel*, we note the craftsmanship, virtuoso realism, and arresting design that have won her acclaim. The subject is witty—very "now" in balancing a Pop Art bagel against a traditionally pretty flower arrangement and contrasting a real bouquet with artificial blossoms on an appliquéd table cover. The composition is a honeycomb of octagons, circles, and quilted or jigsawed cutouts, and the picture's three-dimensional thrust is impressive. This dimensionality adds to the realism (you could almost pick up and eat the bagel). It also energizes the design as the artist shapes her still life with a sculptor's instinct into the form of a carved wall relief, rather than the usual tabletop arrangement.

It is the time-honored virtue of a still life that it is in fact "still." Reasonably motionless, in practical terms, despite fading flowers and bananas turning brown. And esthetically still: serene and immutably ordered. Hence, Cézanne's artificial fruit and Moore's wooden glove forms. Modern art, however, is about contradictions, and Freckelton's watercolors are shot through with tension between objects seemingly about to move and the tight design structure they are locked into. A crumpled glove or paper that appears to be unfolding is a typical theme, and the artist likes to draw things that are a little "wrong" so that a certain visual uneasiness is established. In the watercolor we have been looking at, for instance, the bagel is shown down in one corner on a plate tilted so that the bread seems about to slide out of the picture.

Freckelton has a studio in Manhattan and one in the country. But it is the celebration of country furniture, early American quilts, and farm-fresh produce—rather than the urban world of a Pearlstein or Goodman—that we experience in her watercolors. *Cabbage and Tomatoes* (fig. 5.14), for instance, shows us dewily highlighted red tomatoes, yellow squash, and an enormous green cabbage head with leaves unfurled. The painting is a spectacular solution to a difficult pictorial problem, since the leaves of a newly-picked cabbage open and

close by the minute. In order to capture its freshness, Freckelton studied Polaroid shots of the cabbage leaves in motion, made pastel and oil sketches, and finally positioned the cabbage head in her still life by lifting its elephantine leaves into the air with pins and needle and thread.

THE GREAT AMERICAN LANDSCAPE

There are many outdoor painters today, but I can think of no one more directly in line for Homer's mantle as interpreter of the great American landscape than Neil Welliver. Mind you, I don't mean just any landscape, but our country's special vision of pioneer vastness, sporting pleasures, and grandeur unspoiled by city folk that is as mythic as apple pie. The landscape of the Hollywood western, of Hemingway, and the Hudson River school.

Welliver's paintings celebrate the natural preserve he owns in Maine, an estate of 1,200 acres that includes a mile along Duck Trap River, several lakes and streams, and—in addition to the main house and studio—various outbuildings, barns, and windmills for generating electricity. From nearby Lincolnville he ships his work to New York galleries with a world market and flies every other week to Philadelphia where he heads the University of Pennsylvania art faculty.

The symbolism of such a professional life is as fascinating as its logistics. Welliver lives near Homer's old studio in Prout's Neck, and he has had similar critical and financial success. And like Monet, with the famous waterlily gardens at Giverney, he has been able to surround himself with an ideal natural environment that provides the imagery for his paintings.

Not all realists are cut from the same cloth. The old master techniques of some are avoided by others, certain artists work from the model while others use the camera, and painters have differing attitudes toward the brushmark. In contrast to Pearlstein and Moore, who use a neutral style that will not get in the way of the subject, Welliver is what critics call a "gestural" or "painterly" realist. He works with exuberant strokes of a heavily loaded brush, and his oil

Fig. 5.15.
NEIL WELLIVER.
Immature Great Blue Heron, 1977.
Watercolor, 24 × 22½ inches.
Courtesy Brooke Alexander, Inc., New York.

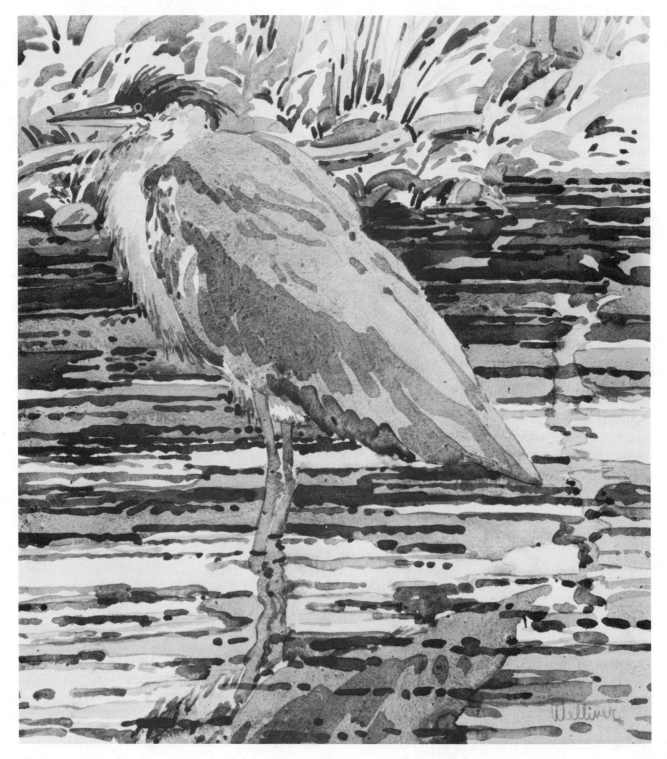

paintings are a battleground on which the landscape image is alternately created and destroyed by smears of pigment. These separate strokes are a bit like the color patches in a mosaic that fuse into a general image only when one stands back a little. And they are developed, as in a mosaic, area by area. Working from a color sketch and a scaled-up drawing, the artist starts painting at the top of an eight-foot canvas and continues to the bottom edge without ever going back.

The watercolors are also composed of separate marks, although here they are applied in a different order—rhythmically around the page rather than section by section—because Welliver's wet-on-dry technique requires that each wash be thoroughly dry before a neighboring stroke is added. He works on printmaking cover paper instead of regular watercolor stock because the hard, pebbled surface gives sharper definition to each gestural stroke. In *Immature Great Blue Heron* (fig. 5.15) we see that these marks are in fact small puddles. They are made with a loaded, vertically held brush on paper laid on a flat surface, and the excess fluid in each mark is allowed to dry with a little ring like a rain puddle. Welliver's initial pencil lines show in the final painting, and he says, the name of the game is to play with washes that move liquidly in and out of these contours.

As a youth, Welliver was influenced by Emerton Heitland, a teacher who did watercolors in the Homer tradition, and by an exhibition of John Marin's paintings. I see both impulses in his current work—Marin's gestural thrusts and Homer's translation of visual experience into shorthand equivalents. The *Blue Heron* is a thoroughly "well-made" watercolor, composed as it is in three simplified zones, each with an abbreviated technique for representing a particular texture. Water is indicated by a Morse code "dot-dot-dash" striping, foliate strokes suggest riverbank greenery, and rhythmic marks imitate the heron's feathers. Welliver also focuses, as Homer did, on arresting motifs: the bird's pointy tail mirrored by the rock below and its storklike legs echoed in the watery reflection at the right.

Any student of watercolor soon learns that the problem of working outdoors, in contrast to still life and figure paintings, is that the panorama of information is so vast that one must begin by deciding what to leave out. Homer simplified matters by reducing sky, land, and water to flat bands, but Welliver has another method. As a modernist, he does not think "background and foreground," but of an image pressed forward like a leaf flattened in a book. Thus, in his handsome watercolor *Deer* (pl. 8), the tangled birch thicket is made into an intricately woven tapestry of vertical trees interlaced with diagonal shadows and fallen branches.

We also observe Welliver's limited palette here, and how much he makes of very few colors. The range of hues one might see in an actual forest is reduced to a few warm and cool tones. Grays and tans define the body of the animal camouflaged against similarly colored birches, while the only intense accents are provided by touches of salmon and leaf green. Above all, we admire the way the white of the paper has been saved for just four definitive touches on the deer's face and throat.

Welliver's watercolors are done, not as a specialty, but as part of a varied creative output, and they often serve multiple purposes. *Deer*, for example, was adapted for a color print edition, and it also served as the study for one small section of a large landscape painting in oil. When I spoke to Welliver about this book, he said: "I don't do many watercolors, but those I do paint are choice." I agree and am reminded of Spencer Tracy's classic tribute to Hepburn: "There ain't much flesh on her bones, but what there is, is 'cherce.'"

PHOTOGRAPHIC REALISM AND *UN*REALISM

Artists have used photography in one way or another since the time of Delacroix, and today it is both an independent art form and integral to many other fine art processes. Nevertheless, among figurative painters, dependence on photographs is a "hot" issue. Critics and museums separate the Realists from the Photo-Realists, and these are not always folks you would invite to the same party.

I say "dependence" on photographs, since the issue is not that of using snapshots for reference (which almost everybody does) but of making photographic imagery central to one's style. Some people believe this makes for

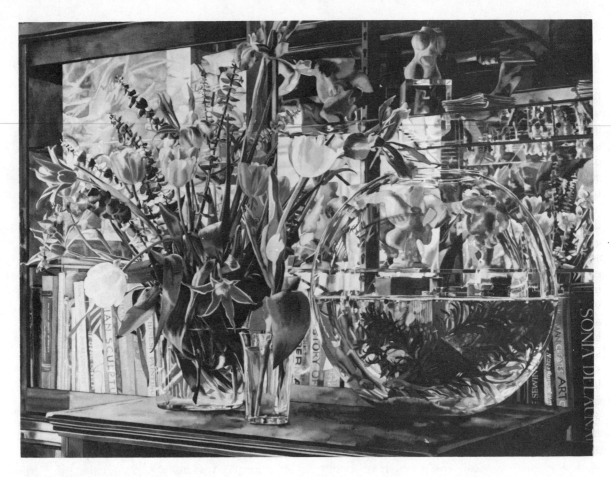

Fig. 5.16.
CAROLYN BRADY.
White Tulip, 1980.
Watercolor, 32 × 44 inches.
Courtesy Nancy Hoffman Gallery, New York.

copyist hack work, while others see the camera as expanding our visual horizons. My own feeling is that photography can be either a trap or an inspiration, depending on how you use it. In general, art students should be discouraged from drawing from slide projections or painting from photographs instead of working from life. Nevertheless, these techniques do have their place. And it is vitally important to appreciate the esthetic discoveries that have led many of our leading painters to become interested in photographic processes. Carolyn Brady's work is a case in point.

Brady is a Baltimore artist who leads the kind of charmed life people speak of as "having it all." At an age when life is supposed to "begin" but seldom does, Carolyn and her sculptor husband Bill Epton, who teaches at Maryland Institute, had their first child, and at about the same time her career caught fire. So when you visit Brady these days there isn't one of her watercolors in the house. She does a painting a month in an upstairs bedroom-converted-to-studio, and it is whisked off in an

oversize shipping tube (so the paper won't crease) to her New York gallery, which frames it and sends it on to an awaiting exhibition or collector. To keep up with career and family, the artist maintains a rigid work schedule, with time out to get her husband's lunch and quitting time in midafternoon when her young son returns from nursery school.

Brady's themes are drawn from her household world in much the same way that Welliver's come from the outdoors and Pearlstein's from the studio. The iconography of *White Tulip* (fig. 5.16) is typical: lush flowers and plants, reflections on glass and polished furniture, fond possessions like her husband's small torso sculptures seen behind and through the fishbowl, and books whose titles can be read either as texture or as words like "sewing," "sculpture," and "Chinese Painting" that evoke a way of life.

In *Baltimore Tea Party with Calla Leaves* (pl. 8) we discover another favorite theme: a table set with fine linens and china in readiness for guests. This reference to a popular art image,

80

the *House and Garden* page, seems to me as innovative as Andy Warhol's Coca Cola bottle of a few years ago. Brady says that compositional ideas mean more to her than subject matter. She does admit, however, that her themes relate to strong feelings about feminist issues, although this is not something she usually talks about.

The artist's watercolors are very large and densely layered with foliage, intriguing objects, and lighting effects. Brady says: "Still life at this scale almost becomes a landscape. I am interested in the idea of a painting that is so big you tend to wander around in it." She is a painter who likes to push ideas to maximum intensity and whose handling of resultant technical challenges is impressive. Although she and Pearlstein use the same five-foot paper, Brady cannot stand up at an easel because, in contrast to his large figures, her still lifes involve hundreds of interwoven small forms. Instead, Brady sits at a giant antique drafting table with cast iron legs, her paper laid loosely on the top, and the slant adjusted low enough to permit work from any of the four sides. The key drawing—made beforehand from a 35-mm slide projected onto paper tacked to the wall—is exceedingly intricate, and the watercolor is then developed in sections fitted into the pencil outlines like pieces of a jigsaw puzzle.

Unlike most artists who build washes gradually from light to dark, Brady starts with the deepest tones, shades rapidly into lighter values (adding water and other colors as she goes), and finishes each passage in one clean wet-on-dry layer with no touch-ups. Photographs of *Baltimore Tea Party* in progress (fig. 5.18) also reveal Brady's technique of painting things from back to front. In watercolor the last mark you make will stand out ahead of all else. Hence the positive silhouette of an object must be painted on top of what is behind it. Brady's teapot, accordingly, is painted *after* she has finished the background wall; the cup and saucer are done *after* the teapot; and the calla lilies up front are saved for last (see pp. 82-83).

These methods may owe something to Brady's years of textile designing where the pattern was laid flat and worked on from all sides. Later she did appliquéd fabrics and then began to exhibit watercolors based on magazine photographs. Today she photographs her own still life subjects, using natural indoor light, Kodacolor film, a tripod, and long exposures of about ¼ second. She avoids the color slides many artists use, preferring instead to paint from enlarged 11-by-14-inch color prints which provide more information and are less deceptively glamorous. The film negative is mounted

Fig. 5.17.
Carolyn Brady painting *Baltimore Tea Party*.
Photograph by the artist.

Fig. 5.18.
Baltimore Tea Party in progress.
This page: Early state, with distant elements painted first.
Facing page: Later stage, with mid-distance completed.
The foreground was painted last (see Pl. 8).
Photographs by the artist.

83

in a slide frame and projected for the pencil drawing. Brady says this works just as well as a positive color slide.

Photo techniques are fascinating, but it is important to understand what the role of photography *is* and what it is *not*. The camera's great advantage is that it provides information more swiftly and completely than the naked eye. Lettering the titles on Brady's bookshelf by hand would have taken hours as compared with tracing them from a slide projection in a few minutes. Furthermore, the amount of information the artist records in the *White Tulips* fishbowl is probably greater than if she had worked from the actual object, because in real life, glass reflections constantly shift and change. Flowers open and close, too, but not in photographs. Thus I suspect that the jungle density of Brady's watercolors owes something to the fact that she relies on the click of a camera shutter.

Still, the main motivation for using a mechanical recording device, as Brady and other Photo-Realists will tell you, is that it abstracts so much. However factual a snapshot may seem, it is actually faithful only to those details that are in a good light. Hence, the horrid flashbulb shot where everything is illuminated and our freckles and shoelaces are recorded in living color. Abstraction rears its head when shadows that erase details appear (as in a portrait study where the features are lighted on one side and dissolve into blackness on the other) or in the sun's glare when forms are bleached into whiteness. This is not how things appear in life, because the eye adjusts and can see into a dark corner as well as out a bright window. However, it is a principle Brady makes vivid use of in her compositions.

The photographs she takes hold very little interest *as* photographs. They do, however, provide information that turns complicated set-ups into exciting dark/light patterns. And despite the realistic effect of the finished watercolors, they have numerous boldly simplified passages. Abstract patterning is encouraged by the fact that the photographs are done indoors, without benefit of flashbulb, against a bright window.

As we see in *Baltimore Tea Party* (pl. 8), this gives objects a central core of darkness with halation at the edges and some dissolving of the spaces behind. Brady's backlighting also creates transparent planes that cut through the picture space. A vivid example is the illuminated panel of cloth under the table (where embroidery is suddenly reversed with openwork holes showing light instead of dark). Another is the overlapping of indoor and outdoor images at the right (where a bright rectangle of sky and trees is reflected on a glass-front bookcase).

Tracing the Realist movement from Boudin's *plein-airism* to Brady's *photo-verismo* has brought us full circle, from a nineteenth century artist confronting nature in the raw to a modernist working at total remove from her subject, with only a snapshot as a guide. That is why I propose Photo-*Un*realism as the logical name for what today's painters are doing with camera information. The significance of their pictures is not that they look so terribly *real*, but that they are in fact so *abstracted*—stylized and impersonalized by an indirect recording device.

In this respect, Brady's method is akin to Roy Lichtenstein's reduction of the image to Ben Day dots, and Chuck Close's use of a squared-off tonal grid. Thus Brady is an innovative modernist; yet she is at the same time every inch a watercolor stylist in the classic tradition. Her compositons are as "well-made" as Homer's, and her washes have the sparkle and first-time assurance of Sargent's.

THE MANY FACES OF REALISM

The Realist movement cannot be fully defined by the achievement of a few individuals. If space permitted, this chapter might well have included Bernard Chaet, Larry Day, Martha Mayer Erlebacher, Patricia Tobacco Forrester, Nancy Hagin, and others who are discussed elsewhere in this book.

Those artists who *have* been considered here, however, illustrate especially well the broad, painterly style that has dominated Realism since the 1850s and is immediately pertinent to your study of watercolor. There is no more important first lesson than simplifying a subject into a few planes that can be realized with broad washes. The artists we have talked about also share a concern for systematic procedures. This

is another common trait among Realists and an essential one for the watercolorist.

Throughout the chapter, I have hammered away at the idea of a "well-made" watercolor—not because there is any morality in it, but because of its practicality. Joseph Raffael says one of the great lies art schools teach is that "watercolor is difficult" when he finds it really the "easiest of mediums." I would agree, but with an important proviso. The truth is that watercolor *is* easy, if you are willing to use it in an orderly way; yet it can be discouragingly difficult for the person who likes to simply start out and then see what happens.

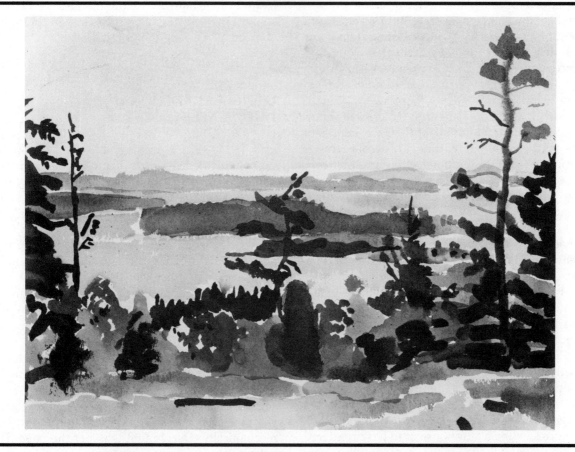

The "Mark" of
a Landscape Painter

In spring a young man's fancy turns to love, and good weather in any season turns an artist's thoughts to working out-of-doors. For some painters this is such a key factor that watercolor becomes a seasonal activity. Sargent and Homer painted on paper during the summer and on canvas in winter unless there was a trip to sunny Spain or the Bahamas. Others use watercolors year round but adapt their working habits to the weather. Patricia Tobacco Forrester paints trees in the temperate months and greenhouse flowers when it is cold, while Susan Shatter does small on-the-site studies in summer that are enlarged later in her New York studio.

Students in an art school usually get a chance to work from nature when autumn leaves turn and again when the spring flowers are out—in short, somewhere in the middle of our "watercolor course," which is where I have put this chapter. Landscape is not the place to start with watercolor, in any case, because—in contrast to an interior study—it involves unlimited space. In a landscape you must cope with hundreds of "things"—plants, trees, clouds, waves, rocks, houses—that require a tremendous amount of simplification. Thus it is a great help to have painted a cardboard box before tackling a farmhouse or to have rendered a single leafy branch before coping with a tree.

When you finally do confront the vast out-of-doors, it will be hard to avoid a few "failures," what with the sun in your eyes and ants crawling on your palette. However, there is an enormous sense of freedom which studio work cannot provide. My recommendation, then, is that after developing confidence with watercolor, you try a few landscapes and then alternate outdoor and studio subjects—the one encouraging improvisation, the other, more definite structure. Remember, too, that even in

bad weather there are exciting landscapes, cityscapes, or backyard themes to be seen through your own or a neighbor's window.

USING A TRADITIONAL LANDSCAPE FORMAT

Composing a landscape begins with proportions. Just as a strip of blue will suggest sky or water in an otherwise abstract painting, so bands of light and dark in a horizontal rectangle evoke a landscape image—sky, land, and horizon—even when there isn't a sailboat or lighthouse in sight. Turn the arrangement around vertically, and the viewer will imagine an upward thrusting pine tree, or perhaps a standing figure (see fig. 6.2).

Before you start, then, you must decide on a format. For a true *land*scape the picture will probably be horizontal with bands representing close-up and faraway space. But if certain objects interest you, a vertical *tree*scape or a squarish *barn*scape may be in order. So when you take out your sketch block, don't just work mechanically. Decide first whether the paper is to be horizontal or vertical, and then consider its proportions. If the composition you envision is narrower or squarer than the standard shape of your pad, use ruled pencil lines to define new borders for the page.

Larry Day's *Church in the Snow* (fig. 6.3) employs a classic landscape format with an economy of means that is at once characteristic of the artist's style and useful in showing us how a complicated subject can be "edited." The washes are flat, texture is lean, and the color almost entirely gray, like a Renaissance fresco in grisaille, with faint pink touches at the church doors and blackish green in the winter pines. Day also gives each spatial zone a separate treatment. The sky is a wide band of untouched paper; the foreground and distance are sharp silhouettes like collage cutouts; and the snowy

Preceding page: Fig. 6.1.
FAIRFIELD PORTER (American, 1907–1975).
From the Top, 1975.
Watercolor, 12 × 16 inches.
Courtesy Hirschl & Adler Galleries, New York.

88

Fig. 6.2.
Landscape formats.

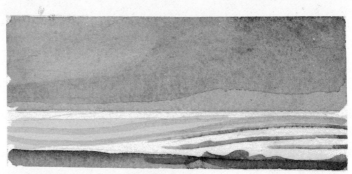

*HORIZONTAL BANDS =
LAND- or SEASCAPE*

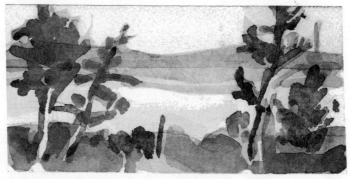

*FOREGROUND AND DISTANCE =
CLASSIC FORMAT*

HOUSESCAPES ARE BLOCKY

*A TREESCAPE IS
VERTICAL*

A FORESTSCAPE IS TANGLED

Fig. 6.3.
LARRY DAY.
Church in the Snow, 1979.
Watercolor, 18 × 22 inches.
Courtesy Gross McCleaf Gallery, Philadelphia.

graveyard in the middleground is developed as a cubist pattern of fence rails, headstones, and winding roads.

Day is best known for large oils done in a severe, dryly pigmented style reminiscent of Della Francesca and Puvis de Chavannes. The watercolors, however, are very small, and the artist sees them as "lieder" in contrast to his more "symphonic" canvases. Rather than painting on the spot, Day composes them in the studio from drawings done on location, and this is an option to consider for your own work. Day's choice of paper is also significant. Instead of the Cold Press surface most artists prefer for its "wet" look, Day works on smooth Hot Press paper which absorbs every brushmark and dries

with the irregular mottled effect you see in the tree and foreground of *Church in the Snow*. The result is a distinctively lean and ascetic paint quality that matches Day's austere imagery.

The advantage of a banded landscape format is that it organizes random objects into clear spatial zones. As a modernist, Day sees these zones as rather flat abstract shapes like the planes of a woodcut. Homer's *Flower Garden and Bungalow, Bermuda* (fig. 6.4), on the other hand, represents a more traditional approach in which foreground, middle ground, and distance are related to principles of linear and aerial perspective. Accordingly, as we see here, the horizontal bands of the landscape become narrower, paler, and more blurred as they recede.

Homer's watercolor also illustrates another important landscape convention: using soft generalized washes in the distance while developing the foreground with specific information and contrasts of extreme dark and light. Thus we observe that Homer gives primary attention to the garden up front, leaving sea and sky as flat, empty areas. And while his foliage gives the effect of jungle overgrowth, it is in fact carefully edited. One palm, a single banana plant, and a border of flowers are spotlighted, and—always "thinking white"—Homer establishes the brightness of these objects by brushing rich darks behind them.

Fairfield Porter uses a similar format in *From the Top* (fig. 6.1), but with more freedom and dash. His on-the-spot drawing is rhythmic but uncomplicated, and everything is done with spontaneous brushmarks. Nevertheless, the

washes, however casual in appearance, are arranged in a classic landscape structure. Foreground, middle ground, and distance are shown in layers like stage "drops," strong darks are kept up front, and distant hills get thinner and lighter as they fade from view.

Porter (1907–1975) had an unusual career. Known first as an art collector with a circle of friends like de Kooning and Bernard Berenson, he became a critic for *Art News* and then, in his forties, began to win a reputation for his own work, which has steadily grown in importance. He is a particularly good role model for art students because, though a sensitive painter, his technique is quite simple and within the average person's reach.

From the Top typifies Porter's modest small-scale approach. On such a 12-by-16-inch paper you can complete a sketch in an afternoon and

Fig. 6.4.
Winslow Homer (American, 1836–1910).
Flower Garden and Bungalow, Bermuda, 1899.
Watercolor, 14 × 21 inches.
The Metropolitan Museum of Art, Amelia B. Lazarus Fund, 1910.

translate dimensional objects like pine trees into fluid brush marks. This is a far cry from the monumental work of a Pearlstein or Brady, but it is the traditional stance of watercolor landscapists from Boudin to Marin and the direction you should take at the outset. Theoretically, any subject can be painted either boldly or with cautious detail. In practice, however, you will find it much easier to be carefree with sun-dappled greenery than with a studio set-up.

BRUSHMARK TECHNIQUES

The painter's "mark" is as unique as a thumbprint. And Mary Frank's *Lily Pond* (fig. 6.5) demonstrates the personal force that can be generated by a few authoritative brushstrokes. Done with colored inks, the picture is reminiscent of Japanese calligraphy, but where an Oriental artist might rely on symbolic conventions, Frank makes her own discoveries, whether in the field for which she is best known—sculpture—or in numerous monotypes and paintings on paper. This is a personally observed image: the single flower stalk, surrounded by lily pads, defined with with no more than a dozen thrusts of the brush, and each mark shaped in kinetic as well as visual response to the subject.

There is no clear-cut division between the wash technique discussed earlier and the brushmarks we are exploring here, and in practice you may want to start a landscape with "washes" for sky and land and then shift to "marks" to indicate things like trees and shrubbery. In general, however, washes are broad,

Fig. 6.5.
MARY FRANK.
Lily Pond, 1980.
Colored ink on paper, 19⅞ × 25½ inches.
Courtesy Zabriskie Gallery, New York.

smooth passages floated between carefully drawn boundaries, whereas marks are a single stroke in width and convey a sense of the brush—rather than a pencil—as the artist's drawing instrument.

Technically, working with marks is like painting washes, only easier. The brush should be loaded with a firm pigment solution and, although there is an impression of speed, strokes are best done slowly so that fluid can flow evenly onto the paper. And there is no need, as with a large wash, to smooth things out by sucking up excess fluid. As we see in Frank's *Lily Pond*, puddles, drips, and splashes can add textural richness and heighten our awareness of the watercolor as a gestural "process."

Historically, some watercolorists, like Homer and Sargent, have preferred a broad wash style while others have relied primarily on built-up marks and "touches." Eakins's strokes, for example, are small, dark, and busily layered; Cézanne's, pale and impersonal; and John Marin's marks, in a watercolor like *Sunset, Maine, Off Cape Split* (fig. 6.6) have a wonderful expressionist vehemence. The artist observes ocean waves whipped by the wind and translates the experience into animated stabs of the brush.

"Translation" is a key concept here. Whereas a wash can be mixed so that it matches a color in nature, marks are more abstract, and you must learn to use them as equivalents, rather than literal statements of what you see. Mary Frank's method, for instance, is to outline her lily pads with a free-brush contour, and this can be effective when your subject has a few large elements.

Fig. 6.6.
JOHN MARIN (American, 1870–1953).
Sunset, Maine, Off Cape Split, 1948.
Watercolor, 10⅜ × 13⁹⁄₁₆ inches.
Courtesy Hirschl & Adler Galleries, New York.

Fig. 6.7.
Malcolm Morley.
Beach No. 3, 1982.
Watercolor, 24 × 28 inches.
Courtesy Xavier Fourçade, Inc., New York.

Fig. 6.8.
John Singer Sargent (American, 1856–1925).
Sky and Mountains, ca. 1908.
Watercolor, 14 × 20 inches.
The Metropolitan Museum of Art, Gift of Mrs. Francis Ormond, 1950.

For a more typical panoramic landscape, however, Marin's approach in *Sunset, Maine* might be more useful. With a vast open space as his subject, the artist uses brushmarks to create texture and movement. Sky and sea are zones of equal weight except for wildly contrasting motifs painted above and below a slightly tipsy horizon line—the waves indicated by frenzily stabbed half-moon shapes like cartoon raindrops and a threatening sky suggested by diagonal strokes overhung with a rippling curtain of clouds. Although Marin "draws" with his brush, the effect is painterly rather than linear, because the gestural repetition of marks, one over another, creates a richly textured spatial field. Painterly nuances are also encouraged by extremely rough paper that can turn a swift stroke into a dry-brush mark and a slow one into a stagnant pool.

The bottom line in working with marks is to be able to simplify boldly while at the same time evoking your subject convincingly. Nothing is more tiresome than the predictable style of an artist with a certain stroke for grass, another for flowers, and still another for trees and houses.

In *Beach No. 3* (fig. 6.7) Malcolm Morley shows how to avoid that trap simply by looking intently at the subject. This is a marvelously involved watercolor in which brushmarks are handled quite differently than in the work of Frank and Marin. Instead of expressionist gestures, Morley gives us strokes that correspond to the objects and bits of color he is looking at: a brown mark to represent a suntanned figure, a smear of blue to suggest a bikini, and striped marks to suggest a T-shirt or beach umbrella. The painting has the charm of a Dufy or of folk art, but without decorative clichés, since each of literally dozens of bathers is a closely observed individual rather than a mere generalized type.

Finally, let's look at a Sargent watercolor done in a more realistic vein, *Sky and Mountains* (fig. 6.8). The panoramic view is like Marin's, and Sargent uses a similar linear motif—in this case, bubbling curves that rise upward like steam from a cauldron. But the arbitrary initial "scheme" is modified by the artist's sensitive response to such visual sensations as *smooth* blue sky, *murky* clouds, and *harsh* mountain crags. And though Sargent uses brushmarks with a good deal of flourish, he blends them, freestyle fashion, with flat and graded washes

and even some dry-brush work. The watercolor is stunning, and as a mixed bag of tricks it may be just the right model for your first landscape ventures.

MODERNIST LANDSCAPE IDIOMS

The paradox of landscape painting is that infinite space is depicted on a finite flat surface. The classic format, as we have seen, resolves the contradiction by simplifying vistas into near and far zones, like friezes, parallel to the picture plane. This approach, used since the Renaissance, is by no means out-of-date. If anything, it has been revitalized by interest in photography and wide-screen cinema.

Yet there are other ways of looking at landscape, and the strategy of Cézanne and the Post Impressionists is especially important. I call this the "bas relief principle" because a typical Cézanne, like *Trees and Rocks No. 2* (fig. 6.9), is conceived like a design lightly cut into a flat surface. Positive objects (the trees) are outlined, and then negative spaces are scooped out by small strokes that seem to recede but never actually go back very far. Here the foreground is unpainted, and there is no real background, because solid areas, like an identifiable blue sky, are studiously avoided. Furthermore, the horizontals and verticals of a realistic landscape illusion are eliminated in favor of a network of diagonals that has no horizon line or specific gravity.

This is the language of abstraction, or "significant form" as the critic Roger Fry called it, which dominated modern art after 1910. Instead of imitating nature, painters from Demuth to de Kooning learned to translate it into pictorial equivalents which could then be rearranged at will. The key to this translation—or "analysis" in Cubist parlance—was the separate brushmark that could reduce coherent objects like trees and mountains to disconnected small planes. Cézanne fathered these ideas and was largely responsible for the emergence of a modernist watercolor style based on little touches rather than conventional broad washes.

Aside from its esthetic importance, Cézanne's technique can be helpful on a purely

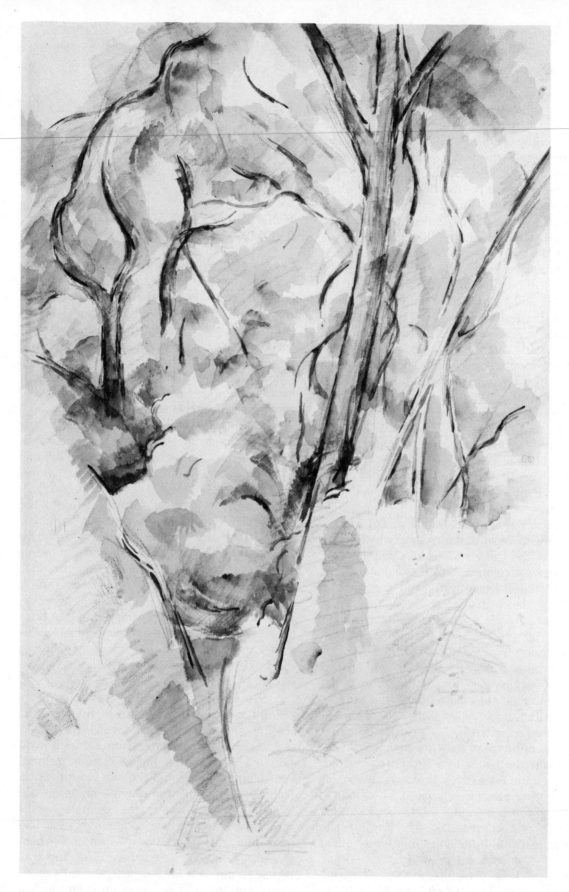

Fig. 6.9.
PAUL CÉZANNE (French, 1839–1906).
Trees and Rocks No. 2, ca. 1900.
Watercolor, 17¼ × 11⅛ inches.
Philadelphia Museum of Art, Samuel S. White III and Vera White Collection.

Facing page: Fig. 6.10.
A Modernist landscape format.
"Open" brushmarks in a shallow space
rather than traditional foreground and distance.

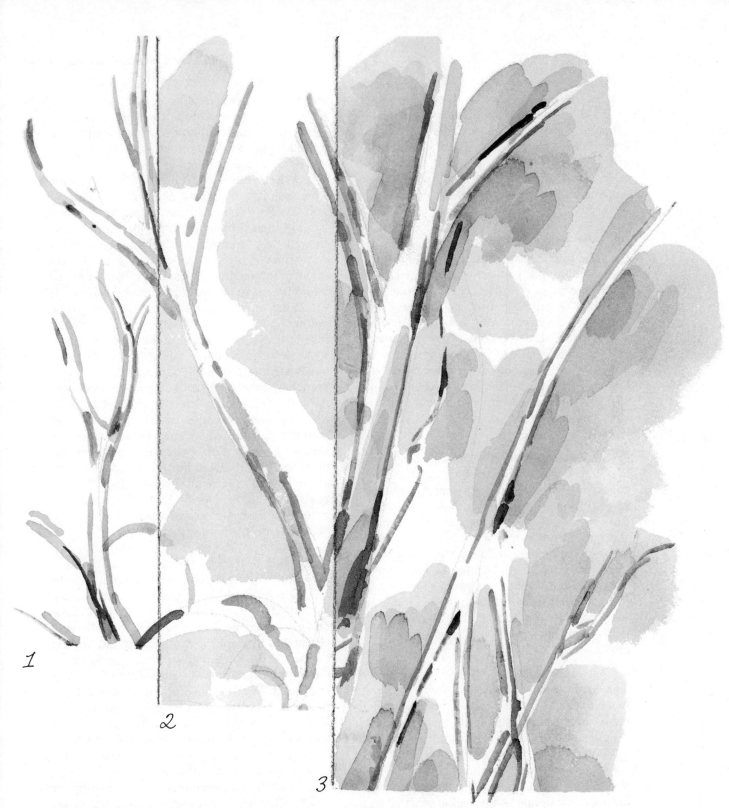

1 *PAINTERLY BRUSH DRAWING—Lines broken into short varicolored segments*

2 *FIRST WASHES—Attached to line on one side, open on the other*

3 *SECOND AND THIRD WASHES—Smaller but also attached on one side*

practical level. Whereas Homer shows you how to work with clean-cut washes extending coherently across the page, Cézanne is a guide to handling disconnected, spontaneous marks and jottings—the kind of situation a beginner often encounters. If you want to simplify your watercolor life, three of Cézanne's principles should be noted:

1. *Don't try to "finish" a watercolor.* In a Cézanne the image grows organically from the first pencil marks, gains strength from accumulated touches of color, and may be considered "finished" at any time. Such an approach helps you avoid overworking a good start, and it is useful in landscape sessions where time is short and you are after an impression rather than details. The trick is to scatter your marks over the page from the outset, leaving rhythmic passages of untouched paper throughout. At all costs, avoid "clotting" the image with too much work in any one place.

2. *Draw painterly contours.* Smooth washes between pencil boundaries create their own edges. On the other hand, a sketchy style may require some painted outlines like those Cézanne used for his trees. The thing to remember here is that a continuous dark line around an object will register as "draftsmanship" and stand out like a sore thumb. Instead, use Cézanne's system of short, broken-contour brushstrokes done in varied tones and with separate directional thrusts. These will mesh with other marks and thus seem "painterly."

3. *Shade with tonal clusters.* Everyone enjoys fresh spots of color set down freely on white paper. A problem arises, however, when these separate impulses must be unified. One simple way of connecting marks is to paint them in a tonal cluster. This consists of two or three color spots laid over one another so that they shade from light to dark and from vagueness on one side to a definite edge on the other (see fig. 6.10).

Although Cézanne's delicate, improvisatory style influenced early modernists like Demuth and Marin, there is a current shift away from it. On the whole, today's watercolors are larger, more heavily painted, and tend to avoid any hint of sketchiness or easy charm. At the same time, the Cézanne concept of abstract form—the compression of observed reality into a shallow pictorial space like a bas relief—is as widely accepted as ever.

We see this in the innovative work of such watercolorists as Susan Shatter and Patricia Tobacco Forrester. Both have been called realists, yet their primary concerns are formal. And though they have intense feeling for the landscape image, it is expressed in a modernist idiom of interacting planes rather than the traditional language of foreground and distance.

Like many contemporary artists, these painters are identified with highly personal imagery: Shatter works with views of water and rocks seen from above, while Forrester's strategy is a frontal tableau of densely interlaced tree branches. In each case the choice of free-form natural shapes lends itself to abstract patterning, and the advantages of this kind of visual material should be kept in mind on your own sketching trips. With rocks and trees there are no absolute verticals or horizontals to cope with as there are with regular objects like houses, boats, and silos. Nor is there anything that requires a perspective drawing or that can't be bent into an interesting shape.

Swirling Water (pl. 10) demonstrates Shatter's ability to transform observed reality into a powerful abstract statement. With a similar subject, Homer would have given us a comparably forceful design, but in the context of Renaissance perspective. Here spatial depth is largely eliminated by omitting the horizon and tipping the scene up toward the picture glass, like a topographical map in an atlas. One of the earmarks of a Cézannesque format, incidentally, is that it minimizes the viewer's sense of sky, land, and gravity, and if you turn this picture around, you will find it reasonably coherent from all four sides. Notice, too, that Shatter divides her visual material like a two-part musical form into antiphonal zones—rough-cut rocks at the lower left and churning waves on the upper right. These twin motifs are also developed as complements: the rocky shore as a light area climaxing in black shadows near the center of the picture, and the sea as a wine-dark shape erupting in furious foam.

Shatter's watercolors bridge two worlds: the tradition of small sketches done on one's

travels, and the eighties scene of momumental studio compositions. She does both supremely well and is thus an artist of interest to both advanced watercolorists and those starting out. Actually, the small studies—painted during Maine summers, or on visits to the Cycladic Islands, the Grand Canyon, or Mexico—serve both as independent works and as models for large watercolors and oils. At the end of such a location trip, Shatter photographs each site and, upon returning to her New York studio, she uses both the camera record and the small watercolor version of a scene in developing a full-scale composition. First accurate informational details are drawn in pencil from a 2-by-2-inch slide projection. Then color is freely brushed on according to the creative rhythms of the original on-the-spot sketch.

For her major opuses, Shatter installed an enormous table but found that working flat prevented her from seeing the image properly. She now paints standing up, with a roomful of huge watercolors in various stages of completion taped to the walls. What makes this technically possible is her discovery of an unusual paper which, unfortunately, is not available on the retail market. A cotton rag vellum with a curling thread in it, this stock has the special advantage of being *extremely* absorbent, so that as eight or ten layers of washes are built up with a broad Japanese paddle brush, the color is sucked into the paper instead of dripping down the wall. The result is a richly blurred effect that makes Shatter's watercolors unique. If you want to attempt this kind of texture, at least on a small scale, you might try Oriental rice paper or a fiberglass paper called Aquarius.

Forrester is a Washington, D. C., artist who is deeply committed both to the watercolor medium and to direct painting. "I did my last oil painting in 1973," she says decisively, and goes on to describe logistics developed to overcome practical problems on field trips. She carries three things: on her back, a pack of painting materials and a water supply; in one hand, a light table-easel with adjustable top and extension legs; and in the other, flat sheets of 27-by-40-inch Double Elephant paper in a huge plastic baggy which, though wind catching, is less cumbersome than a portfolio.

What I find truly amazing is the vision of this tall woman braving the elements while standing at a small board propped on stork-thin wooden legs and attacking an enormous piece of paper flopped over the top of it. Her picture is lightly pinned with a single thumbtack, since if it blows away it can be retrieved without tearing (as it might do with a firmer mooring). To hold the paper down, she plops a heavy china palette on it and, while painting the upper part, dangles the bottom half in front of her, wrapped for protection in a plastic bag. When she moves to the lower section, the process must be reversed, with the paper hanging down in back. To further complicate matters, Forrester's compositions often extend over several sheets of paper, and this means that she must keep switching from one huge page to another in order to match up the edges.

EDITING LANDSCAPES IN THE STUDIO

Forrester has learned to separate the spontaneous outdoor painting experience from the studio editing process, and this is a principle you might well apply in your own work. She starts with a mental picture of certain muscular tree shapes and an effect of light, such as the bluishness undershot with gold in *Winter Beech* (pl. 11). On the spot, then, she paints dominant branch formations with watery puddles into which she drips variegated colors. There is no pencil drawing, and these improvised washes are at first disconnected shapes on the blank paper, like bits of glass laid in a mosaic with the interstices yet to be filled in.

It is precisely this "filling in" that Forrester does in the studio. This time she is an editor shaping freehand notes into a tight formal structure. The edges of each branch are clarified with shadings from dark to light, and a delicate network of distant branches is laid in to give contrast and a touch of fantasy. Above all, the finishing process provides a deep background which functions, like the leading of a stained glass window, as a setting for the jewel-like brilliance of the original color notes made from nature.

These are somewhat specialized procedures, but you will find it generally helpful to

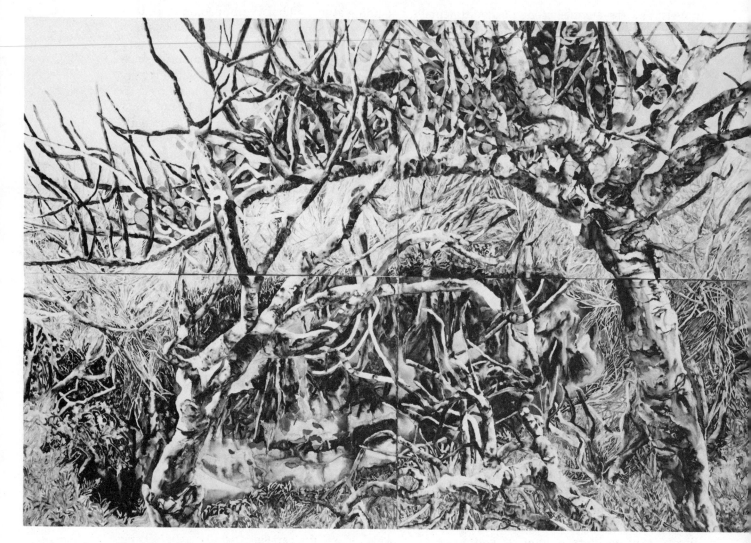

Fig. 6.11.
PATRICIA TOBACCO FORRESTER.
Ravens, Trees, and Pond, 1980.
Watercolor, 51½ × 80 inches, in four panels.
Courtesy Kornblee Gallery, New York.

reevaluate a watercolor done outdoors in an indoor light, studying it from across the room, and perhaps making revisions. Forrester's other idea—that of using several papers in a single composition—is also worth exploring if you are interested in increasing the scale of your work. *Ravens, Trees, and Pond* (fig. 6.11), for example, shows four Double Elephant sheets framed under plexiglass 80 inches wide. Although this is a bit on the colossal side, four sheets of standard 22-by-30-inch paper can be combined in a handsome and entirely manageable 44-by-60-

inch format. Standard sheets are also easy to work with outdoors, and in the 300-lb. weight, they will not warp as anything larger is almost bound to do.

The technical term for what we are talking about is the *polyptych*, or multiple image, and its panels may be combined in various ways. A two-part picture, called a *diptych*, is a traditional Adam and Eve arrangement. The three-part composition, or *triptych*, was used in Renaissance altarpieces, often with the Lord on a central panel and saints on foldout wings.

Forrester's four-part compositions, like *Winter Beech*, give the polyptych form a Cubist logic by cutting the main subject down the middle. The artist has also worked with papers in a horizontal row reading sequentially like an Oriental scroll.

Thus, combining watercolor papers offers exciting possibilities, not only for landscape paintings, but for other subjects and nonobjective work as well. An intriguing question is the extent to which panel divisions in such a format should be emphasized or minimized. Forrester uses subtle variations of shading at the intersections, but the multipaper strategy invites more abstract treatment. One could even go so far as to tone each panel a different color.

FIELD TRIP STRATEGIES

This chapter has described the work of watercolorists whose ideas and techniques might suggest interesting possibilities for your own work. As you march off into the sunset (or twilight or dawn), remember that the important thing is to undertake each landscape project with a sense of specific purpose. And tuck this list of practical suggestions into your back pack:

1. Take along the paper viewfinder discussed in chapter 4. It will be as useful in landscape as in still life painting.

2. Remember that *landscape* is a general term. Your actual subject will be a seascape, barnscape, valleyscape, treescape, gardenscape, or even a cityscape. Pin down your theme before you start to work.

3. Turn your paper the right way (trees are tall, fields wide) and make objects either small, if you are after space, or sufficiently large, if they are the main subject.

4. Since your last brushmark will seem to be in front of everything else, paint the distant sky and hills before putting the tree or barn in the foreground.

5. Pay special attention to the narrow strip of trees and buildings that is farthest away. Everyone paints what is up front, but there are small things happening on the last hill that will make the space in your picture convincing.

6. Use stronger colors than instinct advises. Paintings seem much brighter outdoors than when you bring them home.

7. When you are discouraged, remember that whatever goes wrong outside can be rectified by intelligent afterthoughts in the studio.

Wet-in-Wet Techniques

When pigments are applied to premoistened paper, they fan out into blurred effects that are excitingly variable, yet more controllable than you might suppose. The nature of the control, however, is more indirect than in painting on dry paper, where an experienced artist can produce a wash pretty much according to plan. In wet work, only the general effect can be counted on. There are always accidents, happy or otherwise, and the secret of success is learning to "ride" with the dynamics of a wash that is in continuing motion after you have brushed it on, while at the same time "reining it in" so that colors spread in the right direction and blend without entirely melting away.

The experience is like playing with one of those toy wind-up cars. You can't actually steer it, but you can control its speed, distance, and direction by the tightness of the winder and the slant of the surface you put it on. Similar variables affect the capillary action of watercolor pigment when it hits wet paper—the amount of moisture, whether the page has been tubbed or spot-dampened, and of course the angle of the drawing board.

Most watercolorists work basically on dry paper, as you have been learning to do, with occasional areas that, in the interest of variety or in haste, are painted while damp. In his little *Cityscape* (fig. 7.2), for instance, John Marin has permitted water to collect in a puddle at the lower left and allowed some of the buildings above to dissolve into the sky. Doubtless you have already had a similar experience with not-quite-dry spots where colors run together attractively in a small space.

In this chapter, however, we will be looking at painters for whom wet work is a primary concern, and you will be asked to take a running dive and full plunge into wet-in-wet technique rather than merely easing into it.

Actually, there are three ways of getting into the swim: you can premoisten separate areas so that color goes on with velvety smoothness, you can use paper that is evenly wet all over, or you can work with standing puddles that dry like tie-dye fabrics. Each approach is distinctive. I suggest you try them all, perhaps starting with tub-soaked paper, since this is the exact opposite of the dry surface you are used to, and then working back toward situations in which only certain areas are moistened.

PAINTING INTO PREMOISTENED AREAS

Every Sunday in good weather Fred Mitchell makes three round trips, starting at dawn, on the Staten Island Ferry. He brings along a 24-color paint box, a water jar, and a 12-by-16-inch sketch block. By now the deck attendants know him and keep the public away while he paints. Mitchell's watercolors are rather like John Marin's Manhattan cityscapes, although more abstract. *Ferry to Staten Island* (fig. 7.3), for example, has misty references to the sun rising in a half-circle, a ship's rail, and a life preserver. Another watercolor, *All the Way Across* (pl. 23), distills the experience of an airplane trip to California into a pattern of eight rectangles that suggest land patterns in a sequence of changing time zones.

A native of Meridian, Mississippi, Mitchell says that whereas watercolor is considered a difficult and somewhat specialized subject in northern art schools, southern artists start with it. For him, watercolor has become what drawing is for many painters, a vehicle for exploring visual ideas to be developed later on a larger scale in oils.

What makes Mitchell's work pertinent to this discussion, however, is his method of feeling out space with clear water before applying pigment. Unlike most watercolorists, he uses no pencil lines and draws entirely with a brush dip-

Preceding page: Fig. 7.1.
NATALIE BIESER.
Tecata, 1981.
Watercolor, 22 × 30 inches.
Courtesy Nancy Hoffman Gallery, New York.

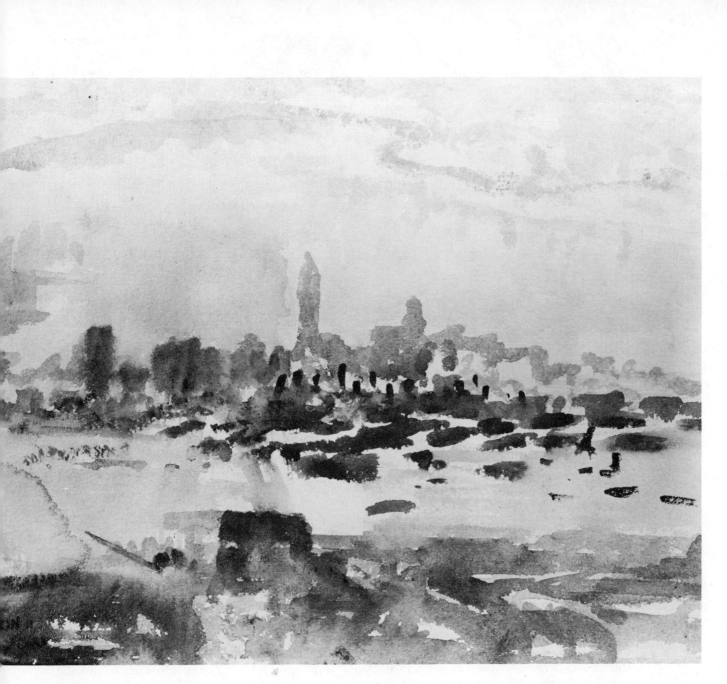

Fig. 7.2.
JOHN MARIN (American, 1870–1953).
Cityscape, 1911.
Watercolor, 8⅝ × 11⁹⁄₁₆ inches.
Courtesy Hirschl & Adler Galleries, Inc., New York.

Fig. 7.3.
FRED MITCHELL.
Ferry to Staten Island, 1982.
Watercolor, 12 × 16 inches.
Courtesy Buecker & Harpsichords, New York.

ped in colorless water. This is a rather mystical process, like writing with invisible ink, because you create an image which exists even though it is without substance. Still, the watery ghost-shapes can be studied thoughtfully and enlarged or altered to your satisfaction before they are fleshed out with color. And if you really don't like a shape, you can let the paper dry and start over again.

The main advantage of a clear water base is that pigments applied to it spread out with the swift smoothness of dye drops splashed into a pool. In *Ferry to Staten Island* Mitchell's sky has been shaped first with water and then touched with intense Cyanine Blue which fans out, blurs, and then fades into a pale glissando. Similarly, the rectangles in *All the Way Across* are defined by corners of red, yellow, and blue that dissolve with a "swoosh" into clear water. Such dramatic shading, and the textural elegance of pigment settling like silt in the paper's hollows, cannot be imitated by "straight" technique. This is because wet-on-dry painting requires the application of a ready-mixed color solution, whereas wet work encourages pigments to mingle spontaneously on the paper and, in a sense, paint themselves.

For Mitchell, wet-in-wet painting is as natural as skinny dipping. He uses it casually, along with "dry" passages, in small-scale works where effects are achieved immediately. The Philadelphia artist Elizabeth Osborne, on the other hand, shows us how the same principle can be used in a more systematic way. Her papers are large, severely designed, and handsomely crafted as "finished" compositions rather than informal sketches.

Like Mitchell, Osborne develops a picture area by area, putting down water first in order to "float" the color on. As we see in *Nava Standing* (fig. 7.4), however, the areas she works with are more sharply defined. Here all visual elements—landscape hills, architectural motifs, sofa cushions, dress patterns, and figural references to hair, face, and hands—are reduced to flat shapes bounded by immaculate pencil lines.

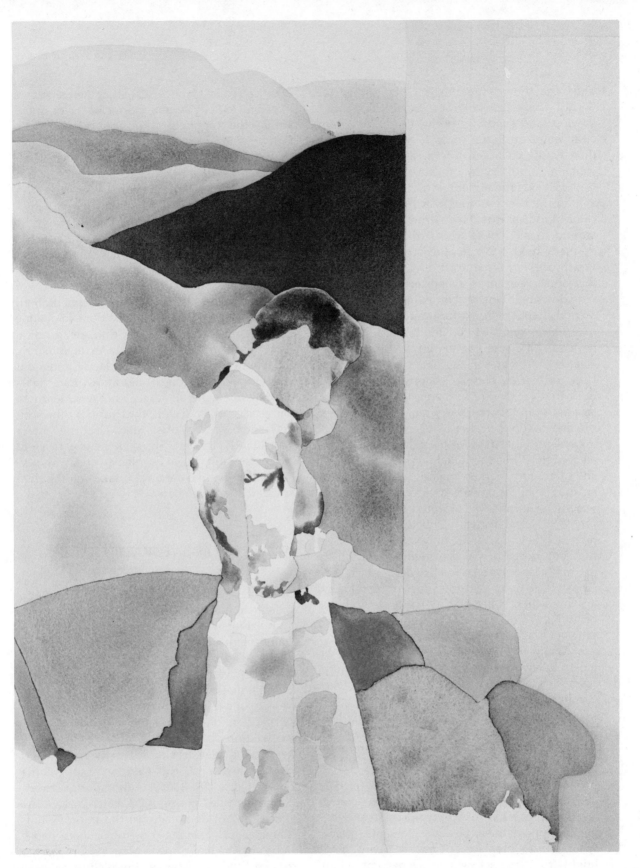

Fig. 7.4.
ELIZABETH OSBORNE.
Nava Standing, 1974.
Watercolor, 30 × 22½ inches.
Philadelphia Museum of Art, Women's Committee gift in Memory of Mrs. Morris Wenger.

Thus the drawn contours act like the metal "walls" into which colored enamels are poured in cloisonné work. Osborne carefully paints clear water up to her intricate pencil lines and then floods color into the area which will be contained until dry by capillary action.

Her edge treatment is particularly noticeable in the sofa cushions which are formed by color puddles that have dried with "rings" around them. Artists who work on dry paper normally hold it at a slant to provide drainage. Wet processes, in contrast, are based on color that spreads in all directions rather than running downhill. Thus Osborne finds a horizontal painting table more appropriate for her work.

On a level surface, standing puddles can be made to create various effects as they dry (see fig. 7.5). Later in this chapter we shall see how, in Natalie Bieser's watercolors, pools of color that are over-full evaporate with irregular striations and dark crusty edges. Osborne's preference, on the other hand, is an even coating of liquid that dries with a delicately accentuated edge. While the initial wash is still damp, she often adds darker touches to create subtle shading. She also likes to give richness and weight to an area by repeated overlays, each time with clear water followed by more pigment. Sometimes this is done in a contrasting hue, but more often in the original color which gradually takes on a patina like a ceramic glaze. Finally, one notes that the edges of her shapes are intensified either by tiny white separations (as in Nava's necklace) or by thin dark overlappings of washes (as in the sofa pillows).

Using wet technique in discrete areas is most effective when moist foggy passages are contrasted with either clean paper or crisp, lightly tinted washes. In short, this is a highly selective process in which a few jewel-like shapes are showcased, and if your intent is overall richness, you might better start with paper that has been completely soaked.

Osborne's *Still Life with Black Vase* (pl. 12) demonstrates the kind of editing that is needed and the importance of empty space. Typically, her sharply defined positive elements—black vase, brown fireplace, purple eggplant, and bright fruit—are set against evanescent white space. There is only the faintest tonal difference between table and walls, and Osborne often makes such a distinction with a band of thin acrylic next to a band of watercolor in an almost

identical color. Notice also that her shadows have blurred edges, and a principal actor in the scene—the Angora cat—has been dissolved into fluffy white vagueness. (To do amorphous shadows like this, simply paint on clear water and then touch the center with a stroke or two of color. As the pigment fans outward, you can also blot the area with tissue to prevent edges from firming up or spreading too far.)

In any case, this picture's "zing" comes from the contrast between such subtleties and the boldness of the black vase. Certain technical niceties also contribute to a brilliant effect. For one thing, the vase's white-line ornamentation, which could so easily have been done in opaque gouache, has been "left." A difficult technical feat, this is crucial esthetically in maintaining the continuity of the paper surface throughout the composition. You should know, too, that—despite my general advice that you learn to paint black objects with a mixture of other colors—some watercolorists, like Osborne, prefer actual black pigment. She says the way to avoid a lackluster effect is to burnish an area with several wet-in-wet layers until it takes on the density and sheen of ebony.

WORKING ON SATURATED PAPER

Painting into wet areas that have been purposely premoistened or that retain dampness from earlier washes is a common practice. Not many major watercolorists, however, work on fully soaked paper, even though this is one of the most creative processes you can experience and one that is unique to the medium. Perhaps watercolor's traditional association with realism has been an inhibiting factor, since letting colors run wild on damp paper is about as "realistic" as shooting fireworks into the sky.

At any rate, the German Expressionist George Grosz (1893-1959) is an important exception to the rule, and his 1934 watercolor *Punishment* (fig. 7.6) demonstrates the improvisatory character of painting on tub-soaked paper. Done after he had come to New York to teach at the Art Students League, the picture recreates the strafing and firebombing of World War I which still haunted the memory of an artist famous for Swiftian drawings of social corruption during the twenties.

Fig. 7.5.
Painting into premoistened areas.

SOFTEN EDGES with clear water

CREATE "PROCESS" TEXTURES with back-up puddles

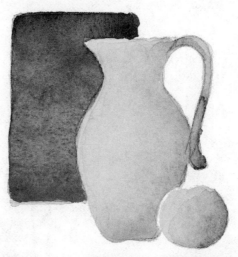

FIRM UP FLAT PLANES with repeated layers

ACHIEVE SUBTLE SHADING with several wet-in-wet overlays

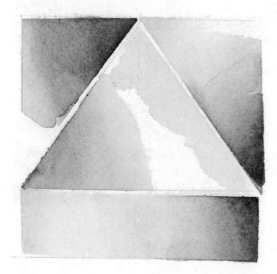

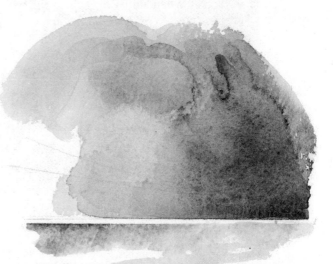

DRAMATIZE PLANES by shading from a dark, firm edge, to a light one dissolved with water

CREATE ATMOSPHERIC EFFECTS with large wet washes retouched with small darks

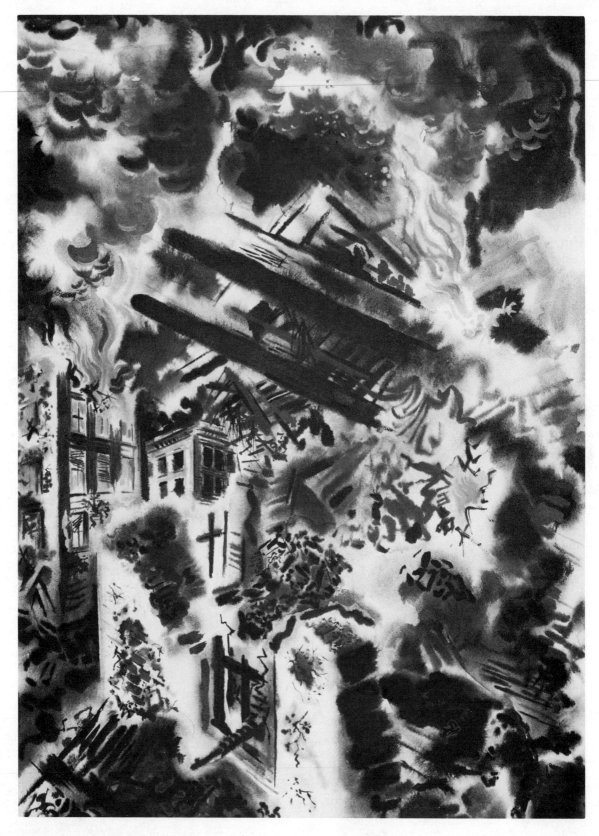

Fig. 7.6.
GEORGE GROSZ (German, 1893–1959).
Punishment, 1934.
Watercolor, 27½ × 20½ inches.
Museum of Modern Art, New York, Gift of Mr. and Mrs. Erich Cohn.

Look at Grosz's watercolor carefully, and you can visualize his working methods and how you yourself might paint in this idiom. In wet work the subject must be vaguely imagined at first and then gradually brought into focus. Thus you start with paper that is sopping wet from top to bottom. After blotting up excess surface water with tissue or a towel, you brush in basic colors: here orange and yellow for flames, cerulean for the sky, and ochres for buildings. But even as you work, the marks dissolve into a blur. Fifteen or twenty minutes later, the paper is damp but no longer fully wet and you start over. This time the flames must be intensified with deeper oranges and reds and the blues in the sky strengthened. Colors still spread out, but not so far. Finally, when the paper is almost dry, it is ready for umber shadows and the small darks that will define edges and add an element of drawing.

Although my current style is different, I worked in this way for many years, beginning each morning with a blurred image that was sharpened up by evening. Our one bathtub was regularly out of commission while paper soaked overnight, and often the day's achievement went back into the tub for a second soaking and a fresh start. This is an exciting process comparable to roughing out a figure in stone before envisioning where a face or hand might emerge, and the beauty of it is that the rhythmic sequence of your marks and thought processes is evident in the finished piece.

It is also a technique that yields splendid results for the beginning painter as long as two simple principles are understood:

1. *There must always be more water in the paper than on it.* When standing moisture is visible on the page, brushmarks dilute instantly and trickle about aimlessly. On the other hand, a paper with wet interior fibers but an evaporated surface encourages pigments to spread evenly in a coherent formation. So soak your paper (or sponge it, if it is stretched) for a long time, and either let it settle until the glittering wetness has disappeared or remove surface water with a blotting device before starting to paint. Remember, too, that every brushstroke you make adds not only pigment but also more liquid which must be given time to sink in before you can return to the area. They say curi-

osity killed the cat. I don't know about that, but in wet-in-wet painting impatience can kill the most promising start.

2. *This is a progressive rather than a one-time process.* Each section of your watercolor must be approached with the thought of returning to it again, and perhaps a third or fourth time. Keep a color sequence in mind—for example, yellow first, followed by ochre and then greenish bronze; or a bluish chord like cerulean, cyanine blue, and ultramarine. And your initial washes should be broad, with later smaller strokes anticipated, as in Grosz's painting.

Although this has the sound of advice given in earlier chapters, there is a practical difference here. In classic technique admirable effects can be achieved with a single wash, and if another is needed, you always know when the paper is sufficiently dry. In wet work, on the other hand, almost nothing can be completed in a single thrust. Anything that looks good at first will soon melt away, and yet the necessary second layer cannot be applied immediately. You must wait until the surface is drier than in the first go-round, but still damp. This timing is as crucial as taking an omelette off the stove at the right moment.

Fortunately, both stiff and runny omelettes have their charms and so do watercolors in various degrees of wetness. As I have suggested, working *too* wet is the usual error, but sometimes there is the opposite problem of maintaining sufficient moisture. For this purpose an atomizer, such as a clothes dampener, comes in handy, and I like to work on paper laid over a wet turkish towel so that moisture seeps through from underneath.

There are also devices for correcting or revising a wet watercolor that you may want to try. After drying out, a brightly colored paper can be soaked again and repainted in darker tones or even opposite hues. A painting can also be toned down in midstream with strokes of a sponge and then built up again. Charles Schmidt sometimes reworks a picture after putting it under the faucet and scrubbing the whole surface with a bristle brush until a silvery "ghost image" emerges.

Ultimately you may want to firm up a vague wet-wash image with a line drawing of

Fig. 7.7.
GEORGE GROSZ (German, 1893–1959).
*Maid Arranging Hair of
Corpulent Woman*, ca. 1934.
Watercolor, 27½ × 20½ inches.
Philadelphia Museum of Art, Gift of Bernard Davis.

some kind. In another of his satirical water-colors, *Maid Arranging Hair of Corpulent Woman* (fig. 7.7), Grosz does this with a delicate brush drawing painted in after the initial pastel-toned washes have dried.

Most artists, in any case, rely on a preliminary pencil drawing done before the paper is soaked. The graphite lines show through subsequent washes as a guide for the finished painting. An India ink drawing, applied at the end, is another possibility, and you will get interesting results with an old-fashioned wooden kitchen match. Dip the nonflammable end into the ink and use both the sides of the match for textures and the point for contours. A clean matchstick will also scratch out white incised lines in a wet-in-wet passage while it is still damp. (For a description of this technique, see chapter 11.)

OVERPAINTING WET-IN-WET WORK

Painting on dampened paper has two quite opposite functions. When used alone, it encourages the kind of expressionism we have seen in Grosz's work. Alternatively, however, it may be employed as the first stage in a picture to be finished with layers of realistically detailed overpainting.

Charles Schmidt is a past master of the latter technique. He sees watercolor as a "tiger to be tamed."[1] By this he means letting wet work run wild at the outset and then—after the paper is thoroughly dry—starting over, with every

[1]Charles Schmidt, "The Watercolor Page," *American Artist* 41, no. 423 (October 1977), 62-64, 94-96.

trick up one's sleeve, to give the page coherent shape, while at the same time preserving the initial energy. Thus the *underpainting* becomes the "id" and the *overpainting* the "ego" in a fascinating interplay of expansive and contractive strategies. Although Schmidt's technique in a picture like *The Disc* (pl. 14) is elaborate, his basic concept of a free wet underpainting followed by a more sharply defined second layer can be used successfully by the beginning watercolorist.

You will need to start with an appropriate subject. Wet-in-wet painting normally calls for vivid colors, as in Grosz's picture of bombs bursting in air. When used as an underpainting, however, it is largely a textural expression that works best with objects of muted color and worn, pitted, or splotchy surfaces. Schmidt is attracted by Roman ruins and abandoned factories where corrosion transforms mundane objects into forms that are at once abstract and a little strange. And he collects everything from antique tools and fossils to junk. The imagery of *The Disc*, for example, includes such oddments as architect's dividers, the faceplate from a quarry scale, a barn pulley, a brass pendulum, the ring from a horse's harness, and a pair of ornamental plasterer's templates.

Such visual material—discarded stuff with a sense of history, displacement, and deformation—is a vital resource for the art student. It is easy to come by if you think in terms of "found objects" rather than collectibles. In the city, a walk around the block on trash day will yield material for a set-up, while at the shore marvelous things can be found in the sand—rusty strips of metal, bleached and tarred boards, and bottles worn by the sea. The advantage of things like these is that they offer representational challenges, while at the same time encouraging abstract design since nothing "goes together" in the conventional still life sense.

When it comes to arranging such objects, the simplest principle is best. Just lay them on a table or, as Schmidt does in *The Disc*, hang them on a wall. By keeping the table or wall parallel to the picture plane, you can move things about like pieces on a checkerboard, composing them as flat shapes seen from above without complicated foreshortening. In general, it is wise to keep the composition open, with space for background washes to spread out, and to punctuate it with small objects that will provide interesting detail in the overpainting. Linear elements like string, straps, tape, and nails are also helpful. Schmidt's grid of bent wires, for instance, defines the space architecturally—he even hangs things on it—while permitting the artist to draw free-form lines with whatever twists and turns the design calls for.

Your wet-in-wet underpainting should be equally simple and direct. Since details will be developed later in an overpainting, it can be left in a generalized, blurred state, without much retouching. At the same time, it should be done with a sense of purpose and deal clearly with three pictorial elements:

1. *Local Color*. Most set-ups include certain objects of distinct hue. Schmidt's painting, for instance, has a large yellow disc and, in the upper right corner, a small blue rectangle. Both colors are suggested in the blurry underpainting, and then intensified and given more distinct shape in the overpainting. The beauty of this approach is that the two passages don't quite coincide, with some of the gold dissolving poetically at the top of the metal disc. As it happens, Schmidt paints first and draws only after the underpainting is finished. For a less experienced artist, however, I recommend a preliminary drawing, done before soaking the paper, that can serve as a guide for the placement of colors.

2. *Cast Shadows*. Think of your underpainting as an echo of the things you will describe more definitely a bit later. Shadows come and go and shift from bluishness to browner tones, all the while imitating the shape of the parent object. Thus the softness of wet technique evokes them especially well.

3. *Texture*. Textures provide visual excitement and spatial density. Schmidt likes to use rhythmic drips and splatters, and there are other interesting devices you can use. The look of marble, corrugation, or wood grain can be imitated with brushmarks, and a bit of crumpled tissue or window screening brushed with color and then imprinted on damp paper can sometimes give just the right effect. Anything from a palm print to a bottle cap can be transferred by pressing it against a color-soaked

pad and then onto the page. A further possibility, with a geometric subject like Schmidt's disc, is to cut a cardboard replica of the shape, paint it, and then stamp it while still wet where the object has been drawn.

When you finally come to the overpainting, everything must be sharp, clear, and detailed. You will rely on close observation of the subject, while developing the three elements of the underpainting more specifically. *Local colors* have to be retouched and intensified. A few new *shadows* are usually needed, particularly the shadows cast by small things like a nail or piece of string. And the blurred, impressionistic *textures* of the underpainting must be given weight and substance by careful overpainting. A detail of *The Disc* (fig. 7.8), for instance, shows how Schmidt transforms casual spatters into a convincingly scarred and pitted metal surface. This is done with shadows, added marks, and careful painting around each original splash so that it resembles a tiny hole.

There is one last crucial step in the overpainting, and that is emphasizing *sculptural roundness* (or volume). In Schmidt's painting, this is particularly evident in small objects like the architect's dividers or the barn pulley hung over the disc. Here dark edges are helpful, since they overlap the background with a clean silhouette. It is essential, however, that some part of the object appear lighter than the space behind it. Following this principle, Schmidt gives his dark wires occasional highlights and features a tiny bit of white string by carefully shading around it.

For a beginner the under- and overpainting principle works best when the two stages are clearly differentiated as wet work followed by crisp wet-on-dry passages. The experienced painter, however, can sometimes integrate the two techniques quite seamlessly as Schmidt's *Temple of Jupiter* (fig. 7.9) demonstrates. This luminous interpretation of a foliated Corinthian capital has a mottled green wet underpainting

Fig. 7.8.
CHARLES SCHMIDT.
The Disc, 1980.
Detail of watercolor, 36 × 48 inches.
Collection of Mr. Robert Tooey, Philadelphia.

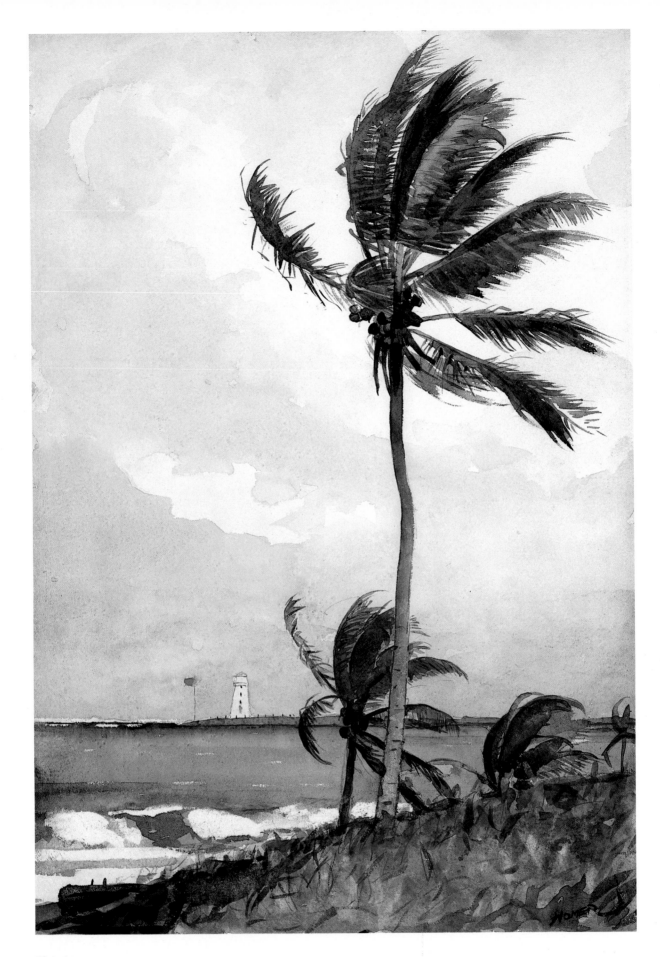

Plate 1
WINSLOW HOMER (American, 1836–1910)
Palm Tree, Nassau, 1898. Watercolor, 23⅜ × 15 inches.

The Metropolitan Museum of Art, Amelia B. Lazarus Fund, 1910.

Plate 2
JOHN S. SARGENT (American, 1856–1925)
Figure and Pool, 1917. Watercolor, 13¾ × 21 inches.

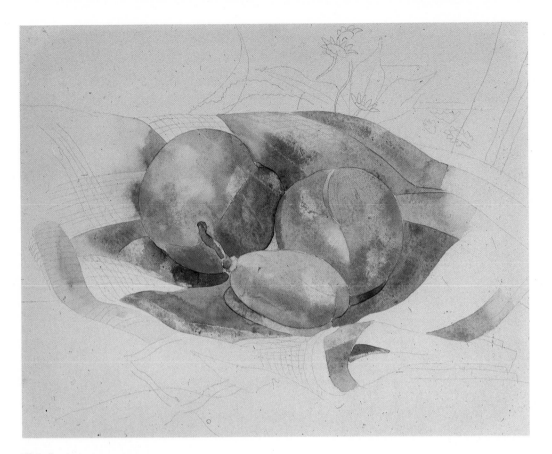

Plate 3
CHARLES DEMUTH (American, 1883–1935)
Peaches and Fig, ca. 1922. Watercolor, 8 × 10 inches.
Salander-O'Reilly Galleries, New York.

Plate 4
JOHN MOORE
Goldfish, 1977. Watercolor, 22 × 30 inches.
Marian Locks Gallery, Philadelphia.

Plate 5
PHILIP PEARLSTEIN
*Model in Kimono
on Wicker Rocker,* 1983.
Watercolor,
29½ × 41 inches.
Allan Frumkin Gallery, New York.

Plate 6
SIDNEY GOODMAN
Woman Taking Off Shirt,
1979–1980.
Watercolor,
15 × 22¾ inches.
Terry Dintenfass, Inc., New York.

Plate 7
SONDRA FRECKELTON
Peonies and Bagel, 1982.
Watercolor, 35 × 26 inches.
Private Collection.

Plate 8
CAROLYN BRADY
Baltimore Tea Party with Calla Leaves, 1983.
Watercolor, 40 × 60 inches.
Nancy Hoffman Gallery, New York.

Plate 9
NEIL WELLIVER
Deer, 1979.
Watercolor, 22 × 25½ inches.
Brooke Alexander, Inc., New York.

Plate 10
SUSAN SHATTER
Swirling Water, 1982.
Watercolor, 49¼ × 58 inches.
Fischbach Gallery, New York.

Plate 11
PATRICIA TOBACCO FORRESTER
Winter Beech, 1982. Watercolor, 52 × 80½ inches.
William Sawyer Gallery, San Francisco.

Plate 12
ELIZABETH OSBORNE
Still Life with Black Vase, 1981. Watercolor, 30 × 40 inches.
Collection of Mr. and Mrs. Bruce Lindsay, Philadelphia.

Plate 13 (opposite)
CHARLES LE CLAIR
Basil and Nectarines, 1982. Watercolor, 40 × 30 inches.
More Gallery, Philadelphia.

Plate 14
CHARLES SCHMID
The Disc, 1980.
Watercolor,
36 × 48 inches.
Collection of Mr. Robert Tooey

Plate 16 (above)
MALCOLM MORLEY
The Palms of Vai, 1982.
Watercolor, 29½ × 17¾ inches.
Xavier Fourçade, Inc., New York.

Plate 15 (left)
JOSEPH RAFFAEL
Return to the Beginning: In Memory of Ginger, 1981.
Watercolor, 33½ × 71 inches.
Nancy Hoffman Gallery, New York.

Plate 17
BERNARD CHAET
Strawberries, 1983. Watercolor, 22 × 30 inches.
Marilyn Pearl Gallery, New York.

Plate 18
MARTHA MAYER ERLEBACHER
Still Life Supreme, 1979.
Watercolor, 16¾ × 20 inches.
Collection of Glenn Janss, Sun Valley, Idaho;
courtesy Robert Schoelkopf Gallery, New York.

Plate 19
TODD McKIE
Home Sweet House, 1981.
Watercolor, 44 × 53 inches.
Barbara Krakow Gallery, Boston.

Plate 20 (right)
ROBERT KEYSER
The Oracle Contemplates the Great Clapper, 1981.
Watercolor, 25 × 18 inches.
Marian Locks Gallery, Philadelphia.

Plate 21 (below)
NATALIE BIESER
Come from Behind, 1981.
Watercolor, 40 × 60 inches.
Nancy Hoffman Gallery, New York.

Plate 22 (left)
JOHN DOWELL
Love Jamb, 1979.
Watercolor, 30 × 22 inches.
Private Collection.

Plate 23 (below)
FRED MITCHELL
All the Way Across, 1970.
Watercolor, 22 × 30 inches.
Munson-Williams-Proctor Institute, Utica;
gift of Mr. James McQuade.

Plate 24
JAMES McGARRELL
Tabletop Joys, 1979. Watercolor on
handmade paper, 34 × 48 inches.
Collection of Jalane and Richard Davidson, Chicago.

Fig. 7.9.
CHARLES SCHMIDT.
Temple of Jupiter, 1981.
Watercolor, 30 × 40 inches.
Courtesy Rosenfeld Gallery, Philadelphia.

that is pinned down by a few flatly painted shapes, like the triangle in the upper center. Much of the surface, though, has been remoistened and treated as a second layer of wet work laid over the first.

THE PUDDLE AS "PROCESS"

One of the most viable approaches to abstract painting is through *process*. This principle assumes that the shape of a work of art should be derived from the way it is *made* rather than from what it *represents*. Some obvious examples are Jackson Pollock's dripped painting, Braque's Cubist collages, and Seurat's Pointillist canvases.

In watercolor there are many distinctive processes, but none is more fundamental than brushing on colorful puddles and then waiting to see what surprises are in store when they dry. For an artist like Natalie Bieser or Joseph Raffael, the rhythm of a paint spill is as significant as the spin of the wheel for a potter. And though only a few watercolorists work in this way, their concept is widely recognized as an innovative approach to the medium.

These are West Coast artists whose paintings evoke the processes of nature—swirling waters, windblown sands, tropical growth, and geological formations. Raffael talks of being inspired by nature and feeling a connection with the Indians, the Japanese, and Thoreau. Bieser lives on a California ranch, raises a Lippit strain of horses of an ancient breed called Morgans, and uses their names as titles for her paintings—names like *Lippit Ashmore*, *Bullrush*, and *Jubilee King*.

Interestingly enough, the process Raffael and Bieser have seized upon is a technical "error" of yesterday which they have transformed into a latter-day virtue. In classic watercolor style one of the first lessons is to avoid "back-up" puddles, since liquid left standing on the page will dry with a ring around it. Raffael says he used to do careful watercolors. Then one day he looked down at the dish he mixes paints in and noticed how beautiful the rings of color were that had dried on the porcelain surface. Thus the notion of a whole new approach was born.

Like Pollock's paint-spills, puddles can be built up in rhythmically orchestrated layers. Bieser likes to start with two large shapes that oppose yet complement one another. Often they are of contrasting colors, as in *Come from Behind* (pl. 21), where a brilliant yellow descending motif collides with an ascending one in blues and earth colors. The initial shapes also establish dark and light zones dividing the page either above and below, as here, or diagonally as in her watercolor *Tecata* (fig. 7.1). Typically, the artist adds a host of smaller puddles that swirl and eddy like clouds in a sunset sky. Thus the initial shapes act as transparent planes, since they show through the second layer of smaller forms. The effect is like overlapping two projected color slides on the same screen—one bright and full of movement; the other, dark and quiet.

Natural rhythms are central to this process, but a degree of conscious control is also necessary. As it evaporates, each puddle is carefully watched and developed as a wet-in-wet area by adding new colors, or perhaps tilting it at just the right moment to make pigments run together interestingly. After drying, the edges of certain puddles may need to be reinforced by overpainting. In *Tecata*, for instance, you can easily make out which edges are natural rings of dried pigment and which have been strengthened by retouching.

Puddle technique calls for paper to be laid out flat so that pools of color stand level as they dry. Bieser works quite simply on a 300-lb. sheet of standard paper that is unstretched and fastened lightly to a plywood board with masking tape. She applies her standing puddles with a variety of large brushes, including flat housepainters' brushes. One liquid shape suggests

another, and she likes to feel that the work tells her "where it is going."

As you can imagine, a major difficulty with this approach—and one reason why it is not more widely used—is that you must wait endlessly for each puddle to dry before continuing. Fortunately, Bieser's studio opens onto the outdoors in a dry, 100-degree climate that hastens evaporation; but Raffael says he often has to let a watercolor dry overnight between layers.

Most people get exciting results with color puddles when they are composed abstractly. Unfortunately, combining them with subject matter doesn't work very well in a normal scale, since the puddles—which should be freely formed—become tighter and tighter as you try to make them "look" like something. Raffael manages this successfully, but in order to make room for his flooded effects, he uses oversize paper cut from a roll and staple-stretched on a huge plywood board. Work at this level of technical involvement obviously is not for everyone. Still, there is much to learn from this artist's pictures of tropical fish and exotic flowers painted with dazzling wetness. And when you feel sufficiently advanced in the study of watercolor—or brave enough—you may want to try some of the things he is into.

Raffael always carries a camera in the way that other artists keep a sketch pad at hand. He takes hundreds of shots of the random patterns of nature—multicolored Asian carp (or koi) in Hawaii, autumn leaves floating on a California river, or flowers from his garden. A painting like *Rise* (fig. 7.10) starts with the selection of a color slide—here an iris blossom—that is projected onto the paper for a preliminary pencil drawing. Later Raffael projects the slide again while he works, this time on the studio wall. He says he looks down at the painting spread flat on a work table, then ahead at the photographic image with the feeling of actually looking at nature. Doubtless the sensation is akin to that of an actor playing a scene with the conviction that the stage set is the reality he recalls with an inner eye.

Like Bieser's paintings, Raffael's are animated by floating, amorphous shapes. Sometimes the themes are simple, as in our cover illustration of a single rose blossom silhouetted against a sea of dark washes. Often, however,

Fig. 7.10.
JOSEPH RAFFAEL.
Rise, 1982.
Watercolor, 53½ × 43½ inches.
Courtesy Nancy Hoffman Gallery, New York.

the artist's compositions are so complex that one wonders how he pulls them together into a recognizable image. The way positive elements emerge as lights, rather than darks, is especially remarkable.

This is achieved without the aid of a masking device. Raffael's principle is simply to paint all the light areas first, achieving the delicate nuances of flower petals or the glitter of darting fish before dealing with the background. Later the spaces behind these positive elements are brushed in with standing puddles of rich color. At the same time detailed attention is given to the edges of forms which are sharply painted before the liquid background washes are dry. The flower petals in *Summer Memory in Winter* (see cover), for instance, are given intricate krinkly contours despite the blurring of tones throughout the painting as a whole.

You will recall that this is the exact opposite of Carolyn Brady's method of painting from back to front. Yet the principle is the same: namely, that the last stroke painted creates the firmest edge. Brady's cups and saucers appear solid because their edges are painted in front of the background, while Raffael's flowers and fish float like champagne bubbles because dark tones are confined to the space behind them.

Finally, one notes that the principle of *imitation* is crucial to this idiom. Just as Bieser imitates accidental puddle formations in her overpainting, so Raffael works with constant awareness of similarities between the specific and the accidental. His color slides are chosen with an eye for watery or bubbly effects. And the rendering of a rose petal or fish fin is very often made to resemble the contour of an accidental puddle formation nearby.

EXERCISES

Full-size 22-by-30-inch paper, preferably in a 300-lb. weight, is recommended for wet-in-wet painting. In this size it may be used either stretched or unstretched. Since there are advantages and disadvantages to stretching, you might review the discussion of this process in chapter 1 before starting.

Wet work appeals to some artists more than others, but it has applications even in basically wet-on-dry situations. Thus some

experience with it is essential. Four basic wet-in-wet exercises are outlined below. Complete three of them, with whatever personal variations are suggested by your reading of this chapter.

Exercise 1
PAINTING ON SATURATED PAPER

Arrange a still life with a mixed bouquet and two or three other colorful objects. Paint it, after soaking the paper thoroughly, in three stages: First, lay in basic colors that you expect to spread out and fade away. Second, heighten these colors with touches of darker watercolor after they have dried out a bit. Finally, add contours and definite edges with dark, neutral watercolors or with India ink applied with a matchstick.

Exercise 2
PAINTING INTO PREMOISTENED AREAS

Arrange odd objects just a few inches high on strips of brown, beige, and pale blue paper. These might be a persimmon, an ink bottle, a green leaf, a cluster of cherries, or similar random things. The purpose of the exercise is to set rounded forms, modeled with overlaid glazes, against backgrounds of variable tonality. After making a simple contour drawing of the objects and the strips of paper behind them, paint these background strips first with flat washes. Next paint each object, starting with clear water and then floating color into it. Build up the color and create roundness by repeating the process three times after the previous layer has dried.

Exercise 3
OVERPAINTING WET WORK

Tack several faded, rusty, mottled, and torn found objects to the wall. Add strings, wires, straps, or other connecting devices. Paint a blurred impression of the still life on soaked paper. When it is damp—neither wet nor dry—add bold cast shadows. Finally, after the paper is thoroughly dry, paint the main objects in wet-on-dry technique as realistically as you can.

Exercise 4
ABSTRACTING ON THE BASIS OF PROCESS

Cover the page with free-form watercolor puddles, touching them with various other colors while they are still wet. When the paper is thoroughly dry, overlay the first layer of painting with two large shapes—one shadowy and dark, the other brilliant. Afterward, study the interlocking forms and repaint areas that interest you, perhaps adding new shapes, until a satisfying composition emerges.

Painting the Figure

The trick to painting the figure in watercolor is to paint it as you would anything else. If it is naked, think of a breast or arm as an apple or tree trunk; if clothed, study the folds of a dress over a thigh as you would a formation of rags, rocks, or driftwood.

Like pulling a rabbit out of a hat or making goldfish disappear, however, this is no easy trick to master. One difficulty is that the complexities of human anatomy get in the way of seeing shapes simply. Another is that we are apt to be more interested in the minor details of a portrait than those of a still life or landscape. It is all very well to observe that the model's head is egg-shaped, but what about the mole on the upper lip, and how do you put in eyelashes?

In oil or acrylic you can struggle with a likeness and still hope to get the general effect right, but this is not feasible in watercolor. The medium is attuned to broad rather than miniature effects and to first impressions rather than corrections or adjustments. Thus you must have a clear idea in advance of the technique you will use to define the figure. This chapter explores four common strategies: letting a line drawing "carry" the image; reducing forms to flat shapes; modeling the figure with strong darks and lights; and as a more drastic alternative, absorbing all such specific information into a loosely brushed overall "impression."

Figure painting is interesting and enjoyable, but it is not essential for a watercolorist's vocabulary in the way that the still life and landscape exercises of earlier chapters are. In general, working from the model calls for adapting basic techniques to a challenging subject rather than exploring new ground. Therefore, feel free to move on quickly to the next chapter if problems of anatomy are discouraging and you feel you lack sufficient practice in drawing.

You may also be in a situation where finding a model is difficult. Figure poses are usually included in art school painting courses, and if you are not enrolled, you might inquire about an evening class. Or perhaps a friend or family member will sit for you. Working from life is not possible for everyone, but where there is a will there is often a way. I recently met a painter who suggested an ingenious solution to the model problem which might work in your case. She and five fellow artists meet each week at one or another's house, and the host for the evening agrees to pose.

FIGURE/GROUND RELATIONSHIPS

The best way to see a figure simply and directly is to paint it as one of many forms in the picture space—like a single apple, for instance, in an abundant still life. You won't overwork one apple when there are other pieces of fruit and a bottle or basket to do. And such a painting is likely to turn out well because of the interacting shapes and colors, even if the apple itself is unremarkable.

So it is with the figure. Philip Pearlstein's self-portrait (fig. 8.2) gives us a panorama of reflections rather than a standard head and shoulders. The artist's features are repeated on the mirror bevel and in myriad droplike ornaments on the Venetian frame, while a view of Rome spreads out behind. In this kind of format, visual relationships abound. The texture of Pearlstein's knit sweater echoes that of the Italian pines, the furrows on his face relate to cloud forms, and we discover similarities between the shapes of an easel fastener and a row of palazzo windows.

We commonly speak of this as placing the figure in a *back*ground. The more sophisticated phrase, however, is "working with figure/ground relationships," because the pain-

Preceding page: Fig. 8.1.
WINSLOW HOMER (American, 1836–1910).
Girl in Black Reading, ca. 1878–79.
Watercolor, 7½ × 9¼ inches.
Courtesy Hirschl & Adler Galleries, New York.

Fig. 8.2.
PHILIP PEARLSTEIN.
Self-Portrait with Venetian Mirror, 1982.
Watercolor, 29 × 41 inches.
Courtesy Allan Frumkin Gallery, New York.

ter's concern for preserving the picture plane often requires things that are actually in *back* to be brought compositionally *forward* by forceful colors or paint strokes. Accordingly, Pearlstein's pine trees are conceived as an aggressive pattern that strengthens the left corner of his painting rather than as a dim "background."

Although it sounds illogical, the fact is that in figure work you will do better with *more* rather than *less* to look at. You will of course paint at a smaller scale and in less detail than Pearlstein, whose self-portrait is larger than life-size. It is essential, however, to pose the figure in relation to a convincing environment. Homer's small *Girl in Black Reading* (fig. 8.1) and Elizabeth Osborne's big but simply organized *Nava with Green Cup* (fig. 8.3) suggest what you might aim for. Both pictures show a woman holding something, sitting in a room with floor

and wall clearly indicated, and surrounded by furnishings (like Homer's screen and Osborne's patterned cushion) that articulate the space.

Creating visual excitement throughout a picture is always helpful, but the principle becomes imperative in watercolor for a practical reason. You see, concentrating on the figure alone, with the kind of plain background you might use in oils, forces your brushstrokes into a small space that quickly becomes saturated. Nothing is more discouraging than having to wait endlessly for an area to dry (unless it is seeing the eyes and mouth of the model you are painting run together as the result of impatience). Therefore, when I plan a picture like *Southern Exposure* (fig. 8.4), I carefully avoid the problem by making sure there is something interesting, like a patterned quilt or a view out the window, to keep my hand occupied while the lady in the center is drying.

Fig. 8.3.
Elizabeth Osborne.
Nava with Green Cup, 1981.
Watercolor, 41 × 29½ inches.
Courtesy Fischbach Gallery, New York.

Fig. 8.4.
Charles Le Clair.
Southern Exposure, 1982.
Watercolor, 40 × 30 inches.
Courtesy More Gallery, Philadelphia.

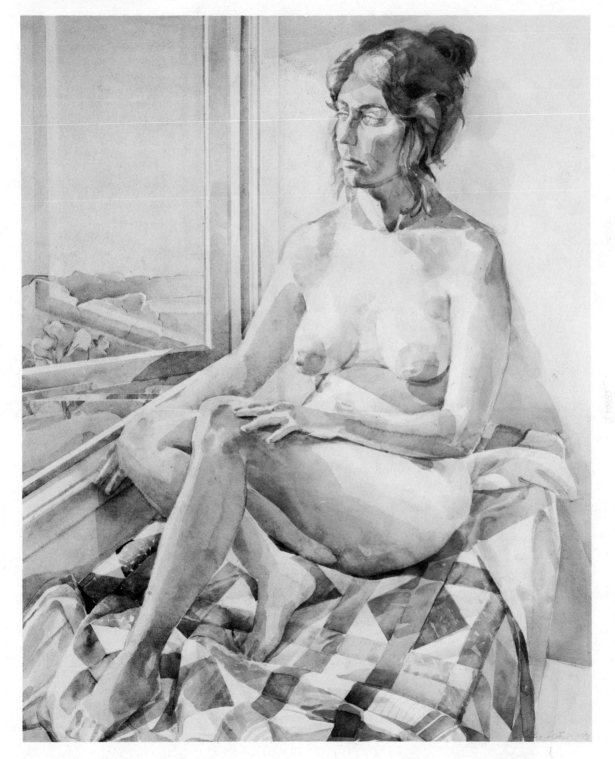

Fig. 8.5.
JOHN SINGER SARGENT (American, 1856–1925).
Arab Woman (Unfinished), ca. 1905.
Watercolor, 17⅞ × 12 inches.
Metropolitan Museum of Art, Gift of Mrs. Francis Ormond, 1950.

NUDE VS. CLOTHED POSES

The naked body has a certain mystique for art students. When a model is announced, class attendance is high, and the question of whether to dress or undress the figure is usually answered by a show of hands favoring an undraped pose.

Perhaps you feel this way, too. If you are seriously interested in painting the nude model, I would not want to discourage you, since motivation is half the battle in art. At the same time, you should understand that the unadorned human form presents difficulties that a watercolorist must overcome, whereas costuming provides entirely positive opportunities. Undressed, the model's every finger, toe, and collarbone must be accounted for; clothed, such anatomical details are covered over by loosely formed, easily sketched drapery. And in color and shape, the nude—whether Caucasian, Black, or Oriental—has a fixed tonality and set proportions, while costuming permits you to use rainbow colors and divide the figure into various shapes and patterned areas.

In the end you will perhaps want to work with both the nude and the clothed figure. I suggest, though, that you start with the latter because of the freer and more creative watercolor opportunity. Osborne's *Nava* gives an idea of the ease with which you can animate a skirt or blouse with textile patterns, and Sargent's *Arab Woman* (fig. 8.5) illustrates the kind of casual brushwork that can be used with drapery.

Meanwhile, the problems of composing a nude study like Galuszka's *Nude in a Blue Bath* (fig. 8.6) or my *Southern Exposure* are considerably lessened by developing the project in stages, first as a reasonably accurate informational drawing and then as a more freely interpreted watercolor. In order to work with assurance, you need pencil contours, and these are difficult to set down directly without erasures and smudging. Tracing-paper overlays and cutouts, on the other hand, permit you to redraw a head or knee and to change proportions and gestures. I recall making tucks in the tracing paper to shorten my lady's torso, and in composing a figure like Galuszka's bather, the arms can easily be raised or lowered for best effect.

Fig. 8.6.
Frank Galuszka.
Nude in a Blue Bath, 1981.
Watercolor, 22½ × 30½ inches.
Courtesy More Gallery, Philadelphia.

Another advantage of this system is that anatomy and architecture can be studied on different sheets. The room's vanishing points, furniture placement, and quilt or bathroom tile patterns are detailed on one drawing. Later, an outline of the figure is overlaid and moved up, down, or sideways until a satisfactory adjustment is found.

Finally, the composite drawing is traced onto watercolor paper with a graphite transfer sheet. One always hopes the painting will turn out well. But if it doesn't, the preparatory drawing may be used again for a "new and improved" version.

LINE AND WASH SKETCHES

A *wash drawing* is the most direct vehicle for the figure. This is simply a line sketch, usually in pencil or ink, with a light overlay of watercolor. When the lines become obscured by heavily brushed pigment, we speak of the work as a watercolor "painting." In a wash "drawing," however, the image is fully defined (or "carried") by dark lines. Thus transparent colors may be overlaid with the utmost freedom.

You have seen this in old master drawings, and Demuth's illustrations are outstanding modern examples of the genre (see chapter 10). His *Boat Ride from Sorrento* (fig. 8.7) shows two characters from Henry James's *The Beast in the Jungle* being borne out to sea by a sinister oarsman, with a smoking Vesuvius in the distance. As a wash drawing it is, typically, quite tiny so that a single pencil line will suffice for a face. It is also swiftly sketched, with vague marks to suggest sails and houses along the shore. And we note that these watercolor additions serve mainly to establish a somber mood and silhouette the hero and heroine.

In watercolor, scale often determines your procedures. As we have seen, a sizeable nude requires a preliminary drawing that will account for anatomical details and architectural setting. Figures as small as Demuth's, on the other hand, can be drawn freehand in the most casual way. After all, the heads are only an inch high, and the beauty of a sketch like this is that whatever the pencil fails to achieve, the brush can compensate for, and vice versa.

Your best bet, then, is to begin with small watercolors conceived as wash-embellished drawings before tackling the figure at a scale requiring full painterly technique. Although a soft (4B or Ebony) pencil is usual, the basic drawing

Fig. 8.7.
CHARLES DEMUTH
(American, 1883–1935).
The Boat Ride from Sorrento, 1919.
Watercolor, 8 × 10⅛ inches.
Philadelphia Museum of Art,
Gift of Frank and Alice Osborn.

Fig. 8.8.
EMIL NOLDE
(German, 1867–1956).
Magicians, 1931–35.
Watercolor, 20⅛ ×
14⅜ inches.
Museum of Modern Art, New York.

may be done with pen and ink, conté crayon, charcoal, or even pastel. Washes are then added and, as a last step, it is always possible to superimpose additional lines in ink or dark watercolor. We see this in Nolde's *Magicians* (fig. 8.8).

INVENTING YOUR OWN FIGURES

Working from life is valuable experience, and some artists paint only from direct observation. Yet there is another world of figure painting to explore—the imagined or invented composition. In contrast to Pearlstein's faithful self-portrait, for instance, Demuth's boatman and Nolde's conjuring magicians are obviously made-up and, indeed, any attempt at realism here would have been at odds with the fanciful intent.

In addition to painting from the model, then, learn to interpret the figure in freely imagined situations. Since inventing poses without anyone to look at takes years of experience, I have two suggestions: First, recycle your life drawings by combining elements from them in new watercolor compositions. Second, develop an exciting sketchbook.

Elizabeth Osborne's work admirably illustrates the first point. Her subjects are real, but she paints from analytical studies rather than from life. In preparation for a watercolor, she makes drawings of the model, records fabric patterns, and takes color photographs of still life objects and the shadows they cast. Then in a picture like *Nava with Green Cup*, she selects elements from these studies which are rendered in a freely poetic way. Frank Galuszka's methods are similar. Although he does not use a camera,

he draws regularly from the model and has a collection of studies that serve as source material for his paintings. Thus a watercolor like *Nude in a Blue Bath* is a mixture of things imagined or remembered, things reused from old drawings, and where necessary, things freshly researched from the model.

Ultimately, mastering the figure calls for a lot of informal sketching aimed at capturing lifelike gestures and the way people interact in everyday situations. Carry a sketchbook in your pocket for a week, and see how easy it is to jot down impressions on the bus, in the cafeteria, or in the park. "Recollected in tranquility," these notes may prove worth developing. Add a bit of watercolor to the sketchbook page. Then recreate it as an 8-by-10-inch wash drawing, rearranging and improving certain elements as you go. Later, pin several such casual studies on the wall; perhaps you will decide that some are worth developing as full-scale paintings.

COMPOSING WITH "FLATS"

During an 1865 visit to Spain, Manet discovered Velázquez's principle of painting things in flat, unshaded colors. "Flats" have been standard realist technique ever since, and you will find that in watercolor this is the most economical way to achieve a figurative image. Looking again at Homer's *Girl in Black Reading* (fig. 8.1), we see how simple the process is.

Of course you *do* need a good pencil drawing. Preferably one with the edges of each shape neatly outlined as a guide for later brushmarks. It should be pale and clean, rather than dark and messy like Demuth's Sorrento sketch, since the final effect will be one of color rather than line. Even so, the pencil is bound to show through areas of light flesh tone. Therefore, key details like the profile, hands, and frilly jabot in Homer's watercolor need to be drawn with special care.

Before proceeding further, it is a good idea to follow Elizabeth Osborne's practice of pinning up test samples of the colors you plan to use. Sometimes one color can be made warmer or cooler to harmonize with another, and values often need adjusting to ensure a clear progression from dark to light. Homer's color scheme is relatively foolproof—a figure dressed in black (visually a medium gray) posed against a sepia screen with a touch of white at her throat and bright red accents on the mouth and tasseled chair-pillow. The artist's technique calls for simply filling in each area with a predetermined color. Yet the beauty of watercolor is that such "flat" passages are never posterlike, and Homer takes full advantage of opportunities to vary a wash or utilize the paper's mottled texture.

The final step in composing with flat washes is to put in key shadows. These are kept to a minimum by frontal lighting that wipes out most details. Still, there are always a few darks to be added, and Homer's little figure study is a classic lesson in how this is done. A single cast shadow establishes the mass of the figure, while small touches on hair, collar, waist, and chair give a sense of specific portraiture.

Homer's one-two-three process—drawing, followed by color, then shadows—is essential for success with flat washes. You must be clear about these steps and also be willing to *stop*, because further work on a dress or face calls for matching detail elsewhere, and the logic of simple shapes is soon lost.

Flat washes are appropriate to any subject, but they are especially compatible with figure drawings. Rodin's pencil and watercolor nudes are well known, and theatrical costumes have been traditionally represented by color blobs painted over a dashing contour drawing. Since the transparent hues are applied over an outline that can be retraced like a paper-doll module, the color of a blouse, glove, or background can be anything you desire. Thus it is possible to paint from the model and reverse the colors when you get home. Or you can make drawings from life and paint them later from your imagination.

Painting with unadorned flat washes has an important limitation, however—that of size. It is a shorthand idiom designed for a small sketchblock. On a large paper, washes done in a single layer come off as dry and lackluster, and you will find a general relationship between the size of a watercolor and the degree of textural richness it requires. I suggest, therefore, that after learning to paint small figure sketches with a few flat touches of color, you experiment with some larger compositions done with indirect multilayered washes.

Osborne, for example, demonstrates in

Nava with Green Cup (fig. 8.3) how to compose a 41-inch figure study as a series of flat shapes, like a collage or piecework quilt, while at the same time making these shapes sufficiently luminous. In a watercolor of this size, flat areas should have the richness of stained glass or enamels. To achieve this, several layers of pigment are usually required, often with textural variations or shifts of hue. Osborne also introduces patterns, like that on Nava's dress, as well as contrasts between bold shapes and subtly blended passages like the face and hair.

As a modernist, Osborne carries the idea of "flats" even further than Homer. Her shapes are more abstract, and she likes to punch in dark areas behind the figure that reverse normal figure/ground relationships. This is an artist with formidable technique whose basic approach, nevertheless, is quite feasible for less experienced painters.

ROUNDING THINGS OUT

We hear a lot about the virtues of light cuisine and light beer these days. In the realm of art, watercolor is a similarly "light" medium when compared with heavyweight oils. This is why it is wise, in starting out, to work as economically as possible with a pencil sketch and a few flat washes.

The medium has considerable range, however; and whereas Homer used it for quick reporting, Eakins favored slowly built-up, fully dimensional watercolors. As you continue with the figure, you will no doubt want to learn how to render the human form, not only with flat washes, but with roundness and shading as well. For starters, three of the principles Eakins uses in *Sketch for "Retrospection"* (fig. 8.9) will put you on the right track:

Fig. 8.9.
THOMAS EAKINS (American, 1844–1916).
Sketch for "Retrospection," ca. 1900.
Watercolor, 15 × 11 inches.
Philadelphia Museum of Art, Gift of Mrs. Thomas Eakins and Miss Mary A. Williams.

1. *Make sure the figure is strongly illuminated from one side with a clear shadow pattern.*

2. *Plan on one or two strategic edge-reversals* (see chapter 2). This means starting with background tones and varying them so that the figure can be represented as dark in some places and light elsewhere. Here, for instance, the profile and right arm are shadowed against a light ground; Eakins reverses this in the lap, which is light against dark; then, below the knee, the figure is again in shade.

3. *Keep the illuminated side of the figure white, or almost white, until darks are fully established.* For a sense of volume, form is best developed *before* local colors of costume and skin are put in. Fortunately, this unfinished study reveals Eakins's precise working method. We see that the left side of the figure has been "saved" as white paper; that the hair, profile, and chest have been developed as darks; and how—at the point where he stopped—the artist was in the process of tinting each area very faintly, section by section, beginning with the forward shoulder and arm.

The question of what kind of brushwork to use remains. By and large, figure studies are not compatible with the smooth treatment found in many contemporary still lifes. You can paint a plum or tomato with a continuously graded wash, but anatomical forms are complex and activated by angular bone structure. Thus the figure must be developed through a series of thrusts, rather than with rubbery smoothness, and a way of integrating these separate brushstrokes needs to be worked out.

Doubtless you will find your own way in the end, but it helps to study other painters. Eakins prefers very small marks which dry quickly and permit a breast or arm to be built-up in repeated layers. He uses similar strokes in the background, so that the painting as a whole will have a unified texture, and his marks are applied with natural, shifting, diagonal rhythms. This last is especially worth noting, because there is nothing worse than marks stroked in one direction like a venetian blind or in crisscross patches like window screening. In this connection, you might also look at Sidney Goodman's *Woman Taking Off Shirt* (pl. 6). The shading technique is similar to Eakins's, but with a softer blending of strokes.

My own approach to the figure emphasizes clean-cut planes rather than "brushy" marks, and I use a simplified wash technique that may be a useful guide for your own work. In composition, a watercolor like *View from the North* (fig. 8.10) follows the principles of side lighting and edge reversals we have discussed. Note, for instance, how illumination from a window on the left permits the front of the figure to be shown as lighter than the background, while the man's back is thrown into shadow.

The shading, however, is quite different from that of Eakins or Goodman. Instead of closely knit small strokes, I use broad, lightly tinted washes. These are applied in neutral tones according to the Cézanne principle of building forms in a few even steps. In each area, broad shadows are laid in, followed by two or three layers of progressively smaller, darker accents.

Here, for example, the nose was painted as a simple triangle with specific shadows at the nostril and bridge added later; and this principle was used throughout the figure. Finally, when darks and lights were fully established by muted tones, local colors—the tan of the skin and faded blue of the denim shorts—were overlaid with transparent glazes.

UNDERPAINTING AND INDIRECT TECHNIQUE

Watercolor is usually thought of as a vehicle for "direct" on-the-spot painting, and artists from Homer to Pearlstein have been attracted by its immediacy. We must remember, though, that as a medium built-up in layers, watercolor has an equal affinity for "indirect" processes. In indirect work, you don't record what you see right away; you decide to do something else first. If a dress is red, for instance, you might paint it green as a "cool" foundation for the "hot" colors to be put in later.

There is a degree of indirection in any watercolor in the sense that the effect of one wash laid over another must be considered. The term *indirect technique*, however, normally refers to a division of the painting process into two distinct stages—an *underpainting* and an *overpainting*. This may amount to two complete treatments of the subject, yet neither works without the other, and the ultimate effect depends on their interaction. In the last chapter,

Fig. 8.11.
FRANK GALUSZKA.
Judith Practicing Before a Mirror, 1981.
Detail of watercolor, 22 × 27 inches.
Collection of Anne and Harry Wollman, Philadelphia.

for example, we saw how Charles Schmidt shifts from a loose wet-in-wet start to a carefully controlled overlayer, and there are various other ways in which the preliminary and finishing stages may be contrasted.

The most common underpainting technique is the Renaissance method of drawing and shading forms in monochrome before laying in specific colors. Terre Verte green is sometimes used for a silvery, spiritual effect, although Burnt Sienna or Venetian Red is usually preferred because of the sensuous glow a ruddy underpainting gives to flesh tones. The rosy Venuses of Titian and Rubens are familiar instances of the style.

Underpainting is as effective in watercolor as in oils, and it has special advantages in figure work. For one thing, it permits problems of anatomy to be considered quite apart from the joys of color. For another, it allows intricate hatching and dry-brush work (in the underpainting) to be joined with a freely brushed, painterly style (in the overpainting). As you see, this is the mirror image of Schmidt's approach. He puts drawing and shading on top of color; in Renaissance technique they are underneath.

Perhaps these possibilities will appeal to you as they do to the Philadelphia painter Frank Galuszka. Galuszka says that the flesh tones in his early "direct" watercolors were radiant but lacked solidity. To correct this, he now uses an underpainting that is built-up like a chiaroscuro drawing with heavy textures, attention to musculature, and fine-line hatching. Over this, he glazes with intense colors such as Naples Yellow, Manganese Blue, and Dioxazine Purple. The effect is rather like stained glass.

This kind of indirect technique opens up exciting approaches to color. One of Galuszka's strategies is to put blocks of transparent color—a red scarf, a yellow shirt, brown trousers—over specific areas of the underpainting. Another is to establish a dialogue between warm and cool hues by painting the under- and overlayers in opposite tonalities. His *Nude in a Blue Bath* (fig. 8.6), for example, features washes of cool blues and violets over a warm Venetian Red underpainting. The point of such an approach is the shimmering mother-of-pearl vibration that ensues. Here each bathroom tile is delicately shaded as a vignette of warm-and-cool, see-through color relationships. The picture as a whole has a grottolike radiance.

One is struck by the mixture of classical and contemporary impulses in Galuszka's work. Since student days in Rome, he has been fascinated by Italian Baroque art, and the choice of underpainting technique reflects this tradition. Furthermore, many of the artist's subjects, like *Judith Practicing Before a Mirror* (fig. 8.11), are taken from mythological or biblical sources. Others are modern scenes with classical allusions. Galuszka's lady in the blue bath, for instance, has the heroic pose of an Aphrodite rising from the sea, and her torso is drawn in the crosshatched style of Renaissance engravings.

At the same time, this is thoroughly contemporary work. Galuszka's bather holds a hairbrush rather than a symbolic attribute, and her suntan is shaped by a swimsuit bra. The story of Judith, who cut off the head of the Assyrian invader Holofernes, is also newly imagined in a modern version. Instead of a mature, soberly religious widow, this is a Nabokov nymphet "practicing" her sword-stroke with a little broomstick.

Whereas Pearlstein's generation saw the figure in abstract terms, our younger artists often use it as a vehicle for personal narratives and an appeal to senses beyond the purely visual. In this vein, Galuszka speaks of "the pulse" of his compositions as being objectified in the image of a woman. He explains: "There are references to exhilaration, refreshment from washing, from physical exertion, the possibility of sexual contact, the touch of textures on the skin, and images of food and drink."

GLAZING OVER A SEALED GROUND

Technically, Galuszka's watercolors are remarkable for their resemblance to his oils. This is due in part to style: the use of deep colors that block out most of the whites, and reliance on heavily textured surfaces. The wall behind Judith, done with dry-brush shading on semi-rough paper, has almost the look of palette-knife marks on canvas. There is another factor, though; namely, the artist's occasional and judicious use of transparent acrylics.

Acrylics may be combined with water-

colors in either of two ways: as a colorless sealer or as a pigmented, insoluble underpainting. *Sealing a watercolor* is desirable in indirect painting (and sometimes in direct work as well) when more than three or four layers of washes are contemplated. After repeated glazing, eventually the surface breaks down and new washes begin to dissolve what is underneath. At this point, the application of a sealer, composed of matte acrylic medium diluted with water, will permit you to continue with several more watercolor layers.

Underpainting with acrylics, as an insoluble ground for subsequent work in watercolor, is another way of ensuring that forms defined at the outset will not dissolve later on. Like the new typewriters, this kind of underpainting is "correctible" in the sense that errors in the overpainting may be sponged off without destroying the basic composition. A similar effect, incidentally, can be achieved with gouache, which is also insoluble after drying. (See chapter 1.) In either case, the acrylic or gouache should be used transparently rather than with opaque white.

CAPTURING AN IMPRESSION

Anyone seriously involved with the figure must, at some point, consider the nose, the ear, the shape of a foot, the action of a pelvis—in short, study every aspect of a complex organism. Fortunately, such visual experience is cumulative and not forgotten as easily as dates or historical facts. Each time you return to the figure, you will have a little more mastery of its forms.

Figure painting requires a certain amount of this kind of patient study. Yet dogged perseverance is a trap to be avoided. One way to do this is to vary your projects and the time allotted to them. Some of your watercolors should be conceived as three- or four-day projects and others as two-hour studies. You might also experiment with portrait heads, half- and full-figures, and with the model posed on the ground or in a hammock above you.

Another helpful strategy is to paint the figure occasionally with the conscious thought of "trying to forget about it." In *Figure and Pool* (pl. 2) Sargent gives us an object lesson in pulling back from the model and seeing it as part of the total environment. A recumbent male nude stares like Narcissus at his watery reflection. Yet the man's anatomy is shaped by the same rhythmic marks that describe rocks, sand, and blue water. Indeed, the suntanned body blends with the beach so closely that it takes a moment to make it out.

You will find that this approach pays off in terms of building your confidence in handling the figure. Work for an "impression" rather than a "likeness." Set a time limit, because this will give a sense of urgency to your brushstrokes. And devise a pose in which the model is absorbed into the environment, rather than featured as a focal point: Put the figure in shadow, camouflage it with a colorfully patterned costume, or as in Sargent's picture, pose your subject in a sun-dappled landscape.

9

Still Life
Strategies

The rise of still life painting is a curious development of modern art. This subject gets far more attention than in the past, and every other prominent watercolorist nowadays seems to be a still life painter. One reason is the positive image still life has enjoyed, since the days of Cézanne, as the most "abstract" of the representational idioms. After all, composing with apples and oranges is much like arranging colors in a collage. Another factor is its suitability for the large "important" watercolors currently in vogue. Whereas a nineteenth century painter might sketch outdoors, a contemporary watercolorist is apt to paint in the studio where apples and bottles will "hold still" for weeks at a time.

Still life is also a key proving ground for the watercolor student. Aside from the practical advantage of not having to worry about models or the weather, still life offers a comparatively uncomplicated painting experience—the opportunity to work with a few objects in a clearly defined space. A further advantage is your control over every aspect of the set-up—spacing, lighting, and deciding what to include or omit. Clearly, this is the visual equation to begin with, and after ventures afield, a subject to return to again and again.

General aspects of still life painting were considered in chapter 4. Here we will get down to particulars with a look at the work of some leading watercolorists and an eye out for techniques and ideas that may be applied in your own work.

THE SINGLE SUBJECT

A still life painting is "conceived" the moment you decide upon a specific subject. This is the

germinal point, since your initial set-up will determine the possibilities and problems of the painting to follow, and its visual excitement must motivate you to go ahead with the project.

When you are in doubt about what to paint, one foolproof strategy, as we saw earlier, is the "unarranged" still life of abundance. You simply pile everything in the house onto chairs and tables in a flea-market tableau, and take it from there. With a paper view-finder, you can easily pin-point a section of this random "environment" that composes well, and the beauty of this approach is its spontaneity.

If you have a small apartment, however, with not much still life to pull out of closets, you may want to take the opposite tack—working selectively with a few carefully arranged objects. This is the method of most experienced painters who gradually become attuned to particular formats. A novice must do some experimenting, but you will find the options fairly clear. Planning a painting is like planning a garden. It can be symmetrical or irregular, and the space can be as crowded as a cottage perennial bed or as spare as the planting in a Japanese courtyard.

The logical starting point, actually, is a painting with just one strong subject. This can work out well, as Homer demonstrates in his watercolor *Channel Bass* (fig. 9.2). An avid angler, the artist paints his catch in an arched silhouette like a mounted trophy in a sportsman's den. The theme, incidentally, is a traditional favorite among watercolorists, since fish are naturally associated with a watery milieu and their iridescence cries out for a transparent wash rendering. (For contemporary interpretations, see works by Morley and Raffael, fig. 11.4 and pl. 15).

The strategy of a single forceful image is as old as a Byzantine icon and as modern as an Andy Warhol Campbell's soup can, and it has the virtue of capturing immediate attention. *It will only work, however, with the right subject.* The image must be complex enough to hold our interest, and this rules out most still life staples—commonplace things like plates, bottles,

Preceding page: Fig. 9.1.
NANCY HAGIN.
High Shelf, 1982.
Watercolor, 37 × 49½ inches.
Courtesy Fischbach Gallery, New York.

Fig. 9.2.
WINSLOW HOMER (American, 1836–1910).
Channel Bass, 1904.
Watercolor, 11 × 18⅞ inches.
Metropolitan Museum of Art, George A. Hearn Fund Purchase, 1952.

Fig. 9.3.
XAVIER GONZALEZ.
Roses, 1966.
Watercolor, 24 × 18 inches.
Collection of the artist.

apples, and potatoes. Homer's *Channel Bass*, on the other hand, fills the bill precisely. The great fish is visually stunning—decisive in outline, delicately modeled, and glistening. It also has human interest as we observe that the bass is freshly caught, with the hook still in its mouth, and vicariously share the artist's outdoor adventure.

If you want to focus on one subject, there are plenty of options. Start with your closet. Hang a T-shirt or Japanese kimono on the door, throw a leather handbag with tangled flaps onto the floor, or paint a pair of old boots as Van Gogh did. At the grocer's, look for things that come in "heads" or "bunches" like romaine, carrots, or beets. They make a strong unitary image even though composed of parts. And don't overlook the basement, attic, or local thrift shop. Anything from a stuffed pheasant to an antique doll may turn up.

Flowers are probably the most natural still life subject. Consider painting a single stalk of blooms as Xavier Gonzales does in *Roses* (fig. 9.3). A distinguished New York artist who teaches at the Art Students' League, Gonzalez summers in Wellfleet, Cape Cod, where he paints fishing boats, the marshes of Duck Creek, an occasional self-portrait, and roses from his garden. The white rose, in particular, has been a feature of recent one-man shows. It

is a subject the artist obviously enjoys in life and finds compatible with his medium. Gonzalez's palette is based on the neutral blacks, grays, and ochres of his Spanish heritage. In this scheme, his luminous whites create a striking visual climax.

Despite the innovations of modern art, painters continue to be attracted to the traditional themes of portraiture, landscape, and floral still lifes. After all, everyone loves flowers, and their coloration and structure is infinitely varied. With a conventional subject, however, one wants to add an element of newness. Joseph Raffael does this (in the cover illustration for this book) by making a monumental four-foot image out of a small flower. Here Gonzalez does it in still another way, with an offbeat situation. Instead of a prime bouquet, he shows us a single blossom, stuck in a glass tumbler on the studio table, and it is quite dead.

The artist sees beauty in this "last rose of summer," painting the "dried" petals in matching "dry-brush" technique rather than his usual sumptuous washes. What he is after is an impression, and this is suggested by a virtual sampler of watercolor effects—smooth tones above, a standing puddle that has dried like a snow-drop behind the topmost rose, and a stylish dry-brush outline of studio equipment in the lower left corner.

STILL LIFE AS ICON

Homer and Gonzales paint their subjects casually in natural settings. In *La Famille Blanche* (fig. 9.4), Harry Soviak shows us what can be done with a similar theme that is formalized, isolated from the environment, and made into a kind of icon. *Icon* is an ancient word for "image" with an historical connotation of holiness. In modern art, however, icon means simply an image that has an imposing, often stylized and frontal, presence. Symbolism may be suggested, but if so, it is apt to be highly personal or mundane rather than religious or mystical.

Monumentalizing an image has the paradoxical effect of emphasizing the picture's subject matter while, at the same time, heightening its abstractness. Soviak's giant blossom, for example, is more insistently "floral" than Gonzalez's dried rose, and his vase decorations

tell a more detailed story of butterflies, tropical birds, and honey gathering. Yet for all this thematic interest, *La Famille Blanche* is as elegantly abstract as an art nouveau poster.

Soviak (1935-1984) was a talented artist whose promising career was recently cut short by an untimely death. Since 1973 he had worked with the Redon-like theme of flowers in a classically shaped vase. From the outset, these watercolors were designed symmetrically with flowers pushed forward like the corsage on a prom queen's shoulder. Gradually, however, background and table disappeared as the bouquet expanded to fill the frame. In some of the later versions, even the flowers are gone, and we are left with only a vase, or part of a vase, like the fragment of an ornamented Greek amphora.

Don Nice is another New York painter who treats subject matter as an "icon" (my word) or as a "totem" or "heraldic emblem" (his words). His themes are more varied than Soviak's, and he uses them like pictographs in series rather than singly. They also touch many cultural bases. Mythic characters like cowboys, Indians, soldiers, and New Guinea natives interest him, and he draws subjects from a vast collection of antique toys, musical instruments, and illustrated books. One studio wall in his eighteenth century mansion on the Hudson River near West Point is covered with miniature objects from dime stores and penny arcades that he blows up into full-scale Pop Art images.

Nice works with an arbitrary format, but his images are painted quite factually. Indeed, since 1963 when he exhibited life-size canvases of horses and cows, he has been a "realist" in the sense of painting truthfully from direct observation. At the same time, he is obsessed by the idea of making an image look "modern." In pursuing this goal, he has gradually come to disavow the whole idea of figure/ground relationships upon which Western illusionism is based. Thus he eliminates cast shadows and all "referential space," painting his subjects instead on blank white paper. The intent is to make the watercolor into a "thing"—with its own rough-textured, hand-painted presence—rather than a "mirror" of something else. The result is like a print made from several etching plates, and Nice sometimes heightens this effect by embossing his watercolor paper with dimensional "plate marks" before painting on it.

Fig. 9.4.
Harry Soviak (American, 1935–1984).
La Famille Blanche, 1980.
Watercolor, 42 × 29½ inches.
Courtesy Pam Adler Gallery, New York.

Fig. 9.5.
DON NICE.
Alaska BK III PPXVII, 1982.
Watercolor, 60 × 40 inches.
Courtesy Nancy Hoffman Gallery, New York.

Some artists work intuitively. Others, like Nice, proceed from theories. One of his most interesting ideas is that transparent color, and hence watercolor, is the wave of the future since it is akin to television hues and the analine dyes used in magazine illustrations. Another intriguing notion is his numbering of pictures according to formats. These are *totems*, or vertically piled images; *predellas*, horizontal bands like those below a Renaissance altarpiece; and *book pages*, arrangements within a normal rectangle. His paper sizes are indicated by Roman numerals. Thus the title *Alaska BK III PPXVII* (fig. 9.5) translates: "The Alaska image done in Book Format on 40-by-60-inch 300-lb. Arches paper as the seventeenth in a series."

Not many painters are willing to give up all sense of background space, though it is an arresting concept which just might appeal to you. On the other hand, Nice's ideas about imagery, as exemplified by the Alaska watercolor, could be applicable in many situations. The picture memorializes a trip the artist made to the Forty-ninth State recently. Since "eagles were as common as robins," he decided to feature the bird in a heraldic profile against a medallion of native flowers. Below this public symbol, done in a Renaissance circle or *tondo* (the mathematical shape of perfection), is a predella devoted to private pleasures. The predella subject, as it turns out, is the box lunch offered travelers on the Alaskan boat trip. On a field of aluminum foil we behold a sandwich and cookies in plastic wrap, a delicious apple, and a can of fruit juice. Recalling the experience, Nice says that he ate the lunch, knowing most items could be reconstructed later in the studio, but brought home the juice can and its gaily-striped drinking straw for a touch of authenticity.

Like his ice-cream cones, tin horns, and all-day suckers, the Alaskan lunch interests Nice as both a symbol of personal adventure and an artifact of popular culture worth recording. There is an important lesson here, since in addition to finding ways of painting familiar things freshly, we must all be on the lookout for subjects that Rembrandt or even Picasso couldn't have painted. Plastic foam coffee cups are new, just as molded egg-cartons are. A few years ago, Janet Fish discovered the marvelous transparencies and reflections on boxes of tomatoes sealed in plastic wrap. In the supermarket recently, I noted the beauty of iridescent grapes packaged in red string bags. Keep your eyes open!

MODULAR COMPOSITION

Normally, the subject you choose for a painting—whether a portrait, a tree, or a vase of flowers—is sufficiently interesting to become the main element in your picture.

An alternative principle, however, is composing with *modular units*, or small objects of relatively equal size. In other words, painting an arrangement of eggs rather than a picture of the hen. This strategy deals with space and movements in space rather than with solid volumes. To play the game, just think of your page as a chessboard with your still life objects as pawns and rooks to be moved about.

In *Still Life Supreme* (pl. 18), for instance, Martha Mayer Erlebacher uses a striped tablecloth as a "game board" on which she positions sixteen objects in crisscross diagonal rows. Since they are exquisitely painted and include green, red, and yellow apples, along with a lemon, lime, potato, pepper, onion, tomato, and grapefruit, there is considerable interest in the objects themselves. Nevertheless, the point of the composition is the choreographed arrangement of modular forms in space. This is emphasized by the way in which jewel-bright colors of fruits and vegetables are keyed to the stripes in the red-toned chevron background.

Although critics usually consider Erlebacher's work in connection with the New Realist movement, the Philadelphia painter says: "I am *not* a realist; I don't copy reality—I interpret it through mind, vision, and philosophy." A painting like *Still Life Supreme* bears this out. Despite surface illusionism, there is an underlying sense of fantasy. One is struck by the regularity of the geometrical scheme and fascinated by the way odd objects are fitted into it. Actually, Erlebacher likes anomalies, and there is often a subtext to her pictures. She says that this one is a "take-off on modern art," presumably because of the abstract Bauhaus-like design executed in a superrealistic technique.

Stylistically, Erlebacher's watercolors are unorthodox. As the detail of *Still Life Supreme* (fig. 9.6) shows, she avoids standard washes entirely, building forms instead with the miniature crosshatched brushmarks usually associated with Renaissance egg-tempera and artists like Botticelli and Fra Angelico. Theoretically, an egg- or varnish-emulsion is needed to keep such strokes from dissolving as they are built up, but Erlebacher finds that plain watercolor

Fig. 9.6.
MARTHA MAYER ERLEBACHER.
Still Life Supreme, 1979.
Detail of watercolor, 16¾ × 20 inches.
Collection Glenn Janss, Sun Valley, Idaho;
Courtesy Robert Schoelkopf Gallery, New York.

works just as well. She likes to set bright objects against gray shadows that are sometimes painted and sometimes rendered in graphite. With a palette of forty-seven colors (see fig. 1.3), the artist matches tones precisely. In this picture she is pleased to have gotten "just the right green for the dark lime and the special green of the pear as it began to turn color."

Bernard Chaet's *Strawberries* (pl. 17) shows us a quite different approach to modular composition. A teacher at Yale for over thirty years, Chaet is author of several art books, and his paintings have been widely exhibited. In contrast to Erlebacher, he works in an improvisatory direct style that derives from the principles of Cézanne rather than Renaissance traditions.

Typically, Chaet's watercolor still lifes are based on modular units seemingly arranged as if by a throw of the dice. Whereas Erlebacher uses a variety of objects that are lined up neatly,

Chaet pursues the opposite strategy. His objects are uniform—pears in one picture, cherries or strawberries in another—but they are allowed to float irregularly on the white paper like leaves on a pond. His painting technique is equally improvisatory. As you see in a detail of *Strawberries* (fig. 9.7), the treatment of light and shade and the clustering of marks on each single berry (and there are sixty in all) is unique.

This kind of interplay between system and spontaneity is an important avant-garde principle today. Chaet's theories center in what he calls "the choreography of shape and interspace" and making "white of page equal partner to color strokes."[1] In practical terms this means making objects and the intervals

[1]Bernard Chaet, *Bernard Chaet and American Masters of Watercolor* (New York: Marilyn Pearl Gallery, October 19-November 13, 1982). Inside cover, notes on watercolor written in August 1977.

142

Fig. 9.7.
BERNARD CHAET.
Strawberries, 1983.
Detail of watercolor, 22 × 30 inches.
Courtesy Marilyn Pearl Gallery, New York.

between them equally important in your picture. It also involves making sure, in the Cézanne manner, that strokes of color relate not just to each other but to areas of white paper spaced throughout the composition.

Chaet is a sophisticated painter who reduces his art to essentials. In terms of technique, I can think of no more forthright and "direct" watercolorist, and hence no better model for the painter who is either timid or overly elaborate. Chaet deals with just one object at a time, seldom with overlapping forms. He avoids perspective and any suggestion of background other than the neutral white paper on which his pears and strawberries cast simple shadows. And although he works in the clean-cut style of Homer and Sargent, he avoids their broad washes. Instead, he relies on transparent brushmarks and occasional pigments direct from the tube that are shaped by a bit of blotting.

We have seen that modular thinking can involve either working with unitary objects, like poker chips, or dividing the page into spatial units with a grid. As a logical conclusion to this discussion, consider Erlebacher's watercolor of *Fruit* (fig. 9.8), since it is one of those rare pictures which combines both strategies.

The mathematical perfection of the scheme is fascinating. The paper is divided by vertical and horizontal center lines and by corner-to-corner diagonals. Meanwhile, several sets of modular objects are positioned on this symmetrical grid. In dead center, an oval plate is circled by eight oval eggs, four pairs of bananas, and four upright pears, while eight half-moons of dark fruit mark the sides of the frame. The design is like a formal garden in which natural forms writhe seductively within an unnatural geometric scheme; and the alternation of male and female elements, with an erect eggplant in the center, adds psychological interest.

Fig. 9.8.
MARTHA MAYER ERLEBACHER.
Fruit, 1973.
Watercolor, 22 × 30 inches.
Collection Wellington-Thorndike, Doran, Paine &
Lewis, Boston; Courtesy Robert Schoelkopf Gallery, New York.

PATTERNING AND POSITIONING

As we saw earlier, the concept of filling the page with a single dominant subject is as valid today as in Homer's time. Indeed, this may be the logical starting point for your still life endeavors, since the fewer the things you have to cope with at the outset, the better.

You should understand, however, that modernist thinking is strongly influenced by the way Cézanne and the Cubists broke up solid forms into small planes. As a result many painters today see the picture surface as a "field" to be activated by brushmarks, color spots, and other small elements. In this vein, Chaet paints scattered strawberries instead of a massive bowl of fruit. There is also general avoidance of the old notion of a "center of interest." Artists with a taste for definite subject matter, like Erlebacher, tend to favor multiple points of focus that keep every part of the picture alive. Working with modular composition is one way to do this.

Patterning is another important device for animating a composition with interacting shapes and colors. Consider Philip Pearlstein's *Model in Kimono on Wicker Rocker* (pl. 5). Where Rembrandt would have focused his golden light

on the model, the modern artist draws our eye away from the lady by introducing patterns galore—wicker work, kimono flowers, woodwork stripes, rug designs. Ultimately, it is the composition as a whole, rather than the figure, that holds our attention.

In figure work, patterning possibilities are often limited to incidentals like rugs and cushions. In still life, however, they may become the dominant element as Nancy Hagin demonstrates in *Three Red Cloths* (fig. 9.9), one of a series of watercolors painted during a fellowship summer at the MacDowell Colony. Although she had come with the thought of doing landscapes, Hagin discovered a new approach to composition by arranging things on her small studio floor. She collects "junky, silly stuff" like this ornate yellow vase, fluted tureen, and thirties ashtray. With these objects in hand, and a white pitcher that has the important role of reflecting other colors, she threw down everything she could think of that was "red"—an Indian print, a floral cloth, a design of abstract birds, and a bunch of artificial lilies and Oriental poppies. The threefold shaving mirror is a smart added touch, since it both reflects exterior light and creates Cubistic shapes.

This kind of boldly patterned still life should be a *must* for your watercolor experience. The set-up is fun to arrange, and painting the bright, flat designs is a cinch. What may prove tedious, depending on your temperament, is the preparatory drawing. Each flower, bird, and lozenge that is to be painted must be outlined in pencil first, and the spacing has to be in proportion. Once lines are in place, though, filling in colors is simplicity itself, and you will be pleased with the happy result.

Although drapery can be folded, pleated, knotted, or crushed, Hagin simplifies matters considerably by laying out her fabrics flat so that the ornamental designs can be drawn without distortion. Sometimes she puts them on the floor and sometimes, as in *High View* (fig. 9.1), on a wall. Here the elimination of shelf-tops and windowsills, the Mondrian-like severity of the architecture, and the flatness of the fabric design affirm Hagin's concern for preserving the picture plane. Typically, she renders only a few vases or pitchers with fully rounded volume. All else is flat, and even the things that are rounded cast no shadows.

In working with patterns, you will find a floor or wall set-up more effective than the usual table-top arrangement. A view from above is especially interesting because of the diagonal perspective, but pinning things to the wall is often more practical. In a classroom everyone can see the arrangement, while at home a pet or child is less likely to disturb it.

P. S. Gordon's *The Captain's All Vegged Out* (fig. 9.10) is a handsome example of the wall-relief format. Here the artist puts his main objects on a shelf at eye level so that depth perspective is minimized. The overall concept is of inlaid shapes, each assigned a particular color and texture, and these squares and diamonds are finished off one at a time. Like Hagin, Gordon starts with a flat local color. He goes further, however, in developing textures and wrinkles with numerous overlaid washes. The picture as a whole is a tour de force. Yet taken square by square, the technique is not at all impossible to attempt if you have the requisite patience. Gordon says of his own work: "The drawing may take as long as three weeks, but the rest is easy!"

If you are interested in patterning, you may want to explore a more dimensional treatment in which designs are bent or twisted as in Sondra Freckelton's *Coneflower and Zinnias* (fig. 9.11). This kind of depth illusion is encouraged by dramatic lighting and shadows, but it really starts with *positioning*—that is to say, the relationship between your eye and what you are looking at.

In other words, just as in a snapshot, any subject may be seen in flat or depth perspective. Things on a shelf, for instance, appear as flat silhouettes when seen from the front and at eye level. Yet from above or the side, the same objects must be drawn in full perspective as cubical or cylindrical volumes. In *Coneflower and Zinnias*, Freckelton characteristically chooses a close-up view that, like the zoom-lens shot, also emphasizes sculptural volumes. The chair seat is shown from above at an angle that emphasizes its bulk. And the Early American quilt is folded and twisted so that the drawing of each square or triangle is bent into sculptural curves.

Finally, we come to the question of how to shade patterns after the drawing is penciled in. Often, as in Freckelton's still life, this becomes two issues—modeling the folds of an underlying object like a quilt, dress, or cushion and

Fig. 9.9.
NANCY HAGIN.
Three Red Cloths, 1982.
Watercolor, 37 × 49½ inches.
Courtesy Fischbach Gallery, New York.

Fig. 9.10.
P. S. GORDON.
The Captain's All Vegged Out, 1982.
Watercolor, 49 × 40 inches.
Courtesy Fischbach Gallery, New York.

Fig. 9.11.
SONDRA FRECKELTON.
Coneflower and Zinnias, 1979.
Watercolor, 29 × 28½ inches.
Courtesy Brooke Alexander, Inc., New York.

then shading the ornamental designs that have been applied to it. Here my advice is to paint the basic object first as though it were a white sheet illuminated by warm lights and cool shadows. Afterward each decorative band and triangle, like the piecework shapes of Freckelton's quilt, can be laid in as local color, and the shadows underneath will show through.

THE MIRROR IMAGE

Reflections—whether on water, windows, polished metal, or glass—are basic to the watercolorist's vocabulary, since they reinforce the medium's essential quality of transparency. They are also widely used by painters generally, regardless of medium or subject, as a device for inventing shapes that are at once abstract and visually believable.

My own recent work has focused on the creative possibilities of still life reflected in mirrors. A continuing theme in my paintings has always been the idea of duality—a seamstress and her dressmaking dummy, a boy and his photograph, and in a Roman series during the sixties, pasted on words and "matching"

scenes. So when I became interested in direct painting in 1975, after years of more abstract work, using mirrors seemed a natural way to pursue my fascination with the double image.

A mirror is the surface which duplicates forms most exactly, yet one finds that it does so with startling reversals. In my *Cherry Tomatoes* (fig. 9.12), for instance, the spaces on a small table seem vast as red spheres recede into distance, brightly lighted tomatoes become dark silhouettes in the reflected image, and the angles of cast shadows shift and change. The mirror also produces a sense of ambiguity I like. Here there are no clear perspective vanishing points, and although the space is faithfully recorded, its logic is not immediately apparent to the viewer.

Different mirrors create different effects. Pearlstein's *Self-Portrait* (fig. 8.2) utilizes reflections distorted by the beveled edge of the glass in an ornate frame. My first watercolors were composed with an antique threefold mirror that produced strange cut-off shapes and odd perspectives. Arranging a set-up with bulky mirrors is tedious, however, and in the finished picture, their frames add a note of heaviness to the composition. *Cherry Tomatoes*, on the other hand, uses a lightweight, dime store, closet

Fig. 9.12.
CHARLES LE CLAIR.
Cherry Tomatoes, 1977.
Watercolor, 22 × 30 inches.
Private Collection.

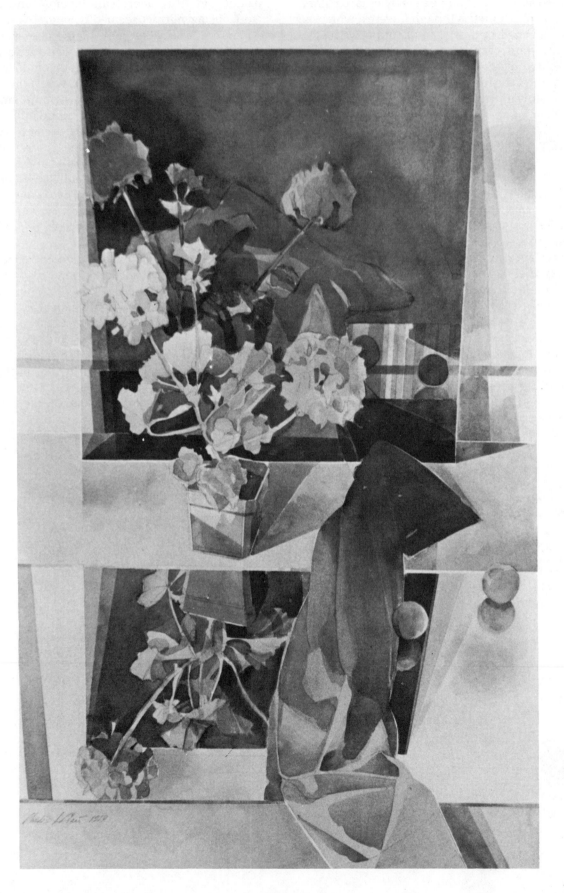

Fig. 9.13.
CHARLES LE CLAIR.
Geranium, 1979.
Watercolor, 40 × 25 inches.
Private Collection.

looking glass. It comes with a thin frame and cardboard backing that can be ripped off for a clean-cut effect. Another option is a plexiglass mirror which is available in 4-by-8-foot sheets that can be cut into panels of any size. Just look in your yellow pages under "Plastics."

The next time you attend a yard sale, you might also consider acquiring a hand mirror or glass box for your still life collection because, as we saw in Hagin's *Three Red Cloths* (fig. 9.9), the most natural way to employ mirror reflections is in a small area of the composition. On the other hand, full-scale use of mirrors produces wonderfully complex shapes, particularly when combined with multiple light sources. The set-up for my watercolor *Geranium* (fig. 9.13) was arranged on the floor with a square of dark glass placed behind a small flowering plant, and a strip of clear mirror in front. In this kind of reflective environment, a dense spatial involvement results as the modest subject is amplified by numerous repetitions and variations of the basic image.

Geranium was painted in 1979. Since then I have moved toward more subtle effects involving semi-reflections or reflections in which there is a shift in color. Clear plexiglas laid over a white tabletop produces an extremely pale reflection of anything placed on it. And in *Basil and Nectarines* (pl. 13), a sheet of blue glass transforms the colors of both the objects that are reflected and the patterned cloth which is seen through it.

In any case, working with reflections is an arbitrary device for creating abstract shapes, and there is no clearer example than Pearlstein's *Two Seated Models in Kimonos with Mirror* (fig. 5.9), which we discussed earlier. Just as his figure studies are of studio set-ups rather than "real life," so my still life paintings are of formal, tabletop arrangements rather than objects casually observed around the house. (For a technical discussion of how mirror edges and shadows are done with masking tape in my work, see chapter 11.)

Eventually, you will want to choose between a deliberate style and a more casual one. Right now, though, the important thing is to develop a vocabulary of shapes and color relationships, and this is encouraged by working with structured approaches to design. All of the strategies outlined in this chapter have this end in view. When you experiment with the "positioning" of still life objects, visualize an egg or strawberry as a "module," or look for "patterns" rather than subject matter, you discipline yourself to think like a painter—abstractly, rather than literally.

Making art, you will find, has to do with arranging things, playing with shapes and colors. And as Lewis Carroll suggests in *Alice Through the Looking Glass*, the most instant changes and miraculous transformations one can think of are made with mirrors. That is why I recommend their use, at least as an occasional strategy, in your watercolors.

10

Formalism
and Expressionism

After you have been deeply involved in the studio for a while, it is helpful to take time out for a look at watercolor from a more detached, theoretical point of view. There are things to be learned from museums and galleries and from reviewing the history of the medium which, ultimately, will stimulate the development of your own work.

Earlier we reviewed Realism from the time of Homer to the present day. In this chapter we shall consider more abstract and experimental trends, starting with such father figures as Cézanne, Klee, Nolde, and Kandinsky, and concluding with a group of contemporary painters.

There is considerable difference, however, between the two bodies of material. Historically, realism has been a dominant watercolor tradition, while interest in the medium's abstract possibilities has been sporadic. More often than not, avant-garde painters who work on paper have preferred gouache, collage, or mixed media. Nowadays, however, the situation is changing as artists discover that it can be daring to use a "plain" medium instead of a fancy one. We see more and more abstract work in current watercolor shows, and some of the more experimental ideas are coming from our younger artists.

CÉZANNE AND FORMALISM

The American public was introduced to modern art by the famous Armory Show of 1913. This was an exhibition of 1,600 art works—including everything from Matisse and Picasso to Duchamp's shocking *Nude Descending a Staircase*—attended by more than 250,000 people in New York, Chicago, and Boston in an atmosphere of brass bands and notoriety.[1]

Paul Cézanne (1839–1906) was one of five European artists accorded the most space in the show. Already, only a few years after his death, the French painter was acknowledged as a giant of modern art, and in the history of watercolor there are few figures of his stature. He painted watercolors throughout his life, producing more than four hundred catalogued works.[2] This oeuvre is not only comparable in quality to the oils, but distinctive in revealing a more improvisatory side of the artist's personality.

In a museum, where Cézanne's canvases and paintings on paper hang side by side, one is struck by the fact that, although the themes are similar, the oils come off as solid and weighty, whereas the watercolors seem light as air. One reason is that the artist allows himself greater openness and fragmentation in the watercolors. A work like *Oranges on a Plate* (fig. 10.2), for instance, is literally only "half" painted. That is to say, Cézanne has put in the shadows and then stopped, leaving the centers of the fruit, china plate, and tabletop as blank paper. The result here is a solid image, but his late papers are increasingly sketchy. Typically, they are delicate in color and made with such scattered marks that the subject hangs in air like a vague apparition. The shimmer of the watercolor version of *Mont Sainte-Victoire* (fig. 10.3), for example, is a far cry from the solidity of Cézanne's familiar oils of this subject.

Modern art is often charted as two streams of ideas—one emphasizing structure, the other emotion. In this scheme Cézanne is considered a *formalist* and father of Cubism and nonobjective art, while Van Gogh and Munch are seen as ancestors of *expressionism* in its various manifestations. Like yin and yang in Chinese thought, these can be useful concepts provided

[1]Abraham A. Davidson, *Early American Modernist Painting 1910-1935* (New York: Harper and Row, 1981), 164-72.
[2]Alain De Leiris and Carol Hynning Smith, *From Delacroix to Cézanne/French Watercolor Landscapes of the Nineteenth Century* (College Park: University of Maryland, October 26 to December 4, 1977), 91.

Preceding page: Fig. 10.1.
WASSILY KANDINSKY (Russian, 1866–1944).
Watercolor Number 13, 1913.
Watercolor, 20⅛ × 16⅛ inches.
The Museum of Modern Art, Katherine S. Dreier Bequest.

Fig. 10.2.
PAUL CÉZANNE (French, 1839–1906).
Oranges on a Plate, ca. 1900.
Watercolor, 12⅜ × 18¾ inches.
Philadelphia Museum of Art, Mr. and Mrs.
Caroll S. Tyson, Jr. Collection.

Fig. 10.3.
PAUL CÉZANNE
(French, 1839–1906).
*Mont Sainte-Victoire Seen From
Les Lauves*, 1902–1906.
Watercolor, 18½ × 12⅜ inches.
Private Collection, Philadelphia.

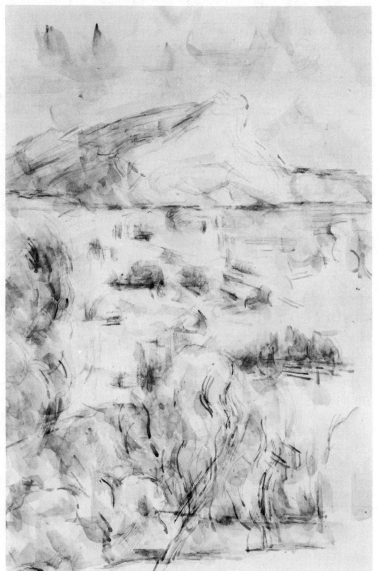

they are understood as tendencies rather than absolutes.

Certainly Cézanne's influence has been predominantly in the direction of formal structure. Even a modest little watercolor like *Oranges on a Plate* can be interpreted as an exercise in pure geometry—overlapping spheres set against a horizontal plane with vertical columns behind. This concept was taken up by Gris and Picasso after Cézanne's death, and it is the basis for our own contemporary view of still life painting as an essentially abstract genre.

At the same time, Cézanne was a transitional painter who anticipated twentieth century formalism without losing touch with nature. Despite their abstract "look," his watercolors are always based on direct observation. On balance, then, his innovations should be seen as expanding the tradition of Homer and Sargent rather than opposing it.

The elements of classic watercolor style are brilliantly embodied in his work: immaculate washes that are layered like waves lapping on sand, painted with evenly stepped values, and never retouched. Yet the artist breaks new ground by letting the paper speak for itself. He also shows us how to avoid realistic local colors in favor of arbitrary warm and cool hues—oranges against blues and violets—that suggest space. And doubtless his major contribution is the shift from traditional broad washes to small, fragmented color planes. For Demuth, Marin, and many modernists, composing with little "touches" became a form of personal handwriting and a way of translating three-dimensional reality into two-dimensional pictorial language.

ABSTRACT MODES: KANDINSKY AND DELAUNAY

Shortly before the Armory Show burst on the American scene, the Blue Rider (*Blaue Reiter*) exhibitions of 1911 and 1912 created similar shock waves in Munich, Germany. This was a society that included the French artist Delaunay, the Russian abstractionist Kandinsky, the Swiss painter and printmaker Klee, and most of the avant-garde of the day. Although the group soon broke up, Kandinsky and Klee continued their association as teachers at the Bauhaus, the most influential cultural center in Germany after World War I.

Wassily Kandinsky (1866–1944) was forty-three when—after starting a legal career, giving it up for art, and finding little success as a figurative painter—he discovered abstraction. In a series of "Compositions" and "Improvisations" he gradually eliminated subject matter until, in 1910, he produced what is thought to be the first serious nonobjective painting. Interestingly enough, it was a watercolor. A prime mover and theoretician, Kandinsky also published an influential treatise that same year, *The Spiritual in Art*, which pointed to esthetic similarities among the various arts.

Although his late work is more architectural, Kandinsky's early abstractions are in the passionately lyrical vein of *Watercolor Number 13* (fig. 10.1). The mood is rhapsodic, colors clash, and brushmarks have a kinetic energy that anticipates de Kooning and Pollock. Furthermore, the spatial conception here is cosmic, like a view of planets moving across the sky, and the artist draws lines either at an angle or curved to avoid any connection with the rectangular frame.

Meanwhile, other artists of the period were taking an opposite approach to abstraction based on geometric schemes rather than intuitive rhythms. The Dutch painter Mondrian was on the way to an idiom of horizontal and vertical lines and primary colors. Malevich launched Russian Suprematism with the ultimate in nonobjective art—a plain black square on a white ground. In Paris, the Cubists Braque, Gris, and Picasso were also at work. Their initial idea was to paint abstractly from nature by "analyzing" the model or set-up, moving around it, and painting simultaneous views. This technique "opens up" the subject, as if it were a fan or deck of cards, transforming a simple shape into multiple facets.

Robert Delaunay (1853–1941)—although he called himself an Orphist rather than a Cubist—shows how the analytic principle works in his watercolor of *The Eiffel Tower* (fig. 10.4). The subject is typical of a period that equated advance-guard art with advances in science and technology. And whereas a traditional painter might have featured the Eiffel Tower at the end of an avenue drawn in vanishing-point perspective, Delaunay shows the monument (which you can make out vaguely a little above

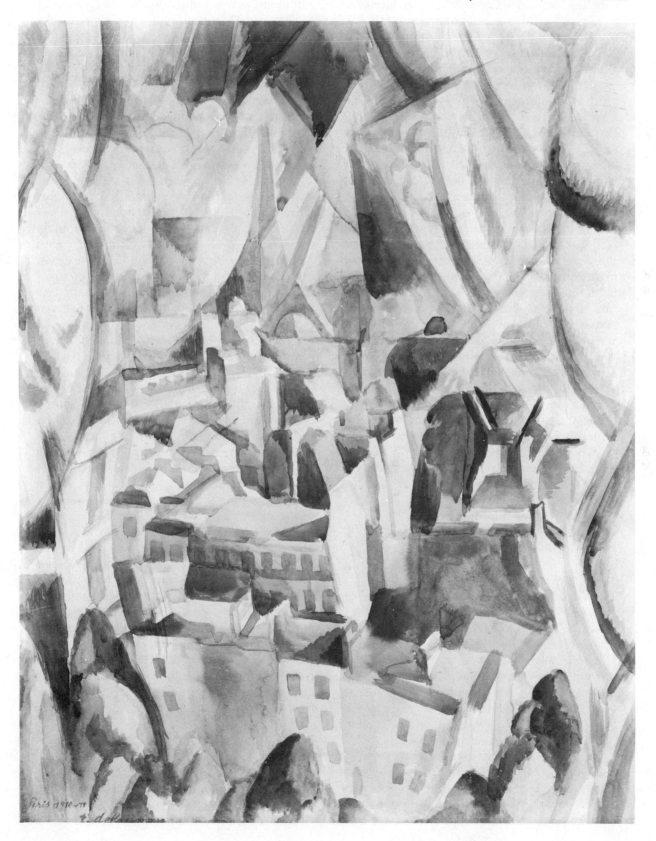

Fig. 10.4.
ROBERT DELAUNAY (French, 1885–1941).
The Eiffel Tower, 1910–1911.
Watercolor, 24½ × 19½ inches.
Philadelphia Museum of Art, A. E. Gallatin Collection.

and left of center) as just one in a series of cubelike forms. To emphasize the architectural design, he also uses stylized trees on all four sides to create a frame—quite the opposite of Kandinsky's idea of unbounded space that avoids all connection with the paper's edge.

In essence, Delaunay's concept is of a bas relief with numerous depressions and bumps which, like ice cubes floating on water, rise to a surface level parallel to the drawing board or canvas. Artists call the principle "preserving the picture plane." It is an idea implicit in Cézanne's work that was later systematized by the Cubists, and it has been a key issue in contemporary painting ever since. (See the discussion of landscape formats in chapter 6.)

The free-form lyricism of Kandinsky and the geometric structure of Cubism are the two main paths to abstraction artists have pursued, in various personal ways, throughout our century. Similarly, if you want to paint abstractly yourself, a clear choice of one or the other of these directions is needed. In contrast to realism, which is based on what you "see," abstract art proceeds from what you have "in mind." This might be anything from an elaborate strategy to a dim feeling of mood, but it simply must be clear. And figuring out in advance whether to improvise or follow a plan, and whether to paint with fluid or geometric shapes, will get you off to an assured start.

AMERICAN MODERNISTS: MARIN AND DEMUTH

Among first-generation American modernists, John Marin and Charles Demuth are our most celebrated watercolorists, although Maurice Prendergast, Arthur B. Davies, and Georgia O'Keeffe also did important work in the medium. At the time of the 1913 Armory Show, Demuth (1883–1935) had not yet returned from studying abroad, but Marin (1870–1953) was back and well established, with ten watercolors in the exhibition.

Homer's career had ended and Sargent's was waning. Marin was recognized as their successor, carrying on the tradition of open-air landscapes in a new era. During the next four decades he painted the Maine coast, the moun-

tains of New Mexico, and New York's skyline. Although he was influenced by the currents of modern art, Marin always saw himself, like Homer and Sargent, as a representational painter responding to nature. He said: "The sea I paint may not be *the* sea, but it is *a* sea, not an abstraction."[3]

Over the years the artist moved from a rhapsodic style not unlike Kandinsky's to the determinedly stylized seascapes of the twenties and thirties for which he is best known. The watercolor *Deer Isle, Maine—Boat and Sea* (fig. 10.5) typifies the subject matter and technique that became a Marin trademark. Working at Small Point, Maine, then at Stonington, Deer Isle, and finally Cape Split, he was attracted by the experience of elemental winds and waves "pushing, pulling sideways, downwards, upwards."[4] And he equated these forces of nature—not with personal drama in the manner of Homer—but with the dynamics of modernist pictorial composition.

There is probably no more forceful American watercolorist. Marin had virtuoso command of the brush, but used it for lunging strokes and dry slashes on rough paper rather than for traditional smooth washes. To achieve the "warring of masses"[5] he was after, he developed a format of separate symbolic elements that play against one another in angular rhythms. Thus *Deer Isle* is divided into six parts that read like hieroglyphs or figures in a cave painting: a stylized schooner against a patch of sea, a circle indicating the sun, waves rippling against the shore, and three tangles of fishing gear on the sand below.

Characteristically, all the lines are either straight or curved with directional force and, as in the Picasso Cubist paintings which Marin admired, active diagonals predominate. The horizon is drawn at a slant, and this tilting of the main image is reinforced by angled marks at the sides and top that have the effect of a frame within a frame. Marin often uses this device, making the inner frame energetically off-kilter so that it carries the eye from the placid rec-

[3]Donelson F. Hoopes, *American Watercolor Painting* (New York: Watson-Guptill Publications, 1977), 148.

[4]Hoopes, *American Watercolor Painting*, 148.

[5]John Marin, "Notes on 291," *Camera Work*, 42 (April–July 1913), 18.

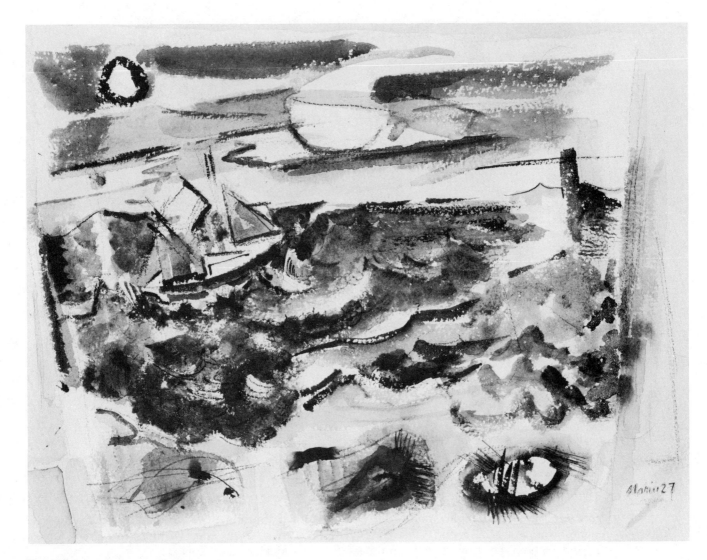

Fig. 10.5.
JOHN MARIN (American, 1870–1953).
Deer Isle, Maine—Boat and Sea, 1927.
Watercolor, 13 × 17 inches.
Philadelphia Museum of Art, Samuel S. White III
and Vera White Collection.

tangle of the paper's edge into the melee of active shapes at the center.

Reputations change, and today Marin emerges as a strong but uneven painter. His youthful work and some of his casual studies remain fresh, but the stylized seascapes admired fifty years ago come off as heavy-handed and dated. Marin's contemporary, Demuth, in contrast, is universally praised as a minor master whose work is consistently subtle and interesting. In view of this current judgment, it is fascinating to hear Demuth's own

assessment: "John Marin and I draw our inspiration from the same source, French Modernism. He brought his up in buckets and spilt much along the way. I dipped mine with a teaspoon, but I never spilled a drop."[6]

Demuth was born, died, and did most of his work in Lancaster, a small Pennsylvania Dutch town. However, he studied abroad where he knew Gertrude Stein and Sherwood Anderson, and he was a regular visitor to New

[6]Hoopes, *American Watercolor Painting*, 148.

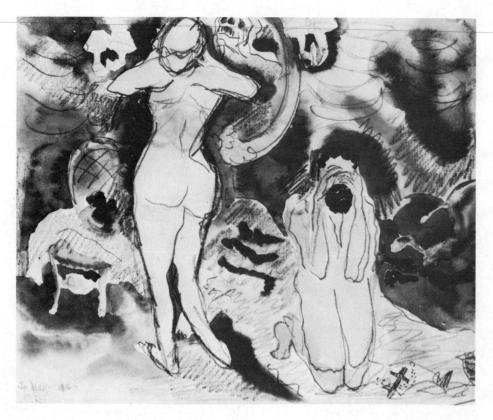

Fig. 10.6.
CHARLES DEMUTH (American, 1883–1935).
Ta Nana, 1916.
Watercolor, 8 × 10 inches.
Courtesy Salander-O'Reilly Galleries, Inc., New York.

York art salons and night spots. Marcel Duchamp was a special friend, as was Eugene O'Neill, whom he saw during summers in Provincetown. The playwright used Demuth for a character in *Strange Interlude*, and the artist responded with a painted *Homage to Eugene O'Neill*. Unfortunately, a permanent limp colored Demuth's life, and after 1919 he worked in the shadow of a debilitating disease. Many of his finest paintings were done during this difficult period.[7]

Although Demuth is best known as a formalist specializing in coolly detached arrangements of fruit, flowers, and houses, he also did figure studies in a more emotional style. Around 1930, he painted a score of watercolors of French sailors in homoerotic poses. Earlier he sketched acrobats observed in a local vaudeville house and did numerous illustrations, for his own amusement rather than commercial use, of scenes from the writings of Poe, James, Wedekind, and Zola.

Typical is the watercolor illustration *Ta Nana* (Your Nana) which reflects Demuth's fascination with things sinister and decadent (see fig. 10.6). He loved Beardsley's notion of the femme fatale, and shows Zola's heroine as a naked courtesan, her clothing and rosary thrown down, standing before a mirror which reflects her face as a death's head. It is hard to believe now but, when first exhibited, the Nana watercolors were considered so daring that they had to be hidden away and shown only "to museum directors and proven lovers of modern art upon presentation of visiting cards."[8]

Demuth's still lifes and architectural studies are something else again—formally structured and exquisitely painted with shaded

[7]Alvord L. Eiseman, *Charles Demuth* (New York: Watson-Guptill Publications, 1982), 10-30.

[8]Eiseman, *Charles Demuth*, 27. Quoted from Henry McBride, *The New York Sun*, October 30, 1914.

planes that owe something to Cézanne. During a 1917 visit to Bermuda, the artist began to work in a Cubist manner which he continued in subsequent watercolors of Provincetown houses like the *Red Chimney* (fig. 10.7). Here arbitrary shifts in perspective create faceted angles, the houses are paper thin, and the lines of the buildings are extended abstractly into space. *Red Chimney* also illustrates Demuth's distinctive blotter technique. Washes are painted neatly against a ruled edge and then blotted off on the other side. When the process is repeated with several overlays, planes are built-up which give the effect of rays of light cutting through a Cape Cod fog.

Like Marin, Demuth also worked in oils. Marin's canvases are cut from the same pattern as the watercolors but without quite the same finesse. Demuth, on the other hand, used oils and tempera for further inventions. Although he is acknowledged as our foremost modern watercolorist, the artist's precisionist paintings of factories and silos, along with the "poster-portraits" of friends like Dove, O'Neill, and Gertrude Stein, would in any case put him in the top rank of American artists.

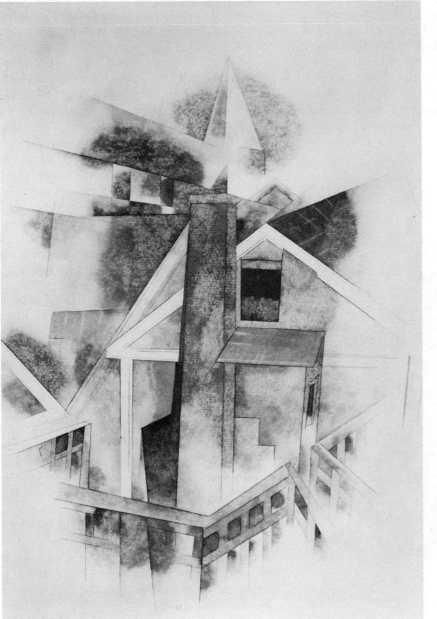

Fig. 10.7.
Charles Demuth
(American, 1883–1935).
Red Chimney, 1920.
Watercolor,
14 × 10¾ inches.
Philadelphia Museum of Art,
Samuel S. White III and
Vera White Collection.

EXPRESSIONISM: NOLDE, GROSZ, AND BURCHFIELD

In discussing *expressionism* one must cut through various usages of the term to a definition that is useful for the practicing artist. Historians speak of any style that distorts nature as expressionistic. The term often is applied to the fervent Northern Gothic impulse as compared with rational Graeco-Roman classicism. And critics of modern art use it in connection with such specific movements as the German *Blaue Reiter*, Mexican mural painting, and American Abstract Expressionism.

In the studio, however, expressionism is best thought of as one of the basic modes of painting from life. If you aren't into abstraction, there are essentially three ways to go; making the picture look like the subject (*realism*), creating a mood without fussing with details (*impressionism*), or pouring out your feelings with hopped-up colors and exaggerated drawing

Fig. 10.8.
Emil Nolde (German, 1867–1956).
Papuan Head, 1914.
Watercolor, 19⅞ × 14¾ inches.
The Museum of Modern Art, Gift of Mr. and Mrs. Eugene Victor Thaw.

(*expressionism*). In this last mode, anything goes. Things can be upside down or out-of-scale, and skin can be purple or green instead of natural pink. (Think of Van Gogh, Chagall, and Munch.) The motivation for such vehemence, of course, is the expressionist's intense emotional response to something seen or experienced in life.

Emil Hansen (1867–1956), called Nolde after his hometown in remote North Germany, is the leading watercolorist of the European Expressionist movement. This started in 1905 in Dresden with the short-lived but seminal *Bridge* group (*Die Brücke*) which brought together artists like Pechstein, Heckel, Kirchner, and Nolde who developed a common style under the influence of the Norwegian painter of *angst*, Edvard Munch.

Nolde's *Papuan Head* (fig. 10.8) was painted during a 1913 ethnological expedition to New Guinea, a trip motivated, like Gauguin's earlier visits to the South Seas, by the ideal of a "primitive" vision that might create a shocking effect. The watercolor seems innocuous enough today, but it does illustrate the artist's use of black brush-drawing in his figure studies. These include portraits, biblical scenes, and symbolic personages. Typically, Nolde paints flat colors to indicate skin, costume, and background; lets the edges of these washes run together; and then draws the subject, as here, with overlaid dark brushmarks. Reminiscent of Rouault's familiar "stained glass" style, this is a technique that a beginning watercolorist can use with good results.

The Expressionists were interested in Freudian psychology as well as primitive culture. They admired child art and cultivated a naïve approach designed to convey deep-seated unconscious emotion more effectively than conventional technique. Accordingly, Nolde painted moody watercolor landscapes and flower studies with poster-bright colors as children do, letting wet strokes run together and covering most of the white paper with pigment. Like *Amaryllis and Anemone* (fig. 10.9), these last are often composed of two or three blossoms in close-up against a sunlit or night sky. As images, Nolde's blossoms float like flowers in a dream garden. As watercolors, they are simple yet wonderfully accomplished. The color is always exciting, and the blots and spills create a rich, earthy texture.

Fig. 10.9.
EMIL NOLDE (German, 1867–1956).
Amaryllis and Anemone, ca. 1930.
Watercolor, 13¾ × 18⅜ inches.
The Museum of Modern Art, Gift of Philip L. Goodwin.

Fig. 10.10.
GEORGE GROSZ (German, 1839–1956).
Eclipse, 1925.
Watercolor, 20 × 16 inches.
Philadelphia Museum of Art, Gift of Mr. Erich Cohn.

Nolde is much admired by today's art students. Many, without knowing it, are of an "expressionist" temperament themselves—individuals intent on conveying their feelings without worrying about rules and regulations. Painting with childlike directness, however, is not as easy as it sounds. Five-year-olds work with poster paints that stay put, whereas wet watercolors run together in an instant.

Thus, if you want to work this way, note how Nolde adjusts his technique to the limitations of his medium. For one thing, he confines himself to themes that can be depicted with a few simple color masses and minimal drawing—subjects like sea and sky, or a blossom and three or four leaves. For another, he avoids standard papers in favor of absorbent stock that sucks up washes immediately so that, when they bleed, it is only at the edges. Some of the papers available today that have this effect are newsprint and construction paper (impermanent), Oriental papers, and soft-surface rag papers designed for printmaking.

Since expressionists deal with emotion rather than fact, they often use *symbolism* to suggest states of mind, erotic overtones, or mystical feelings. A symbol is a representation of something that stands for an idea or cluster of ideas beyond itself. Some symbols are private while others, like the cross or American flag, are in the public domain—generally recognized images which may be expected to arouse an emotional response. After World War I, artists found symbolism particularly effective in conveying their social concerns. We see this in the plays of Brecht, the murals of Orozco, and the late phase of expressionism in Germany dominated by the New Objectivity group (*Die Neue Sachlichkeit*) led by Beckmann, Dix, and George Grosz.[9]

Grosz (1893–1956) was essentially a graphic artist who, as we saw earlier, developed a wet-in-wet watercolor technique which could surround a brutal line drawing with sinister atmosphere. In *Eclipse* (fig. 10.10) he portrays the corrupt middle class as headless automatons in empty starched collars, an image that calls to mind Eliot's poem *The Hollow Men*. These puppet figures sit in a room littered with skulls and bones of war dead, while outside the sun (or perhaps the German state) goes into eclipse. Their conference table is littered with briefcases, a bloody sword, and a toy ass wearing blinders, and the scene is presided over by a medal-bedecked general and a munitions maker with gun tucked under his arm.

This is expressionism with a vengeance. *Eclipse* is also typical of the scathing social criticism that abounded in German art of the twenties. When the Nazis came to power, they banned such works as "degenerate." Grosz fled to America, but like many other modernists, Nolde was put under surveillance and forbidden to paint during their reign.[10]

Expressionism didn't take hold in this country as it did in Northern Europe. Between the two World Wars a number of painters worked in a freely distorted style, and among those known for watercolors, Jacob Lawrence and Ben Shahn are notable for their paintings of social protest. There was little sense of a "movement" here, however, and American Regionalists during the Depression tended to glorify the status quo rather than attack it.

Most Americans whom one might compare with Nolde or Grosz have been loners like the Buffalo painter Charles Burchfield (1893–1967). A wallpaper designer and camouflage artist in World War I, Burchfield began to make it as a serious painter in his late thirties. Turning to art full time, he "stuck to his last," was a prodigious worker, and whereas most regionalist painters of the day have faded into obscurity, his reputation has steadily gained in lustre.

Despite art school training for his early commercial design job, Burchfield was largely self-taught as a serious painter. By 1916, he had developed a vocabulary of symbolic shapes which he called "conventions for abstract thought."[11] These were based on facial expressions which he applied to houses and trees in the way that Disney animators invest nature with human gestures. In *Afternoon in the Grove* (fig. 10.11), for example, the sun shines through a treetop, transforming it into a kind of smiling face with a halo of leaves as hair and a dark tree trunk as the neck. The forest as a whole sug-

[9]Strictly speaking, *Die Neue Sachlichkeit* arose in opposition to Expressionism. In a broad context, however, it may be seen as an extension of the movement, rather than a reversal, with a new focus on social issues.

[10]Martin Gosebruch, *Nolde: Watercolors and Drawings* (New York: Praeger Publishers, 1973), 24.

[11]Hoopes, *American Watercolor Painting*, 151.

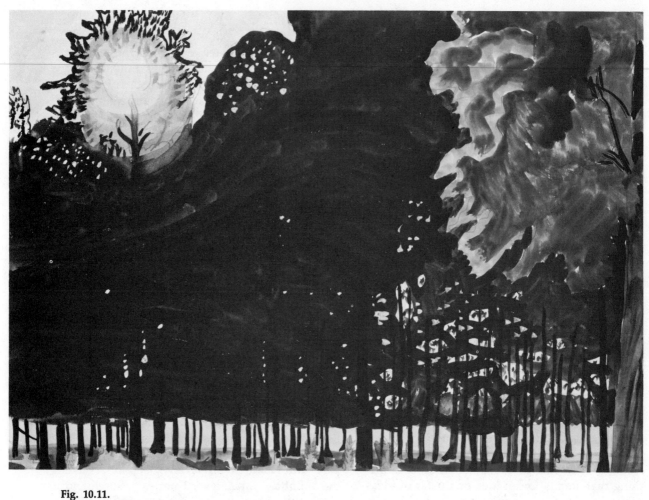

gests huddled figures in a black cloak with legs and feet underneath. We also observe little wiggly marks and sparkles of light that Burchfield often uses to evoke the movement and murmurs of crickets, cicadas, and fireflies.

The painter had a curious career. He started as an expressionist, had considerable fame during the thirties as an Edward Hopper kind of realist, and then after 1940 returned to his original style. A late work like *Purple Vetch and Buttercups* (fig. 10.12) takes up where the early watercolors leave off, except that the composition is now more arbitrary and less tied to an observed situation. The painting is composed like music, with each cloud, tree, and plant assigned a linear motif (or "melody") as if it were an instrument in an orchestral ensemble.

Burchfield has historical importance as the first well-known artist to have used watercolor on the heroic scale which, in the last decade, has transformed it from a minor to a major art form. *Purple Vetch* is a striking 40 inches high, and many Burchfields are as large as 40-by-56 inches. Since modern oversize papers were not available during Burchfield's lifetime, the artist had to combine several sheets which he glued to a backing. When dissatisfied with certain areas, he often cut them out and pasted in new sections, working doggedly at compositions that sometimes took years to complete. With such a system, it is understandable that Burchfield's paint quality is more earnest than fresh. But his compositions have weight, conviction, and the stamp of a unique talent.

EXPRESSIONISM TODAY

It is the nature of art movements to become dominant, fade, and then renew themselves. As

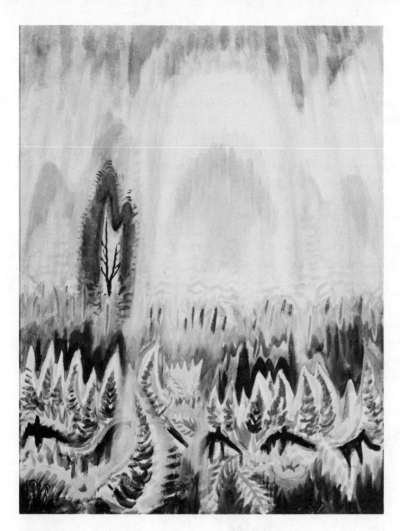

Fig. 10.12.
CHARLES BURCHFIELD (American, 1893–1967).
Purple Vetch and Buttercups, 1959.
Watercolor, 40 × 30 inches.
Pennsylvania Academy of the Fine Arts, Lambert Fund Purchase.

we have seen, the return to representational painting during the seventies sparked widespread interest in watercolor. Currently, there is a swing of the pendulum toward more emotionally charged work, and the critics who coined the term New Realism a few years ago now speak of the "New" Expressionism of the eighties.

This is often characterized by the use of bizarre materials (like paint smears on velvet or broken crockery), an enormous physical scale, and an aggressive mixture of sculptural and painted forms. There are, however, a number of important painters of expressionist temperament who find traditional mediums and formats congenial. Among this group, Malcolm Morley and James McGarrell have done particularly influential work in watercolor.

Morley is a British painter currently living in New York. After an early involvement with Photo-Realism and then with abstraction, he is now working in a highly personal, freewheeling style. *Nude with Plane Crash* (fig. 10.13), for example, has the vehemence of a Nolde or Grosz, yet Morley's approach is astringently up-to-date rather than romantic or old hat. The subject is a miniature airplane, complete with Pan American logo, that has crashed against a naked woman in a symbolic action implying a violent sexual encounter. The painting's eroticism recalls Expressionists like Beardsley and Munch, but it is stated with 1980s frankness. The plane's fuselage is an undisguised phallus, and details of pubic hair and dripping blood are brutally explicit.

Perhaps even more significant is Morley's ability to achieve a "brutal" paint quality with transparent watercolor. Watercolor is a comparatively quiet medium, and for this reason Expressionist painters working on paper usually favor more forceful materials like gouache, grease crayons, collage, or combined media. Yet

167

Morley is able to transform clear, bright washes—through a mixture of slashes, standing puddles, and drips running the length of the page—into an effect of raw power.

Morley's style is similar to that of the New Realists except that he juxtaposes images in a way that invites symbolic interpretation. His *Nude with Plane Crash*, for instance, is not unlike one of Pearlstein's compositions—the figure, with head cropped by the frame, posed against a boldly patterned cloth. Yet the emotional impact is quite different in view of the strange symbolism of the plane crash. Surely this is no toy plane flying about the studio as the model poses. The wounds are too graphic, and not only the woman's flesh, but also the watercolor itself seems to be bleeding. Perhaps Morley intends a metaphor for a passionate force in art as well as life.

This is a fanciful interpretation of a picture meant to invite such imaginings. It is a popular fallacy that a painting may mean anything the viewer sees in it. Nothing could be further from the truth. A portrait, still life, or landscape cannot fairly be interpreted as symbolism unless the artist signals such an intention with some sort of transformation or reversal of normalcy. The association of subjects may be bizarre, as here, or objects may be painted upside down, in illogical scale, or in unlikely colors. To illustrate: Morley's *The Palms of Vai* (pl. 16) would not have had symbolic meaning had the sky been painted flat blue; yet with a giant Cretan bull and the fragment of an antique female torso floating over the horizon, there is no other way to take it.

Like Morley, McGarrell builds his compositions around highly personal symbols,

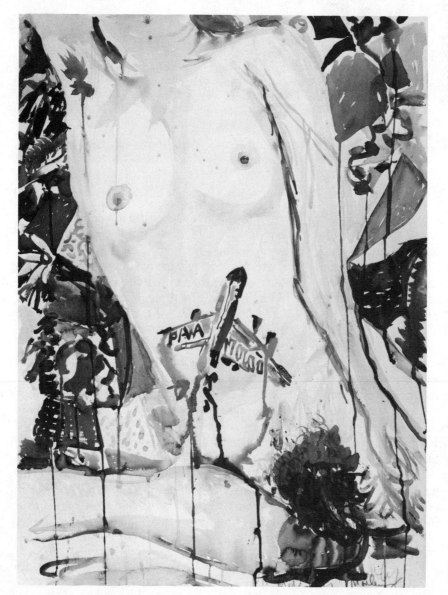

Fig. 10.13.
MALCOLM MORLEY.
Nude with Plane Crash, 1976.
Watercolor, 31¼ ×
22⅝ inches.
Courtesy Xavier Fourçade, Inc.,
New York.

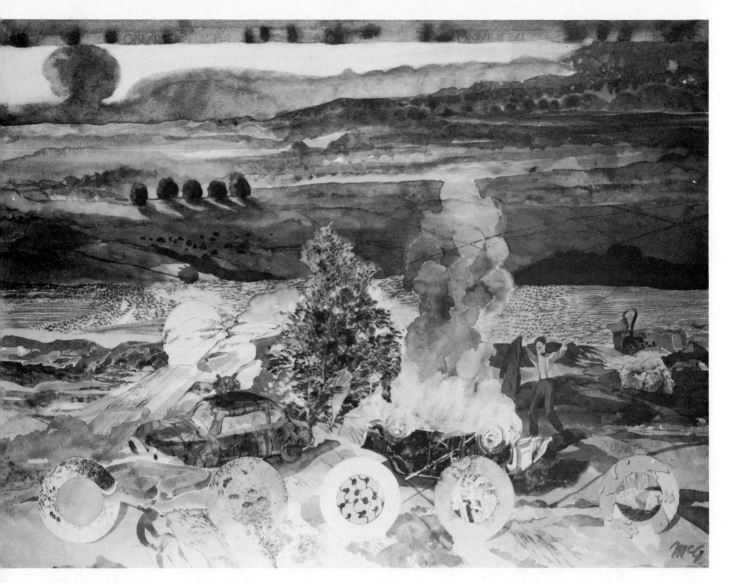

Fig. 10.14.
JAMES MCGARRELL.
Car Fire, 1978.
Watercolor, wax pastel, and colored pencil,
22 × 30 inches.
Courtesy Allan Frumkin Gallery, New York.

although in a more subtle lyrical style. The artist, now at Washington University in St. Louis, taught at the University of Indiana for many years. He also has a home in Italy, where in 1978 he began to work in watercolor, attracted by its portability and the ease of maintaining full equipment in both countries. Nowadays he alternates between mammoth canvases and small, swiftly done watercolors that he finds "more flexible and open" and attuned to "playfulness and improvisation."

A further advantage he sees is the medium's suitability for work done in a series. McGarrell is excited by discoveries made when an idea or image is put through a sequence of transformations. *Car Fire* (Fig. 10.14), for in-

stance, is one of twelve variations on the theme of modern characters in a classical setting acting out precarious events, like this one of an overturned car ablaze in a sunset landscape with an atomic cloud in the distance.

The artist gives obvious clues suggesting that this is no literal traffic accident. A metaphysical tone is established by five medallions arranged up front like actors in a Greek chorus interpreting the scene behind. Immediately, the five trees in the distance take on significance as an echo of this row of round shapes, and we perceive the car smoke as a repetition of the ominous mushroom cloud. The medallions also seem to stand for something—perhaps the circle of life and death or the wheel of fortune. The

central disc has been left blank, McGarrell says, as a "symbol of emptiness," although I suspect an equally valid case could be made for it as a symbol of perfection, like the halo.

Photographs cannot fully suggest the qualities of an original painting, and this is an especial handicap in McGarrell's case because of his intricately rendered textures. Despite the looseness of the larger washes, there are marvelously subtle details one cannot really see without examining the paper closely or even using a magnifying glass. Technically, these are mixed-media paintings done on handmade paper with—in addition to watercolor—colored pencils, wax pastels, gouache, or anything else that will achieve a desired effect. One observes, however, that the opaque touches and delicately drawn passages serve primarily as a foil for broad areas of wet work. As the artist says, "Transparency is what the pictures are about."

Tabletop Joys (pl. 24) is, at four feet in width, McGarrell's largest watercolor, one of his loveliest, and also one of those rare pictures an artist sometimes makes as a *summa* of technique and philosophy. Doubtless the "tabletop" of the title stands for both the drawing board and the board for dining and wining, and I would interpret the theme as an apotheosis of the joys of art and life.

Here we have every watercolor technique in the book put to the service of a metaphysical image of the artist as interpreter of the universe. A painter stands at his easel, backed by mountain storms and an advancing tidal wave. In front are a flock of birds, picnic tables, a modern bicycle, an antique plowshare, and goodness knows what else. Thirty-two oblong medallions frame the scene with a more abstract restatement of these same elements of nature and art. There are emblems of birds, animals, and fish as well as references to such painting genres as portraiture, still life, and landscape.

Today's artists approach watercolor with an ambitiousness that, a few years ago, would have been reserved for weightier mediums. The Realists broke new ground by expanding the size of their work, and McGarrell shows a similar pictorial ambition in the grandeur of his themes. *Tabletop Joys* is unabashed cosmic symbolism. Even in his smaller watercolors, the artist typically establishes an heroic mood by using Renaissance formats and linking modern incidents with classical imagery.

EXPERIMENTAL MODES: KLEE AND SOME CONTEMPORARIES

In a watercolor class, I keep two books at hand to illustrate this or that point for students. They are monographs on Sargent and Klee. You can find almost any representational technique you are looking for in Sargent's work, because he painted in such varied ways. In an abstract frame of reference, the same can be said for Klee. He approaches each subject as a new experience, and there are innumerable experimental ideas to be noted in his paintings.

Paul Klee (1879–1940) was a Swiss artist who spent most of his life in Germany, where he taught at the Bauhaus and then in Düsseldorf until the Nazis dismissed him in 1933. If he were living today, I suspect Klee might be called a "conceptualist." This is a musician who finds painting analogous to composing music; a poet who writes imagist titles like "The Twittering Machine" or "The Equilibrist Above the Swamp"; and a student of dance, opera, and theatre who paints his friends as though on a stage complete with props, masks, and puppet strings. Above all, Klee is a painter whose ideas center in systematic use of the basic elements of line, value, and color. This emphasis on form links his painting with modernist abstract art. And the way he strips figures down to basic shapes adds a note of primitivism, childlike naïveté, and Freudian suggestiveness that is in the spirit of Expressionism.

To illustrate, let's look at Klee's watercolor portrait of *Jörg* (fig. 10.15). The gentleman's frontal position and gesture suggest a theatre pantomimist; he is costumed like William Tell with a feather in his cap; and his face is a paper-bag-like mask. Doubtless Klee was influenced here by the Bauhaus theatre program which featured marionettes, ritual ceremonies, circus and vaudeville acts, and students performing with masks or painted faces. We also note how Klee builds a picture with linear motifs repeated like musical themes—*circles* for eyes, locket, armpits; *parallel marks* for the feather, costume shading, and Abraham Lincoln beard; and a *V shape* for the nose and breastbone. Even the curling feather tip repeats the tail-stroke of the letter *G* above it.

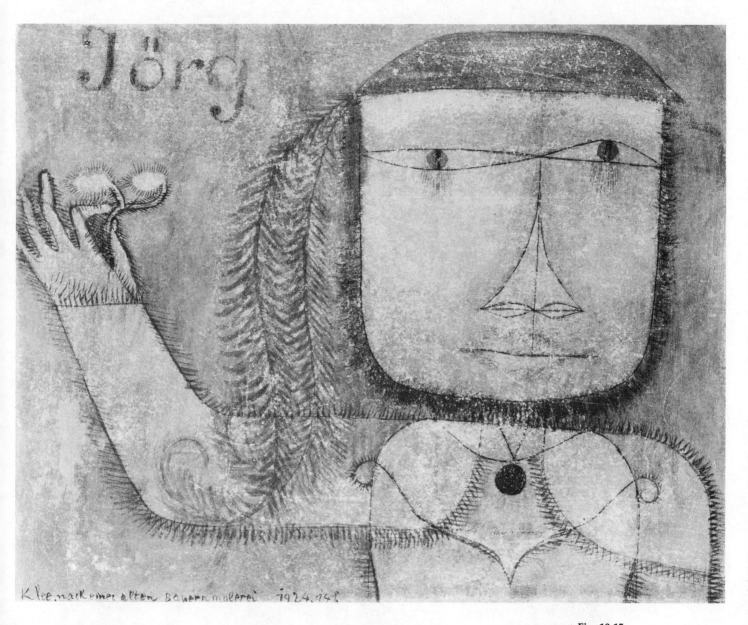

Fig. 10.15.
PAUL KLEE (Swiss, 1879–1940).
Jörg, 1924.
Watercolor, 9¼ × 11¼ inches.
Philadelphia Museum of Art, Louise and Walter Arensberg Collection.

Fig. 10.16.
PAUL KLEE (Swiss, 1879–1940).
Dying Plants, 1922.
Watercolor and pen and ink, 19⅛ × 12⅝ inches.
The Museum of Modern Art, Philip L. Goodwin Collection.

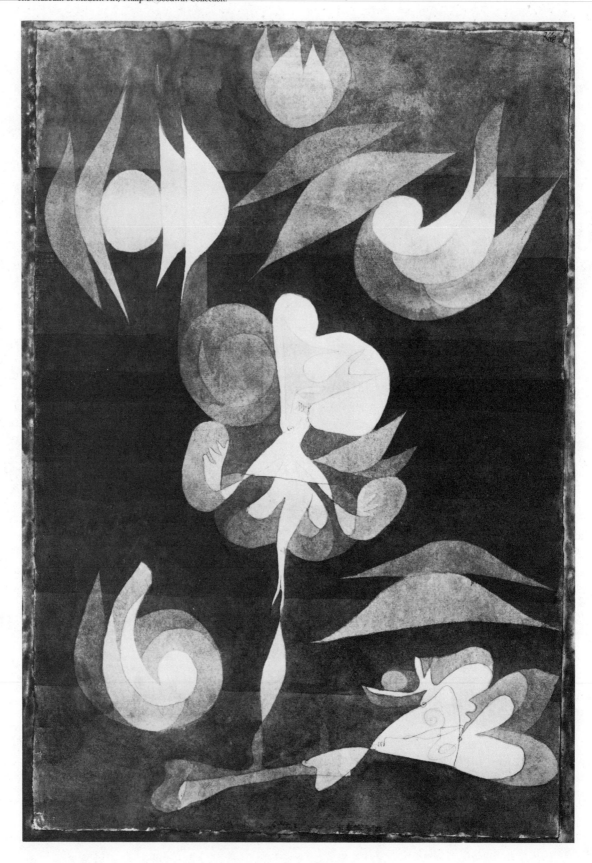

Just as Cézanne influenced twentieth century formalism, Klee is a key figure in avant-garde "experimental" painting. This is a pervasive attitude in modern art that sees the painter less as a creator of esthetic order than an inventor, explorer, and discoverer of novel visual games. In particular, Klee's work foreshadows what is going on today in its use of *diagrammatic space.*

Instead of Renaissance perspective, or Cézanne's simplifying planes, a watercolor like *Dying Plants* (fig. 10.16) charts what is happening the way technical illustrations, "how to get there" maps, and video games often do. The story starts at the top with a blossom that is alive and well. Then horizontal bands create a time frame for the descending drama of the plant's last hours. The eye follows light shapes down the page like the bouncing ball in a sing-along cartoon—first a round flower, then one with peeling petals, next a crumpled blossom that begins to look humanoid, and finally, a flower lady lying dead on the ground. Klee usually has a story to tell, but his concept of diagrammed spatial movement is applicable to nonobjective art as well. In current abstract art, movements are often charted by arrows, dotted lines, or written directions as in a Monopoly game.

Traditionally, small-scale work in watercolor had been associated with open-air sketching. Klee's contribution was the notebook-oriented, experimental, quirky little painting on paper. This has remained a viable contemporary idiom, as we see in the work of Robert Keyser.

Keyser is a Bucks County artist who exhibits in New York and teaches at the Philadelphia College of Art. Like Klee, he builds a picture around a narrative. In *The Oracle Contemplates the Great Clapper* (pl. 20) the theme, he says, is "time." One discovers that the mysterious phallic shapes at the top are in fact "escapements," which the dictionary defines as parts of a clock that measure beats and control its speed. So a ticktock rhythm is established as the "oracle" gazes out at the lower left. This is a headless sculpture which Keyser sketched in Italy and adopted as a recurrent personal image. Meanwhile, the elements of nature are suggested by a blue sea washing over sand and what might be a kite on a string. There is also a mazelike drawing at the top that is repeated in reverse down below and filled in with brilliant colors.

Just what all this means cannot be said precisely, because it is not only personal symbolism, but imagery in which some references (like the oracle sculpture) are clear, while others (such as the escapements) are untranslatable without a key. What one does appreciate is that the artist's shapes derive from "concrete" references in his life and thus avoid the banality of the generalized stripes and grids one so often sees. I also suspect there is some truth in the theory that a deeply felt private symbol, even when obscure to the observer's conscious mind, will arouse an unconscious emotional response.

Keyser's *How to Cure the Hecups* (fig. 10.17) is again reminiscent of Klee in the humorous title and diagrammed story. A *he*-man does sit-*ups* and hence, perhaps, the jabberwocky word "hecups." The figure exercises to the beat of ectoplasmic clapping hands, which Keyser explains as a traffic cop's "stop and go" fingers—the kind of detached body parts one sees in cartoons.

Mood and technique, however, are distinctly 1980s in feeling. As we have seen, Klee approached every picture differently. One might be on cheesecloth, another on faked antique paper; yet like most early modernists, his goal was a homogeneous paint surface and a "handmade" look in each case. Today's artists, on the other hand, often favor *eclectic* (or mixed) effects, combining free brush and mechanical rendering in the same watercolor. Thus Keyser depicts his he-man in three quite different styles. First there is an outline drawing in black ink, then a dotted-line diagram in which underwear is indicated with a ruling pen and, finally, a blurry "hand-painted" cast shadow. The border contains similar surprises. Expressionist wiggles enliven three of the sides, while the lower strip contains a ground plan of the events above and two wormlike forms crawling, like Muppets, into the composition.

The only certainty in modern art is that, whatever the status quo, it is about to change. So to put a finger to the wind, it is a good idea to check out what younger artists are doing. Marilyn Holsing, Todd McKie, and John Dowell, for instance, are experimental painters who may very well represent the wave of the future. Each has a unique point of view, and together they represent three distinct and important new directions in watercolor.

Holsing's *The Divers in the Islands* (fig. 10.18) is representative of the swing toward per-

Fig. 10.17.
Robert Keyser.
How to Cure the Hecups, 1981.
Watercolor, 15 × 15½ inches.
Courtesy Marian Locks Gallery, Philadelphia.

sonal narrative themes in much recent art. Painted in 1981, it is one of ten watercolors in a series called "The Bride," which expressed the artist's ambivalent thoughts about her forthcoming marriage. We see impending disaster in the form of a flood rising outside the house. In preparation for crisis, the groom-to-be practices swim strokes on the living room carpet, while the future bride rehearses diving motions. Aside from personal references, water is of course a universal symbol of fertility as well as danger. The drink in the window is a particularly nice touch—perhaps a toast to the bride, or a modern holy grail in the form of a common glass tumbler.

In comparison with Keyser's polished technique, Holsing's work is also a little *funky*. This is an interesting word which used to have the negative connotation of "foul" or "evil-smelling," and currently refers pleasantly to art that is earthy, unconventional, or offbeat. Where Keyser stretches paper smooth and paints delicate washes, many younger artists prefer earnest rather than suave techniques. In *Divers in the Islands*, for example, Holsing stains each area a flat, unvarying color and indicates ruglike textures with studiously repetitive marks. The drawing is also simple. The figures are like paper dolls, and Holsing uses *isometric perspective*—perspective without vanishing points, in which a house is shown as a paper box seen from above. Conceptually, the work

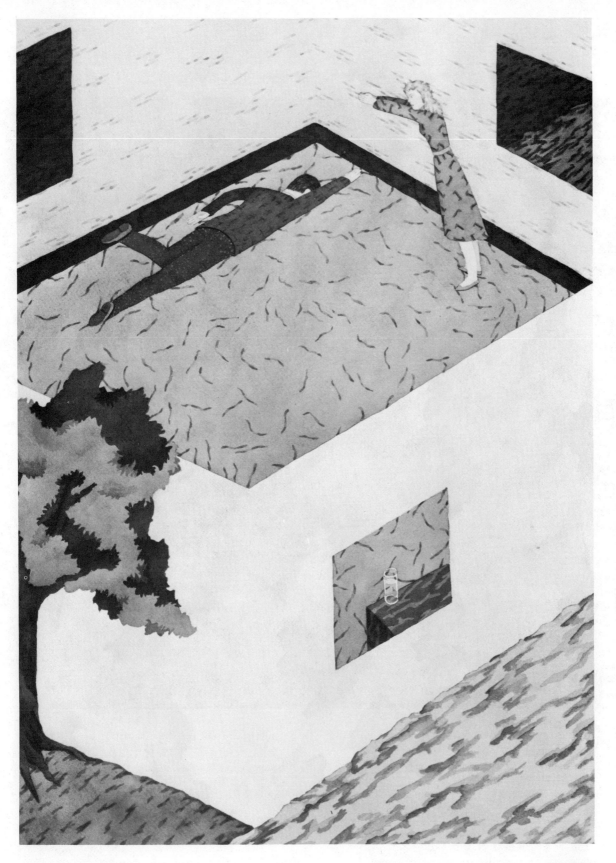

Fig. 10.18.
Marilyn Holsing.
The Divers in the Islands, 1981.
Watercolor, 25½ × 36¼ inches.
Courtesy Jeffrey Fuller Gallery, Philadelphia.

Fig. 10.19.
TODD McKIE.
Accidents Will Happen, 1981.
Watercolor, 44 × 53 inches.
Courtesy Barbara Krakow Gallery, Boston.

reveals a sophisticated awareness of Oriental screens, Italian primitive landscapes, and Klee's diagrammatic space. Technically, however, it is disarmingly direct, and therein lies a valuable lesson for the beginner. Watercolor requires simplification of some kind, and painting two or three apples on a plate is one way to go. On the other hand, you can tackle the most complicated of subjects (like this scene of figures acting out a story in an indoor-outdoor space) provided you learn to pare down your technique.

Although most experimental work today is, like Keyser's and Holsing's, quite small, Todd McKie shows what can be done with abstract watercolors on a monumental scale. McKie is a Boston artist now living in New York. In his *Home Sweet House* (pl. 19) and *Accidents will Happen* (fig. 10.19) Klee's influence is evident in the overlapping shapes and in schematic devices like the word "PARIS" and the directional arrow. There is also subject matter to be "read." A silhouette of the artist is at the center of each composition, with a dog at his feet and a chair on the left that stands for his wife. *In Home Sweet House* the figure prepares supper with a huge fish (tail up) over his shoulder, a stick of butter on the chair, a snail at the ready, and a napkin over one arm. And in *Accidents Will Happen* our hero is shown in the studio, smoking a pipe with a Calderish mobile overhead, while an upset paint can spills over his work table.

McKie stakes out new territory, however, in blowing up such fanciful Klee-like images to the scale of a Brady or Pearlstein. We have seen how contemporary realists use shadows, rugs, fabric patterns, and wood-grain textures to solidify surfaces. These devices, on the other hand, are not available to an abstractionist like McKie whose challenge is to make broad, empty color areas seem substantial rather than like watery veils.

He succeeds admirably with procedures that can be adapted to any home or school situation, provided you have space for a huge plywood board and a table to lay it on. (McKie has a Roto-Tilt table that dips in any direction, but this is a help rather than a necessity.) After preparing the plywood with a waterproof varnish, the paper is fastened to it with two-inch masking tape, half on the board and half pressed to a line marking a one-inch border. Next McKie washes the paper repeatedly for five minutes with a sponge. His purpose is not really to stretch it, although the paper does smooth down a bit, but to remove the sizing so that colors will sink in. Traditional technique calls for washes to float over the surface, but watercolors can also be encouraged to penetrate like dye. In McKie's case, it is this drenching of the fibers that gives textural body and a distinctive, slightly mottled effect to his work.

When the paper has dried after sponging, a key contour drawing is penciled in. McKie develops this in a novel way, using small diagrams and cutouts enlarged to full scale by an opaque projector. Images such as the chair, the dog, or the snail are moved about in the projector window, lines are corrected, and when proportions are right, the artist simply props his plywood board in the path of the projected design and traces it onto the paper. Solid color areas are then filled in and completed in one or two wash layers. Most shapes are shaded, either from dark to light or from one hue to another in a rainbow glissando. Unlike most watercolorists, McKie also covers virtually all of the white paper with deep hues that give his work the visual weight of an oil or acrylic on canvas.

The third of our experimentalists is John Dowell, a Philadelphia painter and printmaker who carries forward the ideas of Klee and Kandinsky in quite another way. Instead of employing stories or symbols, his watercolors are nonobjective. They do make use of diagrammatic space, however, and take the concept of painting's kinship with music—an idea that delighted first generation modernists—to its logical, and *literal*, conclusion. Dowell conceives his watercolors as actual musical scores, and he makes appearances with a group of musicians who "play" them.

This is not to suggest that a painting like *Love Jamb* (pl. 22) is *only* a musical score, or that it must be "played" to be enjoyed. It is, however, conceived in relation to music. The lines have melodic shape; forms are gestural, like the thrusts of a conductor's baton; and like each of Dowell's "pieces," it has a distinctive tempo and beat.

Thus when we "hear" Dowell's watercolors interpreted by a combo of piano, vibraphone, saxophone, clarinet, and percussion instruments, the "visual" experience is enriched. At the same time, we are introduced

to a new "sound" experience and made vividly aware of Dowell's primary concern: the relationship between painting gestures that take place in *time* and their simultaneous location on the *space* of the page. (For a discussion of the artist's technique, see chapter 2.)

CONCLUSION

In this chapter we have looked at the work of modernists who, rejecting conventional realism, have sought an art of greater intensity. Some, following Cézanne's lead, have moved toward formal design, while others, inspired by Nolde and Klee, have worked in expressionistic or experimental styles.

Even though no homework assignment is given here, I hope you will make up a list of projects for yourself. Any number of strategies might be challenging—reducing a still life to Cubist planes, painting watercolors in a series as McGarrell does, giving brushstrokes a musical profile in the manner of Dowell, or using Holsing's device of the personal narrative.

Don't forget that abstraction is as dependent on orderly thought and technical assurance as realism is, even though there is not the same point of reference—a tangible set-up you can relate to. Abstract art focuses on *ideas* rather than things and, above all, on the ideal of creativity. The concepts you work with and the motivation to pursue them, therefore, must be your own. So, though it would be easy to provide a conceptual "exercise" here, in the end it will be best for you to name your own game and then, by looking at what is going on in the art world today, figure out how to play it.

11

Special Effects

Nowadays science-fiction movies are made in two stages. First the script is shot, and later on "special effects" are dubbed in. Sometimes camera wizardry and drama are convincingly wedded, but at other times technical marvels are the main reason for seeing the show.

The trouble with watercolor is that it lends itself all too easily to special effects—indeed, to the point where artists often think of it as a lightweight medium lacking the importance of oil, acrylic, or even pastel. Thus, a divisive situation exists. On one hand, popular enthusiasm for watercolor runs high, and bookstores are loaded with splashy "how-to" texts. On the other, colleges all too often offer watercolor as a "commercial art" rather than a "fine art" subject; museums classify it as a minor medium, under "drawing" instead of "painting;" and painters of national stature who use watercolor avoid all connection with that other breed of painter, the "technician" who stars in Watercolor Society exhibitions.

My own position is clear. In watercolor, as in moviemaking, you should master fundamentals before specialized techniques. Yet these, too, have their place, and this last chapter is an important one. It may even be the place where you get "turned on," because we shall be discussing exciting processes and ways to enrich your work with subtle textures.

Texture is the most seductive of art elements. In fashions, it spells the difference between a St. Laurent gown done in brocade and the muslin sketch. In painting, texture can be either a positive or negative factor, depending on how it is used. Many contemporary watercolorists bend over backward to avoid tricky effects in the belief that texture should be the natural result of a simple, direct style, as it was for Homer and Cézanne. On the other hand, inventing bizarre textures was as important for Klee as coming up with new shapes.

Preceding page: Fig. 11.1.
CHARLES SCHMIDT.
Spirit Level, 1982.
Watercolor, 30 × 40 inches.
Collection, Michael Greenberg, M. D., Wayne, Pa.

And the unique quality of a Demuth watercolor derives in large measure from the artist's elaboration of surfaces.

Both dos and don'ts are important here. The main thing to keep in mind is that texture in a painting is not, like icing on a cake, something added at the end. Instead, it must be "baked in," as it were, as part of the total creative process. All of the illustrations for this chapter point to this principle. When Demuth sprinkles salt on a watercolor of Provincetown dunes, it is with the idea of creating a sandy texture throughout. And when Marin paints with drybrush, he doesn't attach it to specific "dry" objects like grasses or tree bark, but uses the technique as a constructive principle for the composition as a whole.

DRY-BRUSH PAINTING

Dry-brush painting is a classic example of a "special effect." Everyone has heard of it, and after a week or so in any watercolor class, someone will eagerly inquire: "What about drybrush?" Yet once explained, the technique has limited appeal, and very few major watercolorists use it except for occasional passages.

John Marin is a notable exception. In much of his work, he overlays even the wettest passages with gritty dry-brush strokes. This gives an effect of juiciness combined with weight that is akin to oil painting. Technically, all that is involved is a brushmark executed so swiftly that it hits the bumps on textured paper without filling in the hollows. For this purpose, the *Rough* surface Marin favored, rather than the usual moderately-toothed *Cold Press* paper, is most suitable.

Movement in Blue and Sepia (fig. 11.2)—a late work painted just three years before the artist's death—is done almost entirely in drybrush, and it demonstrates why this technique works so well when used with sufficient energy. You will see at once that it is the paper, rather than the brush, that should be dry. Marin

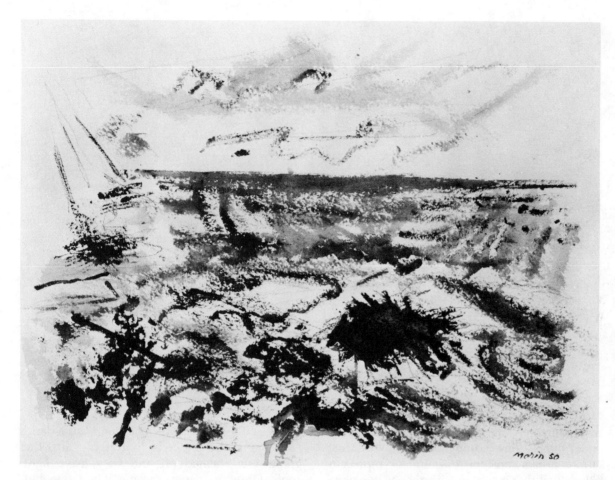

Fig. 11.2.
JOHN MARIN (American, 1870–1953).
Movement in Blue and Sepia, 1950.
Watercolor, 14¾ × 20¼ inches.
Courtesy Hirschl & Adler Galleries, Inc., New York.

conveys a sense of painterly mass and wetness here, even though his forms have bristly edges. Furthermore, the transitions from wet to dry in a given stroke recreate for the viewer the dynamics of the artist's hand as it moves across the page. Look, for example, at the jagged left-to-right thrusts in the sky.

This is how I think you might use dry-brush technique most successfully, although it is not what people usually have in mind when they ask about it. The popular image is of an illustrative watercolor, the kind sold in gift shops, in which dry-brush details are cautiously put in with a tiny brush (after the picture is otherwise finished) to indicate boards in a barn, weathered shingles, or separate stalks in a wheat field. This is what I mean by technique used as an afterthought rather than structurally.

Finely detailed brushwork can create a consistent surface, as in the watercolors of Erlebacher or McGarrell. But there is nothing worse than the picture with a "wet" sky and pond framed by a "dry" farmhouse and parched grasses and trees. Put this cliché at the top of your list of don'ts!

SALTING

Although extensive use of dry-brush creates a distinctive effect, any watercolorist will occasionally let the brush run dry, and hence the technique is considered natural and thoroughly respectable. Sprinkling salt to achieve a bubbly

Fig. 11.3.
Charles Demuth
(American, 1883–1935).
Dunes, Provincetown, 1920.
Watercolor, 10 × 14 inches.
Philadelphia Museum of Art,
Samuel S. White III and Vera White
Collection.

champagne sparkle, on the other hand, comes under the heading of unnatural additives. Most serious artists consider it a gimmick representative of all that is wrong with slick watercolors designed for the tourist trade. Since my feeling is that anything goes, if done well, I was delighted to learn that our most admired American watercolorist, Charles Demuth, had the habit of salting his paintings.

Demuth was a past master of indirect effects. He liked to put down a wash and then tamper with it—blotting with tissue and oddly textured papers, marking with the edge of an absorbent card, and then sprinkling with salt to **create the porousness we see in** *Peaches and Fig* (pl. 3). *Dunes, Provincetown* (Fig. 11.3) is one of the artist's more unusual papers in that textures are achieved without much blotting and almost entirely with simple washes made effervescent by salt. Clouds, distant dunes, and the foreground curve of shore are pervaded by a uniform sandlike texture, as though seen in a dust storm.

If you want to try this technique, use coarse kosher salt rather than the common variety that produces too fine a texture to bother with. In principle, when salt is sprinkled onto a

wet wash, it sucks up the color and turns dark. Later, after the paper is thoroughly dry, the grains are brushed off and they leave light spots. On white paper, these will be white; but interesting effects are also achieved by salting the top layer in a series of washes, in which case the color of the underpainting will show through.

For a successful result, certain cautions should be heeded. Your washes must be intense rather than pale. They must also be wet, yet not too wet. Therefore, it is advisable to wait for colors to "set," and become a little viscous, before applying the salt. Finally, since sodium chloride attracts moisture, all traces must be removed lest your framed watercolor become moldy under the glass. After brushing the finished paper, scrape it down gently with the edge of a flat table knife.

LIFTING, SCRAPING, AND SCRATCHING

Lifting, scraping, and scratching are three ways of removing paint, either partially or entirely,

after color has been applied. Traditionally, as in Sargent's work, these were devices for making judicious corrections or "improvements"; but modernists sometimes use them, like the palette knife in oil painting, to create a distinctive texture throughout the composition.

Lifting is simply the technical term for blotting a watercolor with the intent of removing specific shapes. An abstract artist will sometimes paint a color mass and then reduce part of the area to a light stain by pressing down with an absorbent paper towel. A genuine blotter gives even sharper definition, and it can be cut into specific shapes for an impression of a city skyline or boats in a harbor. Lifting is also an efficient way for the realist to evoke the shine on glass or the look of plastic wrap. Don Nice uses the technique for his wrapped cookies and sandwiches in *Alaska BK III PPXVII*, which we discussed in chapter 9 (see fig. 9.5). To portray something like this, a crumpled facial tissue or paper napkin is effective, since the paper's folds will lift out shapes imitating the folds of the object you are painting. As with salting, it is also important to wait until the wash has settled before removing highlights. If you act too soon, color will seep back into them.

Scratching and *scraping* are techniques for cutting into the paper to reveal its whiteness, or at least paring off some of the paint. The distinction between the terms is not precise, but scratching *out* is usually done with a sharp metal instrument such as a penknife, razor blade, or dentist's probe (ideal, if you can locate one) on *dry* paper. Scraping *off*, on the other hand, works best when the paint is *wet*, and although a dull table knife may be used, wooden or plastic instruments like a spatula or expired credit card are preferable.

Winslow Homer used scratch-out technique to suggest sunlight on water or leaves, and he sometimes shaded objects with finely scratched, parallel white lines, as in an engraving. Scratching became a cliché of the watercolor academies, however, and the New Realists of the 1970s carefully avoided it. Now, with an upsurge of Expressionism, there is a reassessment of techniques that can enliven the surface of a painting. The highly regarded avant-gardist Malcolm Morley, for instance, uses scratching to bravura effect in his watercolor *Fish* (fig. 11.4). Stabs of the knife create rhythmic energy, while flecks of raw paper evoke the glitter of a cold underwater light.

Fig. 11.4.
MALCOLM MORLEY.
Fish, 1982.
Watercolor, 17½ × 42½ inches.
Courtesy Xavier Fourçade, Inc., New York.

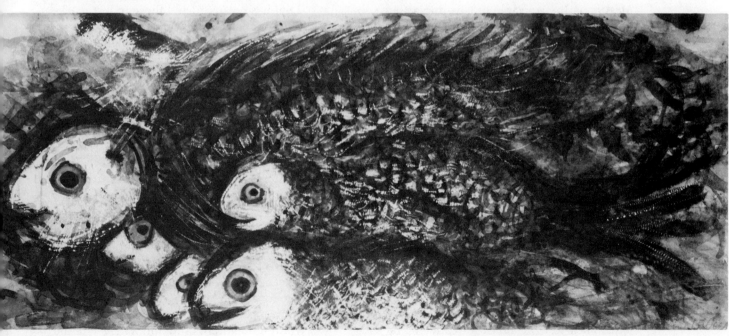

Scratching is difficult, since it takes a lot of assurance to slash into a painting at the last minute. Scraping, however, is a simple and enjoyable process that will produce any number of effects, depending on your tool and how you use it. Watercolor is surprisingly malleable, particularly in wet-in-wet technique. You must apply a heavily pigmented wash, of course, let the paint reach the "almost dry" stage, and then think of it like fudge or dough to be scraped off by a dull blade. Transparency is created by these swipes of a straightedge which pare off excess pigment and indent the damp paper a little, giving it a sculptural quality.

You can also make a light-line graffito drawing by marking the pigment with a point rather than a blade. The effect is like an incised Greek vase design made by painting the white clay-body red and then drawing with a stylus to reveal the subsurface. In watercolor, your stylus must be an instrument that will scrape off paint without cutting into the paper. The tip of a letter opener or the pointed shaft of a paintbrush is the sort of thing to experiment with, but your best bet is the wooden end of an old-fashioned kitchen match.

MASKING DEVICES

Masking is the principle of covering an area so that you can paint over it rather than around it. To show a sailboat mast against the sky, for instance, press down a strip of masking tape cut to fit, paint the sunset with a broad brush, and later just peel off the tape. A trick? Yes, in some situations. But masking *can* be done with integrity, and the alternative—having to "save" the slender white mast by painting "around" it—won't achieve quite the same smooth result.

There are three types of masks: *stencils* made of paper, plastic, or tape that are ultimately removed; *frisket* (or *maskoid*), a liquid rubber cement that you brush on and later rub off; and *crayons* or *chalks*, which are water-repellent, but remain on the paper as a permanent textural enrichment.

For a quick introduction to masking, experiment with *children's wax crayons*, and work either abstractly or with a subject that lends itself to light, fanciful treatment. Be sure to buy the large assortment of crayons that contains white and the light hues you will need. Start with a little white-line drawing. Invisible at first, it will stand out boldly when watercolors are added. Then try a picture in which forms are hatched or stippled with pink, yellow, violet, and aqua crayons. Dark washes, with this kind of bright but pale drawing showing through, have a startling stained-glass brilliance. Joseph Raffael's *Return to the Beginning: In Memory of Ginger* (pl. 15) gives an idea of the effect. Although it is largely "straight" watercolor, there are touches of yellow chalk, and the artist has expanded his use of pastels in more recent work. When you are ready to move from Crayolas to adult pastels, other options include white conté crayon, china markers, colored pencils, and Cray-pas.

Frisket (or maskoid) has an irresistible appeal for the beginning watercolorist, who should learn to use it with integrity rather than as a gimmick. The Philadelphia printmaker and painter Lillian Lent shows us how. Instead of seeing maskoid as a shortcut for "saving" a few highlights, she conceives of it, as Morley does scratch-out technique, as an energizing principle for the whole picture. Her watercolor *Day Dream* (fig. 11.5A) is done like a Javanese batik in which designs painted in wax resist the dye. Here the resisting material is rubber cement applied as a white brush-drawing for the painting that is to come.

Lent has reconstructed these frisket marks in a diagram (fig. 11.5B). Imagine them as originally gray against white paper, then painted over, and finally, rubbed off to reveal clean-cut shapes as shown. For Lent, however, this is only the start of a complex process. If you compare the diagram and the finished watercolor, you will see that most of the masked-off whites have been eventually tinted in various tones and colors. The borders at top and bottom, for instance, glitter like sequins, and no two circles are alike.

The secret of success with any specialized technique is to use it *intensively*. The process, however, must also be compatible with the artist's style and imagery. Masking, for example, is an "indirect" procedure that works well in Photo-Realism, yet strikes a false note in realist painting done from "direct" observation. Lillian Lent's imagery is something else again—a fantasy world reminiscent of Redon where "special

Fig. 11.5A.
LILLIAN LENT.
Day Dream, 1976.
Watercolor, 9 × 8 inches.
Collection of the artist.

Fig. 11.5B.
Diagram of Lent's *Day Dream*.
The initial maskoid lines are shown. Blocked-out whites
were later tinted with vivid colors.

effects" can be magical. Lent is intrigued with what she calls "transformations"—the changes that occur as one's subject interacts with different materials and is developed in various mediums. Tschaikovsky drew upon Pushkin's narrative poem *Eugene Onegin* for his opera of that name, and here Lent goes back to the original source. The theme is a young girl's waking, or conscious, dream of terrible animals. In typical fashion, Lent has explored this image in a *Dream Series* that includes watercolors, etching, inkless relief printing, silk screen, and even embroidery.

Aside from esthetic considerations, certain practical realities should be kept in mind when you use a liquid mask:

1. Rubber cement ruins brushes, so use an inexpensive one for this sole purpose.

2. Maskoid is *fully* effective only on smooth (or Hot Press) paper. Here each shape emerges with a sharp edge. On a moderately rough (or Cold Press) surface, the white marks it leaves are vague and irregular.

3. The mask should be applied after penciled contours have been drawn in. (In Lent's *Day Dream*, for instance, the face is shaded in pencil, which shows through the overlaid wash.)

4. As in batik, you may "dye" the paper with a wash, paint over this with maskoid, then brush on a second color, put on more maskoid afterward, and repeat the process several times.

5. The paper must be thoroughly dry, without any hint of dampness, before the mask is either applied or removed.

6. Neutral gray maskoid is preferable to the pink or orange variety, which may leave a stain.

7. Frisket should be rubbed off very gently with a soft cloth or tissue, since it acts as an eraser that can remove some of the watercolor pigment.

8. Washes change color when laid over areas that have been masked. Therefore, in masking a shape—such as a window you want to block out while toning a wall—the whole area, rather than just the edges, needs to be painted with frisket.

SPATTERING

Spattering involves applying paint in little irregular droplets. I have done it on occasion by holding a loaded watercolor brush horizontally over the paper and tapping the shaft with my forefinger. Most serious spatterers, however, prefer an oil painting brush or a toothbrush—something with stiff bristles that can be stroked with a fingernail or matchstick until the droplets fly off. For more control, another option is to tap a loaded brush on the back of a second brush or wooden stick held in the other hand. If you want a perfectly even spray, rub a toothbrush dipped in paint on the top side of a piece of coarse window screening held over the paper.

Thus the effect can be either impressionistic or controlled, depending on your technique. Spatter-marks on dry paper are sharp, whereas drops sprinkled on a damp surface dissolve like melting snowflakes. And though spattered areas fade out at the edges, a solid tone can be achieved by masking off a distinct shape with a paper stencil. In any case, this is a technique that requires a little practice on throw-away paper until you get the "touch."

Serious painters sometimes think of spattering as disreputable because it is superficial in the literal sense of that word—"laid on the surface," like a touch-up of rouge on a lady's face. Nor do watercolor handbooks help matters by illustrating the principle as if it were the finishing touch on a salad of mixed special effects. A typical suggestion I saw recently invites you to lay wet washes over maskoid, make the passage still more glamorous with "lifts" of crumpled tissue, then add a dash of bubbly salt, and finish off with spatter-work. Spattering *can* be used with conviction and sober purpose, however, and the work of three painters—Tonia Aminoff, Sam Francis, and Charles Schmidt—is offered here in evidence.

Aminoff is a Providence, Rhode Island, artist whose recent abstract watercolors are done entirely in spatter technique. An experimentalist, she says: "I was looking for an innovative way of putting on paint without using a brush. I also like the idea of a process that has structure and is also organic." What she came up with is a two-ounce pipette, a glass tube with a bulb on one end that is used in medical blood work. It is similar to a turkey baster, but smaller.

To execute a watercolor like *Landscape* (fig. 11.6), Aminoff paints through the opening of a plexiglass mat held 1/4 inch away from a sheet of Hot Press paper pinned to the wall. After filling the pipette, she squirts the paint down-

Fig. 11.6.
TONIA AMINOFF.
Landscape, 1982.
Watercolor, 22 × 30 inches.
Collection of the artist.

ward into a saucer, from which it bounces upward onto the paper in an arc—the smaller droplets splashing farther than larger ones, in a wider curve. The resulting image is structured, but with a softened, organic edge. Gradually, a dense yet subtle texture is built up in a process involving as many as 40 or 50 layers of splashes, each of which must be separately dried.

Sam Francis is a well known abstractionist whose strategy is precisely the opposite of Aminoff's. Instead of slowly building up quiet shapes, he attacks the paper ferociously with dripping, flicking, and spattering gestures reminiscent of Jackson Pollock. Typically, Francis leaves much of the surface unpainted in a dynamic, "open" style that is common to both canvases and works on paper. In recent years, the latter have been done in acrylic and mixed media, but an untitled study from the early sixties (fig. 11.7) suggests the lively possibilities of such an approach to watercolor.

Francis's principle of "throwing" the paint produces an entirely different kind of spatter than Aminoff's pipette or the usual technique of rubbing a toothbrush. Each throw has a curved trajectory, often with a hook on the end, in response to the artist's arm movement. Although there is an element of accident, directional thrusts are controllable to a degree, and when a gesture is right, it can be repeated for emphasis. Thus, instead of a tone, throwing produces dynamic lines of droplets that crisscross and carve out space. As Francis shows us, a structured composition can be developed from such an improvised start through a process of layering. Just make a network of spattered lines, stare at it until you visualize interesting shapes, and then paint them with a brush. Later, repeat the process with alternate layers of thrown lines and smaller painted shapes. The beauty of this approach is that it stretches the picture space both *outward*

Fig. 11.7.
SAM FRANCIS.
Untitled, ca. 1965.
Watercolor, 25 × 19 inches.
Philadelphia Museum of Art, Given by Vivian Springford.

by the force of thrown paint, and *backward* toward infinity by the layering, which has a cosmic effect, rather like a view of the heavens in a planetarium.

Aside from these virtues, throwing paint is great fun. You simply load the brush, hold it by the handle tip, and hurl the paint with a snap of the wrist. The paper should be on a slanted drawing table, since pinning it to the wall encourages runny drips, and the floor is too distant for the stand-up gestures you need. Naturally, every stroke splashes far and wide, so you must work outdoors, in a studio where anything goes, or with a drop cloth. The inexpensive clear plastic kind works well. Tack the drop cloth to the top of the wall, let it fall onto the table and over the floor. Then lay your paper or drawing board on top of the plastic, and go to work.

Finally, let's look at Charles Schmidt's *Spirit Level* (fig. 11.1) to see how spattering may be used with a representational subject. As noted in chapter 7, Schmidt is a master of under- and overpainting techniques and here he has come up with an unusual process.

Schmidt began *Spirit Level* by spattering over tightly stretched strings. This masking device creates light lines (which you can see at the top of the picture) in the shape of a squared-off grid against which objects and bent wires are superimposed in visual counterpoint. The spatter-work also provides a textured underpainting, suggestive of decaying surfaces, that flickers in and out of subsequently overlaid washes.

The artist's next step was to loosen the strings, make wet-in-wet puddles, and allow these to dry with the loose strings lying in them. Schmidt says: "This is what created the wires running through the painting. The objects were then worked up out of the 'mess,' as it were, with carefully detailed overpainting." To portray convincingly dimensional wires, for instance, he put in cast shadows and traced the dark and light shifts on every strand with a fine brush.

The ambitiousness of Schmidt's work should not discourage a beginner with some drawing experience from trying something like it. Remember, his is a very large watercolor, and yours, on standard paper, will be half the size and include fewer objects. In any case, working against a spattered grid (masked with string, as

here, or with paper stencils) is an intriguing concept. Letting foreign objects dry in wet puddles is another good idea. You can create exciting effects with anything from old coins to bird seed, and the technique may be used either abstractly or as the underpainting for a representational image.

TAPING

Attitudes toward masking tape are curious, since it is widely accepted as a device for achieving crisp edges in acrylic painting on canvas, yet seldom used with watercolor on paper. Two reasons for the discrepancy suggest themselves: the fluidity of watercolor is not usually associated with hard-edged style, and those who do experiment with taping on paper are often discouraged by technical problems such as paint leaks or torn surfaces. Let me say straight off, then, that *taping is not at all difficult*. By following the procedures outlined here, you should have no mishaps.

In my own work, taping edges is a key structural device and a means of achieving a unified style in the canvases and watercolors. Since I paint architectural still lifes reflected in mirrors, crisp edges are called for. On canvas, masking tape makes a splendid drawing instrument. I begin with large shapes, moving the tapes up and down or sideways, as needed, until the proportions of wall, floor, and table are right. After these spaces are laid in, the smaller shapes of still life objects are outlined with tape and then overpainted. In acrylic painting, this process of adding taped shapes, or changing them, can go on indefinitely.

Masking tape functions quite differently, however, in watercolor. Since there can be no corrections, the mask must be fitted to a carefully planned pencil drawing rather than being used "freehand." Furthermore, it cannot be applied anywhere and everywhere, as on canvas, but only to paper that is either untouched or very lightly pigmented. Two unfortunate things happen when you press tape onto a heavily painted surface: new washes run under the edge, and the old dry paint pulls off when the tape is removed.

Within these limits taping has much to

offer. I encourage you to try it for a paradoxical reason—the freedom this seemingly "tight" technique provides. Perhaps you can see this in my *Yellow Begonia* (fig. 11.8). The plant is shown from above with reflections in a sheet of dark plastic (on the right) and a clear mirror (at the left) that have been laid on a tile floor (visible at the top). A complex arrangement like this intrigues me. The space is dynamic yet ambiguous, since real grapes mingle with mirrored blossoms, and the set-up offers a view of both the upper- and underside of the begonia.

My point, however, is that once boundaries are protected by tape, you can flood an area generously and splash away, as in a swimming pool, without fear of an overflow. Here, for instance, the rich tones of the dark plexiglas area call for seven or eight layers of washes, and the masking had to be put on, removed, and put back gain several times. Tape was also used for the striped tile flooring. Though narrow bands like this are usually rendered in one "shot," I like to handle them freely by creating a masked-off canal into which I can pour fanciful color mixtures. When they don't work, I simply blot the strip and start over.

Beyond establishing straight edges, masking tape is enormously helpful in smoothing out curves. In my still lifes, the rounded shapes of white kitchen utensils and china abound. Thus, in a picture like *Basil and Nectarines* (pl. 13), the blue plexiglass rectangle, against which the main objects are silhouetted, was first masked off, and then the contours of the pitcher, ladle, and nectarines were taped from the inside. Since tape bends with a certain evenness, and is easily pulled off and readjusted, I use it to perfect the symmetry of arcs and elipses that are difficult to get right in the pencil drawing. Tape, of course, bends in only one direction. Therefore, if this were a dark vase that had to be masked on the outside, rather than the inside, taping would be inappropriate.

Ultimately, success with masking tape involves not so much correct procedure as avoiding pitfalls. Like the Deadly Sins, there are seven temptations to beware of:

1. *Using the wrong paper*. Masking tape works well only on good rag paper with a firm, Cold Press finish. It will tear cheap paper or a surface that is too smooth, and it will not always seal the hollows of rough paper.

2. *Using the wrong tape*. Household masking tape is as effective as expensive architect's drafting tape. It is imperative, however, that you use 1/2-inch tape rather than the usual 3/4-inch width.

3. *Pressing down too firmly*. The trick is to affix the tape lightly, and then press on only *one* side with your thumbnail. Also, leave the end unattached for easy removal.

4. *Pulling the tape off too quickly*. Band-aids are best ripped off smartly, but masking tape must be pulled up with the speed of a snail. Otherwise, bits of pigment and/or paper will tear off. Burn this principle into your memory. It is the main point to remember about taping.

5. *Pulling tape in the wrong direction*. Pieces of tape that extend beyond the picture onto the drawing board must be removed by taking hold of an inside end and pulling outward. The reverse action will tear the paper and destroy its deckled edge.

6. *Taping on solidly painted areas*. Tape will "hold," and be safely removable, on a lightly tinted wash, but in any watercolor the build-up of pigment eventually becomes too great. Since accidents are messy, learn to limit your taping to the early stages of the painting.

7. *Letting masked edges touch*. In acrylic or silk-screen work, juxtaposed areas usually overlap slightly. This is not feasible in a taped watercolor, however, since the seal is unsatisfactory unless you leave a thin line of separation between adjacent edges—perhaps a 1/16-inch strip of bare paper for the tape to cling to.

You can see this last technique in *Yellow Begonia*. The bluish mirror, for instance, is separated from the dark plexiglas by a thin white line that reads as a highlight. The device is stylized, but it is a natural expression of the masking process, and it adds vitality by introducing touches of white paper throughout the composition.

ALTERNATIVE WAYS OF APPLYING PAINT

Most of today's leading watercolorists are "straight" painters who apply the paint with a good-quality, but quite ordinary, round sable brush. And when they use special effects, it is usually to make the texture of their brushed-on

Fig. 11.8.
Charles Le Clair.
Yellow Begonia, 1981.
Watercolor, 30 × 22 inches.
Collection, Mr. and Mrs. Gerald E. Parent, Wellfleet, Mass.

Fig. 11.9.
Wassily Kandinsky (Russian, 1866–1944).
Geometric Forms, 1928.
Watercolor and ink, 19 × 11 inches.
Philadelphia Museum of Art, Louise and Walter Arensberg Collection.

are often unaware that a ruling pen can be used, not only with ink as in Kandinsky's drawing, but with watercolors in a heavily pigmented solution, and even with maskoid. The pen should be filled with the tip of a fine brush, so that fluid is held between the blades rather than on the outside, and the pen must be held vertically. White-line effects, done with vivid washes over maskoid patterns drawn with a ruling pen, are particularly handsome. If you want to try this, use smooth Hot Press paper and dilute the maskoid slightly with a few drops of soapy water.

Split-brush technique is another alternative to painting with a standard round brush. In her stunning *Woman with Fishes* (fig. 11.10), Mary Frank uses a flat, square-cut brush several inches wide. The bristles of such a brush separate (or can be made to separate) when wet, with the result that a single stroke divides into irregularly spaced parallel lines. Either a flat housepainter's brush, or an artist's Japanese paddle wash-brush will do the trick. My preference is an inexpensive one from the hardware store because it will hold up under rough treatment. Rather than dipping gently into a large and wasteful container of fluid, I work on a big sheet of glass. This accommodates a generous puddle of watercolor that is fully used up as the brush is pressed down into it with a scrubbing action that loads and separates the bristles.

The function of a split-brush stroke is to carve out spacious tones, usually as the shadowy setting for a subject that will occupy the foreground. Thus, in *Woman with Fishes*, Frank establishes the sweep of sea and sky with two gestures, a giant wavelike stroke below and a vehement twisting thrust above. These split-brush washes in a rusty magenta color are vaporized, as you can see on the upper left, by salt or lifting. Where the figure appears, certain areas of the background evidently have been erased by blotting or sponging. Afterward, Frank's watery naiad was painted in with textural blots that evoke a powerful yet blurred

washes more interesting. Salting, scraping, lifting, and spattering add flutter; taping and stenciling, a sharper look.

For an artist of experimental bent, however, the challenge often is to avoid standard brushes altogether and find an alternative way of putting on paint. We saw, for instance, that Tonia Aminoff works with a medical pipette, and in his 1928 abstraction *Geometric Forms* (fig. 11.9), the Russian painter Kandinsky uses three contrasting non-brush textures: a fine mist done with an airbrush or sprayer, splatters of color dropped from on high to create mooncrater blobs, and crisp lines drawn with a ruling pen and compass.

The ruling pen might seem an unlikely suggestion for a watercolorist, but in a group of art students there is usually someone who enjoys working with mechanical devices. And people

Fig. 11.10.
MARY FRANK.
Woman with Fishes, 1979.
Colored inks, 20 × 26 inches.
Courtesy Zabriskie Gallery, New York.

image. Finally, the blue-black fishes were over-laid with fluid brushstrokes.

Frank is a sculptor who has worked extensively in clay. Thus it is not surprising that her *Woman with Fishes* reminds us of ceramic vase painting. A ceramist relies on freehand marks, rhythmic strokes as the wheel turns, and textures that are a natural expression of process and material. You will find that these same qualities are needed for split-brush work in watercolor. Above all, this is a technique that requires advance planning and practice on trial sheets. When you come to the actual painting, it must be dashed off. Every mark counts and, though it can be modified or partially erased,

there is no way in which a split-brush stroke can be done over again. (*Woman with Fishes*, incidentally, is painted with colored inks, but the techniques it illustrates are equally effective in watercolor.)[1]

Sponge-painting is another process that can be either combined with split-brush work or used by itself to create a similar striated effect. Here a square-cut synthetic sponge is your drawing instrument. Cut it to the desired width, moisten slightly, dip one edge in water-

[1]Since Mary Frank was not available for an interview, the analysis of the artist's technical procedures is based solely upon my examination of her paintings.

color, and make a broad clean-cut swipe. You will find that the porous sponge produces parallel lines, rather than a solid tone, if it is pressed down lightly. An alternative procedure is to paint a solid wash and then erase white lines with a sponge that has been wrung-out in clear water. I like sponge-painting because it is more flexible than split-brush technique. Passages can be put in and then partially wiped out, often to interesting effect. Sponging also works well on damp paper.

Finally, *imprinting* is the logical complement to sponging and split-brush work. After establishing generalized background tones, you can "stamp" a specific image onto the page instead of "painting" it. Just cut the silhouette of your subject out of heavy paper or light card stock, brush it with paint, and press firmly onto the dampened surface of your watercolor.

Imprints typically have sharp edges but an irregular overall texture. Thus a form like the winged arm of Mary Frank's figure may be achieved either by brushing color on, and then blotting it off, or by an imprint that doesn't quite "take." The latter technique has certain advantages. For one thing, you can rearrange the cutouts on the page before deciding on final placement, thus eliminating the need for a pencil drawing. Another advantage is that the same cutout can be used as both stamp and stencil. As an example, consider the back leg of Frank's striding woman. It cuts through the split-brush wave with a clean profile. There are several ways to achieve such an effect, but the most direct is to make a cutout of the lady's leg, hold it in position on the paper, and paint the background right over it. Later, the "stencil" can be dipped in flesh color and used as a "stamp."

The possibilities of imprinting are most fully realized when it is used with *found objects* rather than representational cutouts. At home, at school, or in a walk through the woods, you will discover countless small objects that can be painted and then stamped onto watercolor paper with exciting results. Imprints of leaves and ferns will suggest a jungle, and more structural things such as envelopes, matchbook flaps, buttons, and alphabet blocks can be composed into an abstraction that would make a Cubist proud. In short, imprinting is a truly open-ended process.

FOLDING, COLLAGE, AND OTHER OPTIONS

The possibilities for experimentation with watercolor techniques, and for combining processes and materials, stretch from here to eternity. Therefore, this discussion of special effects can hardly be all-inclusive. It has introduced you, however, to basic approaches which can be varied in the same way that standard recipes are modified by a creative chef. Thus, once you have sprinkled salt on a wash, you may want to try other substances—pepper, for a change, or sand, or sawdust. In the same spirit, look around for uniquely textured objects that can be used to apply or remove watercolor. You can paint through a wire screen, for example, or paint the screen itself and then imprint it on damp paper. And all sorts of oddments make interesting "lifts"—flower-embossed napkins, corrugated cardboard, cork coasters. You name it.

One thing we have not talked about is getting away from regulation watercolor paper and exploring alternative surfaces. The reason is that an introductory handbook like this serves the beginner best by focusing on the essential medium (watercolor, rather than dyes, acrylics, and magic markers) and on the standard painting surface (a rectangle of good-quality white rag paper).

Now that you have mastered first principles, however, you may be ready to set aside your Arches pad and see what happens when watercolor is applied to colored stock, such as toned charcoal paper, or to Oriental rice paper. Although these surfaces pose problems of fragility and permanence, contemporary artists often solve them by minimal application of paint—perhaps a few calligraphic marks or sprayed on tones. Distinctive papers also lend themselves to *folding* and *shaping*, techniques that are of lively current interest.

Dorothea Rockburne, for instance, has revived transparent vellum—the material used for medieval manuscripts—which she paints on both sides and then folds in one of twelve predetermined geometric patterns. And the avant-garde artist Alan Shields weaves, staples, and sews rough strands of handmade paper into

Fig. 11.11.
MARILYN HOLSING.
Untitled, 1977.
Watercolor-Collage, 16 × 22½ inches.
Courtesy Jeffrey Fuller Fine Art, Philadelphia.

openwork shapes that are colored with anything from an eyedropper to a water pistol.

Many abstract painters also combine watercolor with *collage*. This can be done in the manner of a Cubist drawing by adding small paste-ons, such as theatre ticket stubs or newspaper cuttings, to the painted page. Collage can also be used more comprehensively as in Marilyn Holsing's *Untitled* (fig. 11.11). Here the scene—a woman reading in an interior with overstuffed chair, table, lamp, and ornamental screens—is assembled out of flat, intricately patterned pieces of paper. The effect is not unlike a collage of assorted strips of wallpaper, but the pieces are, in fact, all handpainted in watercolor and then put together. Collage is quite simple technically, though there is one caution: to avoid puckering, all painting must be done in advance, and a full day's drying time should be allowed before pasting. For best results, use a nonacid wheat library paste or acrylic medium as the adhesive.

Afterword

These pages have been written on the assumption that readers will be interested not only in technical know-how but also in mastering the "art" of watercolor. Hence the book's title and its emphasis on the relationship between materials and processes and the esthetic concepts they serve.

It is significant that serious painters today speak of what they do as "making art." Like making love, this is primarily a matter of expressing deep feelings, but for the student of art there is a problem. The painter's vocabulary does not come naturally, as the lover's is supposed to do. It has to be learned, and this takes time. Often you can spend a year in a drawing class, or two years painting from the model, without really finding yourself.

The beauty of watercolor painting is that it allows you to move ahead so quickly. In a few week's time you can explore a full range of techniques, thus discovering the medium's possibilities and preparing yourself for the more important task of developing a personal idiom.

For this reason, teaching watercolor has always appealed to me. This is a subject that permits students to *analyze* separate elements and *synthesize* their experience by the end of the course. If this book, for instance, were the syllabus of one of my actual classes, chapter 11 would read "Week Eleven," with four weeks of the semester still to go. This last month is always devoted to an independent project in which each student explores an area of personal interest. Afterward, there is talk, on a one-to-one basis, about the direction of the individual's work and how it might develop in future.

Thus, it is what you will be motivated to do with watercolor *after* you have explored the projects in this book that is of greatest concern to me. Unfortunately, we cannot sit down together for a personal discussion of your paintings, but perhaps some general advice will be helpful.

First, keep in mind that one of the main problems in developing a personal watercolor style is finding a subject and technique that are compatible. It doesn't matter here whether chicken or egg comes first. If you love landscapes, for instance, a broad, loosely brushed style may be in order; on the other hand, if you like to work with precision, you will have to come up with themes that can be expressed with architectural shapes.

This is not an issue to be resolved in an instant, nor one requiring you to adopt one set style, forsaking all others. After mastering basic techniques, however, it should be the next item on your agenda. The way to get at it is to begin to look for painting ideas that can be developed in a series of studies, with variations and comparisons along the way. Someday you may want to have a one-person show with fifteen or twenty paintings that "go together" stylistically; but right now, why not start with a portfolio of four or five related watercolors? These might represent either different treatments of a single subject or various themes done in a particular technique or process that interests you.

The second thing you will need, if you are to work independently, is a way of keeping your spirits up. Friends or family can help you stay motivated, but the surest way is to have a group of your best watercolors framed under glass. There is a world of difference between a rumpled pile of good, bad, and indifferent studies and a few selected watercolors that are proudly displayed for everyone to admire. Framing won't make you an instant professional, but it does give your work a proper setting, and it wll go a long way toward strengthening your image of yourself as an artist.

Finally, I would urge you to consider exhibiting your watercolors whenever an occasion presents itself. You may not be ready to take this step for a year or two, but it is something to aim for because showing your work, in a sense, completes the creative experience. At home, you see a painting from a personal viewpoint. Coming upon your work in an art gallery,

on the other hand, enables you to judge it objectively, and often your assessment of its strengths and weaknesses will change as you see it beside other entries in the same show.

Painting is a way of expressing yourself, and when you have something to say. it is encouraging to find an audience and sense its reaction. Fortunately, opportunities to exhibit abound nowadays at every professional level—in local clothesline shows, community art centers, commercial galleries, regional competitions, and national exhibitions.

I hope you will avail yourself of these opportunities, and that the advice and information conveyed by this book will contribute in some small measure to your success as an artist.

Bibliography

ARTHUR, JOHN. *Realist Drawings & Watercolors.* Boston: New York Graphic Society, 1980.

———. *Realists at Work.* New York: Watson-Guptill Publications, 1983.

BAKER, KENNETH. "New American Watercolor," *Portfolio* 4, no. 5 (September/October 1982): 66–75.

BATTCOCK, GREGORY, ed. *Super Realism: A Critical Anthology.* New York: E. P. Dutton & Co., 1975.

BOSTON MUSEUM OF FINE ARTS. *Fairfield Porter (1907–1975): Realist Painter in an Age of Abstraction.* Boston: 1983.

BROMMER, GERALD F. *Transparent Watercolor: Ideas and Techniques.* Worcester, Mass.: Davis Publications, 1973.

CATHCART, LINDA L., ED. *American Still Life 1945–1983.* Houston: Contemporary Arts Museum, 1983.

CHAET, BERNARD. *An Artist's Notebook.* New York: Holt, Rinehart and Winston, 1979.

———. *The Art of Drawing.* New York: Holt, Rinehart and Winston, 1983.

COHN, MARJORIE B. *Wash and Gouache: A Study of the Development of the Materials of Watercolor.* Cambridge, Mass.: Fogg Art Museum, 1977.

DAVIDSON, ABRAHAM A. *Early American Modernist Painting 1910–1935.* New York: Harper & Row, 1981.

DAVIS, CHRISTOPHER. *Portrait of a Painter* (Neil Welliver). *The Pennsylvania Gazette* 77, no. 6 (April 1979): 16–23.

DERKATSCH, INESSA. *Transparent Watercolor: Painting Methods and Materials.* Englewood Cliffs, N.J.: Prentice-Hall, 1980.

DOHERTY, M. STEPHEN. *Dynamic Still Lifes in Watercolor.* (A study of the work of Sondra Freckelton.) New York: Watson-Guptill Publications, 1983.

EISEMAN, ALVORD L. *Charles Demuth.* New York: Watson-Guptill Publications, 1982.

FLORIDA INTERNATIONAL UNIVERSITY. *Realist Watercolors.* Miami: Visual Arts Gallery, Florida International University, 1983.

FRECKELTON, SONDRA. "The Watercolor Page," *American Artist* 47, no. 492 (July 1983): 42–47, 97–98.

GARDNER, ALBERT TEN EYCK. *History of Water Color Painting in America.* New York: Reinhold Publishing Corp., 1966.

GOLDSMITH, LAWRENCE C. *Watercolor Bold & Free.* New York: Watson-Guptill Publications, 1980.

GOODYEAR, FRANK H., JR. *Contemporary American Realism Since 1960.* Boston: New York Graphic Society in association with The Pennsylvania Academy of the Fine Arts, 1981.

———, ED. *8 Contemporary American Realists.* Philadelphia: Pennsylvania Academy of the Fine Arts, 1977.

GOSEBRUCH, MARTIN. *Nolde: Watercolors and Drawings.* New York: Praeger Publishers, 1973.

GROHMANN, WILL. *Paul Klee.* New York: Harry N. Abrams, ca. 1955.

GUPTILL, ARTHUR L. *Watercolor Painting Step-By-Step.* Susan E. Meyer, ed. New York: Watson-Guptill Publications, 1967.

GWYNNE, KATE. *Painting in Watercolor.* Secaucus, N. J.: Chartwell Books, 1982.

HOOPES, DONELSON F. *American Watercolor Painting.* New York: Watson-Guptill Publications, 1977.

———. *Sargent Watercolors.* New York: Watson-Guptill Publications, 1977.

JAMISON, PHILIP. *Capturing Nature in Watercolor.* New York: Watson-Guptill Publications, 1980.

KENDALL, AUBYN, ED. *Real, Really Real, Superreal: Directions in Contemporary American Realism*. San Antonio: San Antonio Museum of Art, 1981.

LYNTON, NORBERT. *Klee*. Secaucus, N.J.: Castle Books, 1975.

MARILYN PEARL GALLERY. *Bernard Chaet and American Masters of Watercolor*. New York: 1982.

MARIN, JOHN. "Notes on 291," *Camera Work*, no. 42 (April/July 1913): 18.

MELVIN, RONALD McKNIGHT, ED. *Five American Masters of Watercolor*. Evanston, Ill.: Terra Museum of American Art, 1981.

MILWAUKEE ART MUSEUM. *Philip Pearlstein: A Retrospective*. Milwaukee, Wis.: 1983.

NECHIS, BARBARA. *Watercolor the Creative Experience*. Westport, Conn.: North Light Publishers, 1978.

NOCHLIN, LINDA. *Realism*. New York: Penguin Books, 1971.

ORESMAN, JANICE, ED. *Twentieth Century American Watercolor*. Hamilton, N.Y.: The Gallery Association of New York State, 1983.

PIKE, JOHN. *John Pike Paints Watercolors*. New York: Watson-Guptill Publishers, 1978.

PLANT, MARGARET. *Paul Klee: Figures and Faces*. London: Thames and Hudson, 1978.

PORTER, RICHARD, ED. *Sidney Goodman: Paintings, Drawings, and Graphics, 1959–1979*. University Park, Pa.: Museum of Art, Pennsylvania State University, 1980.

REYNOLDS, GRAHAM. *A Concise History of Watercolours*. New York and Toronto: Oxford University Press, 1978.

RISHEL, JOSEPH J., ED. *Cézanne in Philadelphia Collections*. Philadelphia: Philadelphia Museum of Art, 1983.

SALANDER-O'REILLY GALLERIES. *Charles Demuth: Watercolors and Drawings*. New York: 1981.

SCHMIDT, CHARLES. "The Watercolor Page," *American Artist*, 41, no. 423 (October 1971): 62–64, 94–96.

SEWELL, DARREL, ED. *Thomas Eakins*. Philadelphia: Philadelphia Museum of Art, 1982.

SHAMAN, SANFORD SIVITS. "An Interview with Philip Pearlstein," *Art In America*, 59, no. 7 (September 1981): 120–26, 213–15.

SPASSKY, NATALIE. *Winslow Homer at The Metropolitan Museum of Art*. New York: The Metropolitan Museum of Art, 1982.

UNIVERSITY OF MARYLAND ART GALLERY. *From Delacroix to Cézanne: French Watercolor Landscapes of the Nineteenth Century*. College Park, Md.: 1977.

VIOLA, JEROME. *The Painting and Teaching of Philip Pearlstein*. New York: Watson-Guptill Publications, 1976.

WILTON, ANDREW. *British Watercolours 1750 to 1850*. Oxford: Phaidon Press Limited, 1977.

Index*

A

Abstract Expressionism, 162
Acrylics, usage with watercolors, 108, 133
American Watercolor Society (A. W. S.), 65-6
Aminoff, Tonia, 186-7
 Landscape, 187
Angelico, Fra, 141
Arches paper, 2, 3
Armory Show, 154

B

Balthus (Balthasar Klossowsky), 71
Beal, Jack, 74, 76
Beardsley, Aubrey, 167
Beckmann, Max, 165
Behnke, Leigh, 46-7
 Study for "Time Sequence: Value, Temperature, and Light Variations," 46-7
Berenson, Bernard, 91
Bieser, Natalie, 115-8
 Come from Behind, Pl. 21
 Tecata, 103
Blake, William, 58
Blue Rider (Blaue Reiter), 156, 162
Botticelli, Sandro, 141
Boudin, Eugène, 59, 92
 Beach Scene, No. 2, 59-60
Brady, Carolyn, 21, 36, 48, 55, 60, 66, 80-4, 92, 118
 Baltimore Tea Party with Calla Leaves, Pl. 8
 White Tulips, 80
 Carolyn Brady painting "Baltimore Tea Party," 81
 "Baltimore Tea Party with Calla Leaves" in progress, 82-3
Braque, Georges, 69, 115
Broad style, 58, 84, 128-9
Brushes:
 types, 7
 basic selection, 7-8
 care, 7
 Japanese paddle brush, 99, 192
Brushmark techniques, 92-5, 130, 141, 192
Burchfield, Charles, 165-7

 Afternoon in the Grove, 166
 Purple Vetch and Buttercups, 167

C

Caravaggio, Michelangelo, 71
Cézanne, Paul, 25, 28, 95-8, 130, 144, 154-6, 173
 Trees and Rocks, No. 2, 96
 Oranges on a Plate, 155
 Mont Sainte-Victoire Seen from Les Lauves, 155
Chaet, Bernard, 84, 142-3
 Strawberries, Pl. 17
 Strawberries (Detail), 143
Chagall, Marc, 162
Chavannes, Puvis de, 90
Chiaroscuro, 40, 71-2
Close, Chuck, 84
Cold Press paper, 3, 180
Collage techniques, 195
Color (element of), 32-7
 properties of, 33
 value, hue, and intensity, 33
 applying color principles, 33
 Creating a color chord with layering, 35
 color exercises, 36-7
 local color, 114
Colors (paints) 10-2
 recommended colors, 10-1
 artists' palettes, 10
 Martha Mayer Erlebacher's palette, 11
 arrangement on the palette, 12
 care of tube colors, 12
Composition:
 arranging the set-up, 41-3
 composing with a viewfinder, 43-4
 lighting the subject, 46
 developing a composition, 51-6
 the single subject, 136-8
 modular composition, 141-3
 patterning and positioning, 144-9
 diagrammatic space, 173
Constable, John, 58
Copley, John Singleton, 70
Courbet, Gustave, 59-60

*Illustrations and color plates are indicated in italics.

Crayons and chalks, 184
Cubism, 69, 95, 115, 144, 154-8, 161

D

Davies, Arthur B., 158
da Vinci, Leonardo, 48
Day, Larry, 84, 88-90
 Churches in the Snow, 90
Degas, Edgar, 63
de Kooning, Willem, 69, 91, 95, 156
Delacroix, Eugène, 78
Delaunay, Robert, 156-8
 The Eiffel Tower, 157
Demuth, Charles, 22, 25, 48, 126-8, 156, 159-61, 180-2
 Peaches and Fig, Pl. 3
 Three Red Apples, 27
 Bermuda Houses, 49
 Zinnias, 49
 The Boat Ride from Sorrento, 126
 Ta Nana, 160
 Red Chimney, 161
 Dunes, Provincetown, 182
Diagrammatic Space, 173
Direct and Indirect Painting, 40, 59, 72, 130-4, 143
Dix, Otto, 165
Dowell, John, 10, 22, 25, 48, 173, 177-8
 Love Jamb, Pl. 22
 Paradox on a Parallax, 24
Drawing:
 drawing boards, 13
 the preliminary drawing, 48
 principles, 48-51
 Tips on drawing, 50
 transfer techniques, 51, 125-6
 wash drawings, 126-7
 using a sketchbook, 128
Dry-brush technique, 138, 180-1
Duchamps, Marcel, 160

E

Eakins, Thomas, 61-5, 70, 93, 129
 In the studio, 64
 Sketch for Retrospection, 129
Eisenstadt, Jane Sperry, 51-5
 Strawberries and Asparagus, 52
 Flowers in a Doorway, 53
Epton, William, 80
Equipment and Supplies, 12-4
 pencils, 12
 water jar, 12
 portfolio, types of, 12
 supply kit, 12
 transfer paper, 13
 drawing board, types of, 13
 My "compleat" paint kit, 13
 shopping list, 14

Erlebacher, Martha Mayer, 10, 65, 84, 141-4, 181
 Martha Mayer Erlebacher's palette, 11
 Still Life Supreme, Pl. 18
 Still Life Supreme (detail), 142
 Fruit, 144
Exhibition opportunities, 197-8
Exposition Universelle, 58
Expressionism, 162-70

F

Fabriano paper, 2
Field trips, 101
Figure painting, 120-34
 figure/ground relationships, 120-1
 nude vs. clothed poses, 125-7
 inventing figures, 127-8
 composing with "flats," 128-9
 creating volumes, 129-30
 underpainting technique, 130-4
 capturing an impression, 134
Fish, Janet, 141
Flats, composing with, 128-9
Flaubert, Gustave, 58
Foamcore, 14
Folding and shaping possibilities, 194
Found objects, imprinting with, 194
Forrester, Patricia Tobacco, 84, 88, 99-101
 Winter Beech, Pl. 11
 Ravens, Trees, and Pond, 100
Framing, 4, 197
Francesca, Piero Della, 90
Francis, Sam, 186-9
 Untitled, 187
Frank, Mary, 92, 192-4
 Lily Pond, 92
 Women with Fishes, 193
Freckelton, Sondra, 21, 43-4, 55, 66, 74-7, 145-9
 Peonies and Bagel, Pl. 7
 Spring Still Life, 42
 Yellow Apples, 55
 Cabbage and Tomatoes, 76
 Coneflowers and Zinnias, 148
Fresco, 70 footnote
Frisket (*see* Maskoid)
Fry, Roger, 95

G

Galuszka, Frank, 10, 125-7, 133-134
 Nude in a Blue Bath, 125
 Judith Practicing before a Mirror (detail), 132
Gonzalez, Xavier, 48, 137-8
 Roses, 137
Goodman, Eileen, 41, 43
 Nine Eggs, 41
Goodman, Sidney, 48, 51, 65, 66, 70-2, 130
 Woman Taking off Shirt, Pl. 6

Study for "Summer Afternoon," 71
Woman Disrobing, 72
Gordon, P. S., 55, 145
Quasi-Moiré, 54
The Captain's All Vegged Out, 147
Gouache, 9
Gris, Jaun, 156
Grosz, George, 108-13, 165, 167
Punishment, 110
Maid Arranging Hair of a Corpulent Woman, 112
Eclipse, 164

H

Hagin, Nancy, 84, 145, 151
High Shelf, 136
Three Red Cloths, 146
Hals, Frans, 58
Heitland, Emerton, 78
History of Watercolor:
in England, 58
Realism in France, 58-60
Homer and his influence, 60-1
Sargent and Eakins, 63-5
New Realism, 66, 68-78
Photorealism, 78-84
Cézanne and Abstraction, 154-8
Demuth and Marin, 158-61
Expressionism, 162-70
experimental modes, 170-8
Holsing, Marilyn, 173-4, 195
The Divers in the Islands, 175
Untitled, 195
Homer, Winslow, 16, 21, 28, 60-5, 70, 77, 84, 88, 90-3, 98, 121, 128-30, 136-7, 143, 183
Palm Tree, Nassau, Pl. 1
Natural Bridge, Nassau, 17
A Wall, Nassau, 58
Ship Unfurling Sails, 60
Hurricane, Bahamas, 62
Flower Garden and Bungalow, 91
Girl in Black Reading, 119
Channel Bass, 137
Homosote drawing board, 13
Hopper, Edward, 122, 165
Coastguard Station, 15
Horter, Earl, 22
Toledo, 22
Hot Press paper, 2, 90, 186

I

Ibsen, Henrik, 60
Iconography, 74, 138 (*also see* Symbolism)
Impressionism, 59, 162
Imprinting, 194

Indirect technique (*see* Direct and indirect painting)
Isometric perspective, 174-5

K

Kandinsky, Wassily, 33, 154, 156, 192
Landscape, 34
Watercolor Number 13, 153
Geometric Forms, 192
Keyser, Robert, 21, 173
The Oracle Contemplates the Great Clapper, Pl. 20
How to Cure the Hecups, 174
Klee, Paul, 18, 28, 30, 154, 156, 170-3, 180
Goldfish Wife, 30
Jörg, 171
Dying Plants, 172

L

Landscape painting, 88-101
traditional formats, 88
Landscape formats, 89
brushmark techniques, 92-5
contemporary approaches, 95-9
A modernist landscape format, 96
editing landscapes in the studio, 99-101
field trip strategies, 101
Lawrence, Jacob, 165
Le Clair, Charles, 25, 32, 121, 130, 189-90
Basil and Nectarines, Pl. 13
The brushes I use, ¾ size, 8
My "Compleat" paint kit, 13
Checks and Balances, 32
Breakfast Coffee, 24
Southern Exposure, 123
View from the North (detail), 131
Cherry Tomatoes, 149
Geranium, 150
Yellow Begonia, 191
Lent, Lillian, 184-186
Day Dream, 185
Day Dream (diagram), 185
Lichtenstein, Roy, 84
Lifting, 182-4
Lighting the subject, 46, 130

M

Malevich, Kasimir, 156
Manet, Edouard, 58-60
Marin, John, 16, 28, 78, 92-5, 98, 104, 156-61, 180-1
Seascape, Maine, 17
Sunset, Maine, Off Cape Split, 93
Cityscape, 105
Deer Isle, Maine—Boat and Sea, 159
Movement in blue and Sepia, 181
Marks (*see* Brushmark techniques)
Masking tape, 56, 184, 189-90

Maskoid, 184-86
McGarrell, James, 66, 167-170, 181
 Tabletop Joys, Pl. 24
 Car Fire, 169
McKie, Todd, 48, 173, 177
 Home Sweet House, Pl. 19
 Accidents Will Happen, 176
Mexican mural painting, 162
Mirrors, composing with, 120, 149-151
Mitchell, Fred, 104-6
 All the Way Across, Pl. 23
 Ferry to Staten Island, 106
Mondrian, Piet, 156
Monet, Claude, 21, 59, 61
Moore, John, 43, 73-5
 Goldfish, Pl. 4
 Watts, 73
 Thursday Still Life, 75
Morley, Malcolm, 95, 136, 167-8, 183
 The Palms of Vai, Pl. 16
 Beach No. 3, 94
 Nude with Plane Crash, 168
 Fish, 183
Munch, Edvard, 154, 162, 167

N

National Academy of Design (N. A.), 65
Negative space (*see* Positive and negative space)
New Objectivity, The (Die Neue Sachlikeit), 165
New Realism (*see* Realism)
Nice, Don, 10, 34, 138-141
 Alaska BK III PPXVII, 140
Nolde, Emil, 127, 154, 162-5, 167
 Magicians, 127
 Papuan Head, 162
 Amaryllis and Anemone, 163

O

O'Keefe, Georgia, 158
Open-air painting, 59
Orozco, José Clemente, 165
Orphism, 156
Osborne, Elizabeth, 6, 33, 43, 106-7, 121, 125, 127-9
 Still Life with Black Vase, Pl. 12
 Pennsylvania Still Life, 42
 Nava Standing, 107
 Nava with Green Cup, 122
Overpainting (*see* Under- and Overpainting)

P

Palette, 9-10 (*see also* Colors)
 alternative meanings of the word, 9
 types of painting palettes, 9-10
 Martha Mayer Erlebacher's Palette, 11
 limited palette, 78

Paper, 2-7
 grades, 2
 finishes, 2
 weights, 3
 sizes, 3
 blocks and rolls, 3
 stretching, 3-6
 Tips on handling paper, 5
 flattening, 6
 tearing, 6
 soaking, 7
Particle board, 6
Patterning, 144-9
Pearlstein, Philip, 10, 30, 48, 65, 66-74, 81, 92, 120-1,
 144, 149, 151, 168
 Model in Kimono on Wicker Rocker, Pl. 5
 Self-Portrait with Venetian Mirror, 121
 The Great Sphinx, Gisa, 67
 Female Model in Kimono, 68
 Two Seated Females in Kimonos with Mirror, 69
Pencils, 12
Photographic techniques, 81-84, 99, 116
Photorealism, 78-84
Picasso, Pablo, 141, 156, 158
Plein-airism (*see* Open-air painting)
Plexiglass, uses of, 6, 13, 151, 186
Plywood, 4, 13
Pollock, Jackson, 115, 116, 156, 187
Polyptychs and multiple panels, 100
Porter, Fairfield, 28, 91-92
 Easthampton Parking Lot, 29
 From the Top, 87
Portfolios, 12
Positive and negative space, 40
Predella, 141
Prendergast, Maurice, 158
Process, as a creative principle, 115

R

Raffael, Joseph, 21, 33, 115-8, 136, 138, 184
 Return to the Beginning: In Memory of Ginger, Pl. 15
 Rise, 117
 Summer Memory in Winter, cover illustration
Ragin, Nancy, 66
Realism:
 definition, 58
 in France, 58-60
 Homer, Sargent, and Eakins, 60-65
 the New Realism, 66-78, 167
 Photorealism, 78-84
 studio definition, 162
Regionalism, 165
Rembrandt van Rijn, 71, 141, 144
Rockburne, Dorothea, 194
Rodin, Auguste, 128
Rouault, Georges, 162

Rough paper, 2, 158
Ruling pen, 192

S

Sabeline brushes, 7
Salting, 181-2
Sargent, John S., 28, 60, 63-5, 88, 95, 134, 143, 158, 170, 183
 Figure and Pool, Pl. 2
 In the Generalife, Granada, 63
 Sky and Mountains, 94
 Arab Woman, 124
Sceptre brush, Winsor & Newton, 7
Schmidt, Charles, 4, 111-5, 133, 186, 189
 The Disc, Pl. 14
 The Disc (detail), 114
 Temple of Jupiter, 115
 Spirit Level, 179
Scraping, 182-4
Scratching, 182-4
Seurat, Georges, 115
Shatter, Susan, 66, 88, 98-9
 Swirling Water, Pl. 10
Soaking paper, 7
Soviak, Harry, 40-1, 138
 Tulips, 39
 La Famille Blanche, 139
Spattering, 186-9, 192
Special effects, 180-95
Split-brush technique, 192
Sponges and sponging, 13, 193
Still life painting:
 arranging the set-up, 41-3
 composing with a viewfinder
 lighting the subject, 46
 virtues of, 77, 136
 strategies, 136-51
 the single subject, 136-8
 the still life of abundance, 136
 still life as icon, 138-41
 patterning and positioning, 144-9
 use of mirrors, 149-51
Supplies (*see* Equipment and supplies)
Supply kits, 12
 My "compleat" paint kit, 13
Suprematism, 156
Symbolism, 165, 168-70, 173

T

Taping (*see* Masking tape)
Texture, 180

Transfer paper, 6, 125-6
Turner, Joseph M. W., 58

U

Underpainting and overpainting:
 dry over wet technique, 112-5
 definitions and basic procedures, 130-3
 glazing over a sealed ground, 133-4

V

Values, 28, 33
 value scale, 30
 composing with four values, 28
 Using a value scale in layering technique, 31
Van Eyck, Jan, 58
Van Gogh, 154, 162
Velázquez, Diego, 58, 128
View finder, 43-44

W

Warhol, Andy, 81, 136
Wash drawing, 126-7
Wash techniques, 15-26
 dry vs. wet paper techniques, 16
 flat washes, 18-9, 25
 washing vs. glazing, 18
 graded washes, 18-21, 25
 edge shading and reversals, 21-23, 25, 130
 the wash drawing, 126-7
Watercolor medium, 9
 tubes vs. cakes (or pans), 9
 watercolor vs. gouache, 9
Water jars, 12
Welliver, Neil, 10, 28-9, 33, 66, 77-8
 Deer, Pl. 9
 Study for Print of Salmon, 29
 Immature Great Blue Heron, 79
Well-made watercolor, 60-1
Wet-in-wet techniques, 16-18, 104-118
 with premoistened areas, 104-8
 with saturated paper, 108-12
 Painting into premoistened areas, 109
 with dry overpainting, 112-5
 puddle techniques, 115-8
 exercises, 118
Wet-on-dry painting, 16-8
Whatman papers, 2, 3, 58
Whistler, James A. McNeill, 32
White Sable brushes (Robert Simmons), 7
Winsor & Newton supplies, 7, 10